LORI GOLDSTEIN
STYLE IS INSTINCT

Lori Goldstein with Sandra Bark
Foreword by Steven Meisel

HARPER
DESIGN

An Imprint of HarperCollinsPublishers

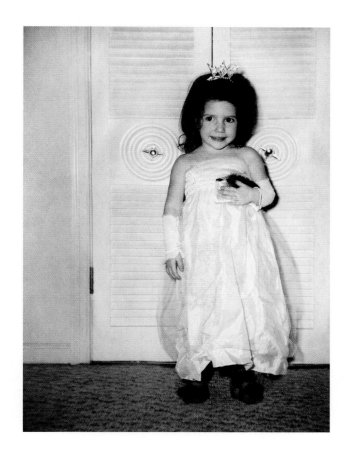

"Who looks outside, dreams; who looks inside, awakens."
CARL JUNG, *Letters, Volume 1: 1906–1950, 1973*

FOR MY MOTHER, MARCIA

Without your loving criticism and inspiring strength, I would not be who I am today.

CONTENTS

FOREWORD

Lori Goldstein is one of the most talented and real people in the fashion business. She and I have collaborated for so long that, to be honest, I don't even remember when I first met her or where we first worked together. It might have been before I was a photographer, or maybe it was for *Lei* magazine. I'm seriously drawing a blank.

But I can tell you this: success has not changed Lori at all. She is the same as she has always been.

She is a survivor, and she never quits. Even when not-so-great things happen, she just turns the page and moves forward, which is an unbelievably wonderful quality.

Lori and I have a lot of fun when we work together, even though work can be extremely stressful at times. Other editors freak out, making everyone crazier, but Lori remains peaceful and calm. Don't get me wrong: she is very serious about her work, but she knows that in the bigger picture it's important for us to enjoy what we are doing and to be as creative as we possibly can under the circumstances.

One of the main reasons that Lori has been able to stay at the top of her game for so long is that she has always kept a healthy arm's length from the industry. I don't think she would have it any other way. She doesn't get involved in politicking and nonsense, and she genuinely cares about the job. She is an artist and isn't interested in being a star. The work and her passion for it come first, not her ego.

What really sets Lori apart is her unrivaled ability to mix. She loves mixing everything: periods, collections, fabrics, colors, prints, new, old, everything. She is amazing at it. And trust me, she'll go to the ends of the earth to find something unusual or something that you haven't seen before. You never know what you're going to get when you arrive at a shoot with Lori, because there is such a variety of things that she has chosen. Yet she puts it all together, and it works.

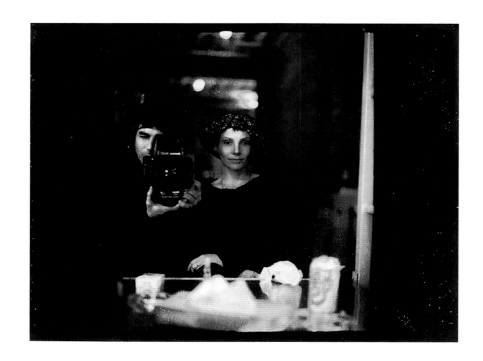

STEVEN AND LORI, New York City, 1991

In some ways Lori works like a painter, mixing colors and textures. And like a true artist, she sees it immediately. She's eclectic, taking a bit from here and a bit from there; mixing something very expensive with something vintage. And why not? If you have a great eye and great taste, you can afford to break the rules. Not everyone can pull that off. She's one of those people you go to a store with and even though you're looking at the same clothes and accessories, she will be the one to come away with something amazing and unexpected.

I really think that Lori was the first to bring vintage fashion back into style. She was certainly the first fashion editor I worked with who was searching out all sorts of places for vintage, especially in Los Angeles. And she was the first one to start mixing vintage with new collections. Nobody used those clothes before.

For Lori, styling comes naturally because she absolutely loves and understands clothing and accessories. I think that's one of the main reasons her LOGO by Lori Goldstein collection for QVC has been such a hit. She brings an honesty and passion to the collection, and women are able to relate to her because she is not phony. She loves women and knows how to help them at a price point that is accessible. She really is interested in helping women put themselves together, whether she's doing it on QVC or in the pages of Italian *Vogue*. These two venues aren't contradictory for Lori. Whatever work she's doing comes from a place of passion, openness, and fearlessness.

Besides, strict rules are for other people. Lori is a free spirit who lives life to the fullest. She is a rebel, certainly, but armed with her sense of humor, her amazing taste, and her heart, she is my kind of rebel.

— Steven Meisel

INTRODUCTION

Where does style come from? For some people, it emerges from suggestion—this season's jacket; this season's boot—but that isn't style. That's fashion. That's trend. Style goes deeper; it's an appreciation of what lies beyond the conventional definition of beauty, that is, of what is different, of what upsets a surface, turning a still pond into something with waves, something more like an ocean.

My aesthetic emerged at a young age. I always knew what I wanted to wear, what I wanted to see. I was captivated by the blue of the sky, by the rough texture of the bark of the trees, by the freedom that I felt when I was outside in the summer with the sun on my face. That was what I sought then and what I seek now: to be surrounded by beauty; to be suffused with freedom; to be allowed complete creative expression.

That is what style has always been and will always be to me: the expression of a personal philosophy about beauty, about the world, about the nature of life itself. My style is an expansion of the notion of beauty, sometimes slipping, sometimes pushing beyond the familiar or the obvious: adding layers, textures, colors, more, always more. My style says chaos is beautiful. It says ugliness is beautiful. It says everything is beautiful.

I ask myself, if that is style, what is a stylist? A dream catcher. A conjurer of fantasy. A partner to the photographer, to the subject, to the moment. A stylist produces a physical entity so that the photographer can capture a dream. A stylist turns the subject into a fantasy—or reveals his or her humanity. A stylist respects the value of the moment, bringing everything into one place so the moment can take hold.

And then, snap. Clothes, hair, makeup, set, stylist, subject, photographer, and moment all disappear into the finality of the right photo, the photo that makes people stand up and point at the monitors—the photo that becomes the one.

Like any beautiful sonnet, sonata, or still life, a great photograph has a quality of timelessness—it conveys a sense of always having been there, of being meant to be. But in order for something to be meant to be, it must be meant. Someone has to envision it, imagine it, breathe it into being.

The first stage of creation, whether building a mood, feeling, or story, is the same: discovery. At the outset of a project, I am an obsessive collector of all the ingredients I need to cast my spells. For me, the hunting doesn't begin when the agent or the magazine editor calls or when the photographer asks about my availability. I am always working, hunting and gathering wherever I happen to be. Whether I am in the stores, at the markets, or on the streets, I am looking, discovering, responding, finding, taking, collecting.

I always bring my newest treasures to a shoot: a pair of sunglasses—which I saw on an elderly woman in Palm Springs—that I fell in love with because of their shape, or more jewelry than I could possibly ever need because too much jewelry can never be enough. The point is, you never know what you'll want to use, and it's often those very clothes or accessories that I go for instinctively that make their way into the pictures, then into fashion magazines and the stores, and then back out to the street again.

Every shoot begins with an idea for a way to communicate this season's line, that designer's collection, or a photographer's vision. I listen. I listen closely, and after the listening comes the understanding. The feeling. The knowing. My subconscious takes over, my conscious mind flees, my senses sharpen, my heart imagines.

Styling is pure instinct honed by practice, but not born of it. You can study a craft, you can learn a skill, but if you want to be a master, you have to learn to trust the voice that lives inside you. And sometimes, you have to trust the voices of others because instinct respects collaboration. It welcomes the gathering of creative minds. But it needs room to maneuver, space in which to root and grow. It requires collaboration with creative minds who need room too, who also understand the rooting and the growing.

Then there is an idea. Then there is a meeting. Then there is a vision. And I go to the racks, to the piles, and I pull, and I toss, and I try, and I try again, until the look I'm trying for is perfect. But what is perfect? It's what it is. It's what it becomes. It's what I knew it could be, what nobody else could see until the pieces were all there, until the hat was there, the bag was gone, the model went inside, came outside, and there—there it is, the moment, balanced, harmonious. There it is: the picture that looks like it was always meant to be there, a picture that is at once a picture of beauty and beauty itself.

THE SICKNESS

BEAUTY

is in the eye of the beholder: that's what people always say when they don't understand whatever they're looking at—particularly if it is new to them or strikes them as strange. I sometimes wonder if anyone besides me really believes that beauty can be open to interpretation, that it can exist in as many different forms as there are people. For years, I've been partial to my own kind of beauty, a personal expression influenced not by popular ideals or conventions, but by the intimate land of my imagination— the interior world that lives inside all of us but that we are rarely encouraged to explore as we grow up and are schooled in the importance of conformity.

Just beyond the edge of convention is what I called the sickness—that moment of individuality that transcends the pretty, the perfect. When you're working as a stylist, making an image, bringing together each component, pushing it farther away from the expected, almost too far, that's where the sickness lies.

It's never a matter of pretty. I've always known what pretty is and I know how to do a pretty shoot, but the sickness is not about achieving perfect prettiness. The sickness

expands that notion, inflates it until it bursts, and then reconstructs it, held together at the seams by the nuances of real life, and defined by its own unique and wondrous beauty. The sickness takes chances. It messes things up. It is the "other," the "queer," the threshold on which everything turns, the point when the meanings shift.

The sickness is that one millimeter off, and it makes every difference between the mundane and the magnificent.

The sickness is never ugly, and it's never thrown together. It maintains an elegance, a specific kind of glamour not readily found in mainstream culture. It is never obvious. It requires you to look beneath the surface, to read between the lines, to let go of judgment and prejudice. It is not a question of "Why?" but of "Why not?" It's a place where things are pushed past their limit, right out of their safety zone. There, the don'ts become dos, and there are no rules.

The sickness is a kind of joy. It adds an element of fun, presents an opportunity for satire. No matter how beautiful or polished or extravagant something might be, the sickness always comes with a wink. That's how I see life: approaching it with a certain lightness, always asking questions, maintaining a voice of dissent when needed, questioning conceptions of beauty, keeping the status quo on its toes. Ultimately the sickness is a celebration of everything that makes us rich in our individuality, with all our imperfections. The sickness insists that beauty is in the eye of the beholder and if you want to find it, you have to open your eyes wide.

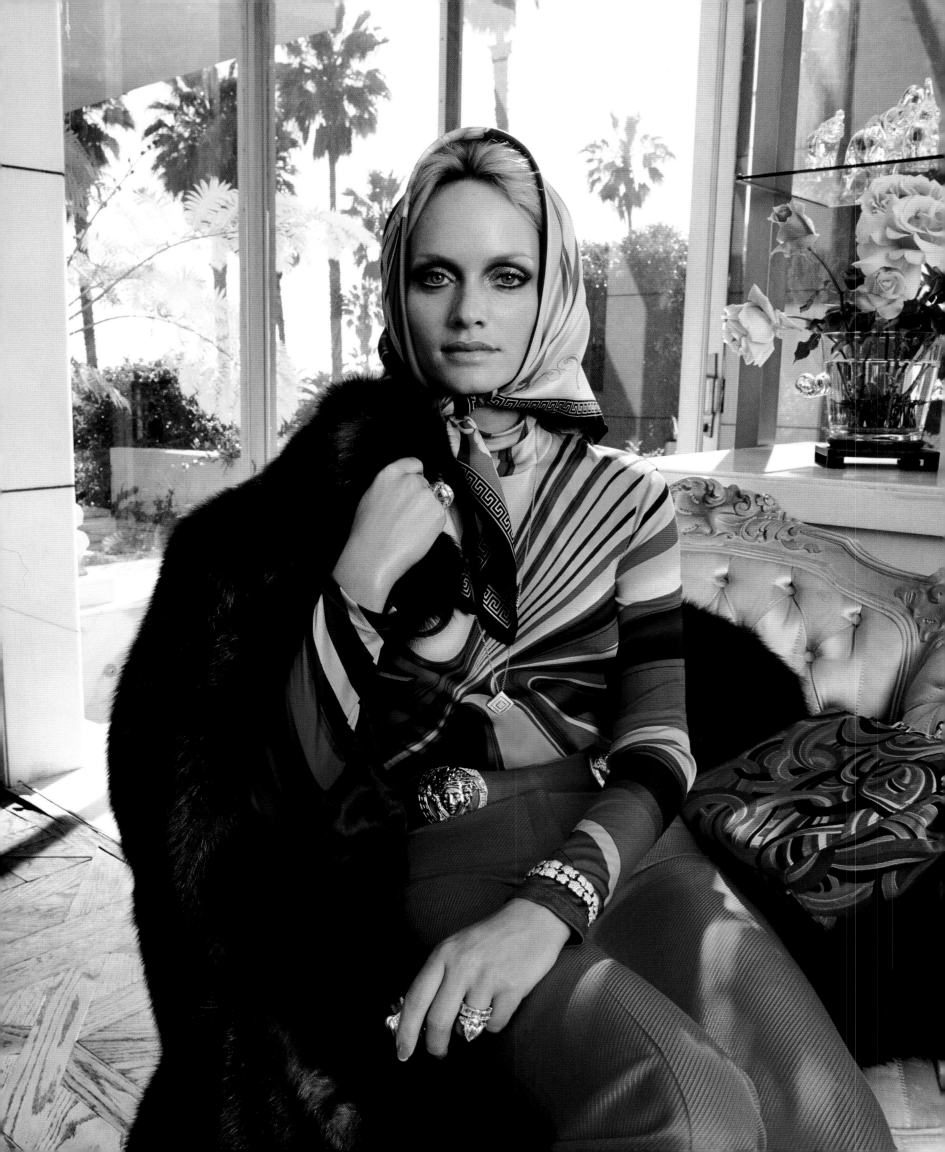

was about to start high school when I first read *Valley of the Dolls* and entered the world of Jacqueline Susann's fabulous, passionate, and totally tragic women. Her questioning of glamour and fame, so unsettling in its honesty, crept into my head and stayed there, lingering for years until finally I was able to give it my own expression. When Steven Meisel and I began working on the Versace print campaigns for the fall 2000 collection, the novel became a source of inspiration; *Valley of the Dolls* was all there, in the hair and the makeup, in the clothes, and in the location. For three days Steven, hair stylist Orlando Pita, makeup artist Pat McGrath, Donatella Versace herself—all of us— lived and worked in this house in the Trousdale Estates in Beverly Hills surrounded by the sickness, a place that was exactly where we thought the female character we were creating for the campaign would live. The house was like a movie set, a total fantasy world, a mirror to what at the time was this bubbling fascination with excess.

This campaign for Versace does more than showcase clothes. Through the detailed environment and the body language and facial expressions of the characters, the campaign tells a story, almost editorially. The campaign was a celebration of a very specific persona: a rich woman whose life has a veneer of perfection, who herself appears flawless to other people, yet who is actually very much in the doldrums. I wanted the models, Amber Valletta and Georgina Grenville, to portray that level of beauty, privilege, and control to the point where they stepped across the edge into the sickness. We were extremely methodical in directing their gestures and expressions, and we summoned the bizarre perfection of these characters. And that stunning sense of boredom. They really became the Versace character we had envisioned: everyone in the world wants to be in her shoes, and she'd rather be anywhere else.

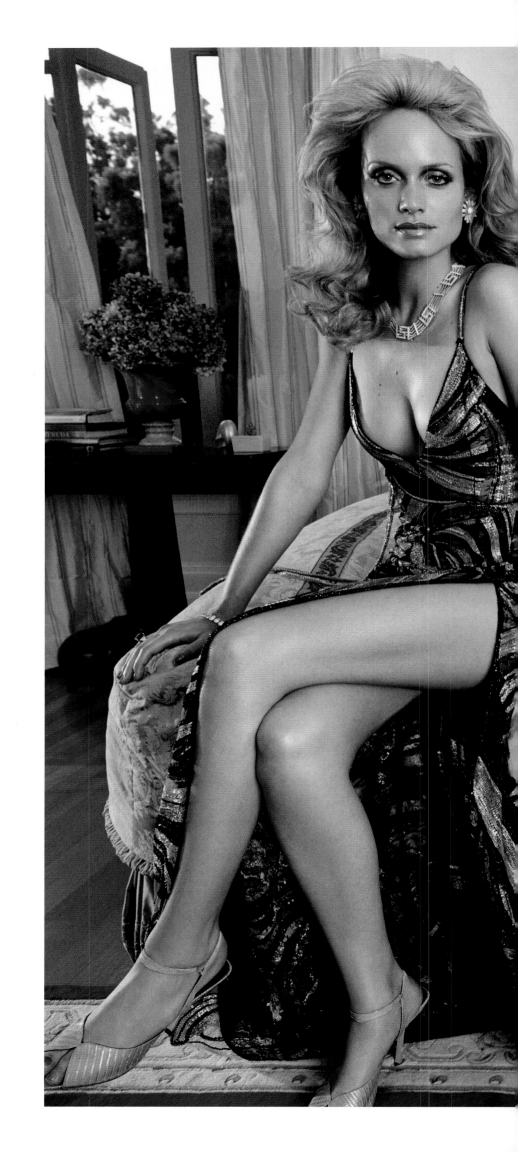

pages 20, 22 – 23
Steven Meisel, Versace, Fall 2000

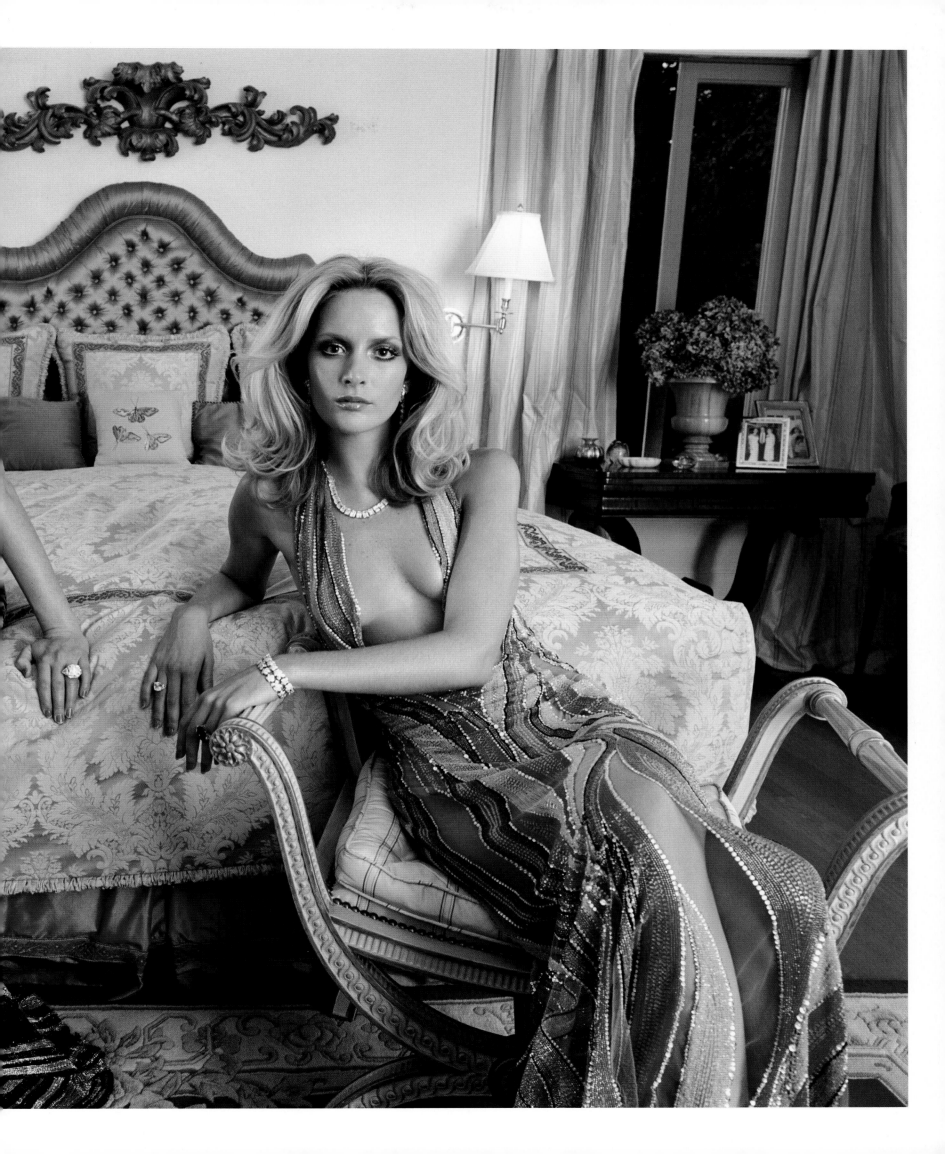

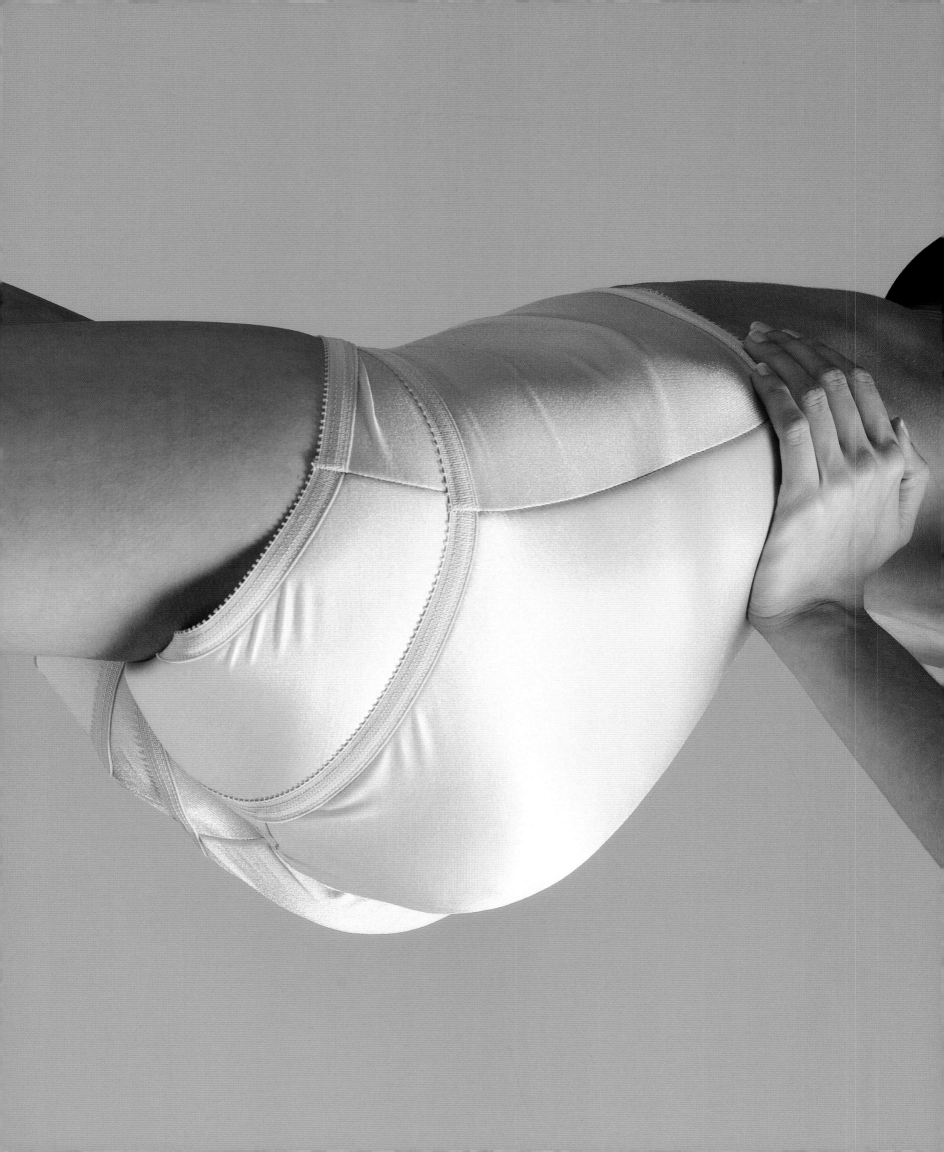

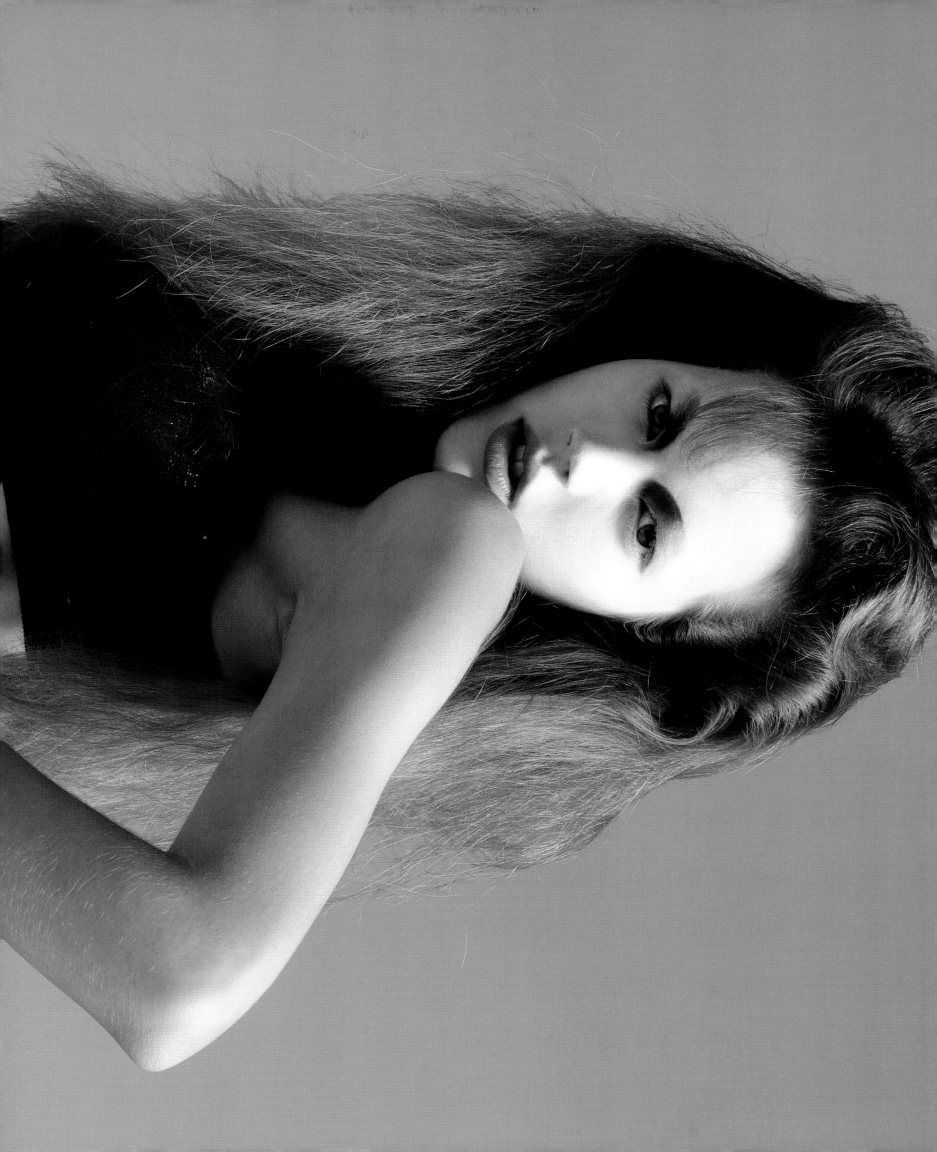

MEDIOCRITY IS LIKE A SPOT ON YOUR SHIRT: IT NEVER COMES OFF.

HARUKI MURAKAMI, *Dance Dance Dance*, 1994

T his image of Freja Beha came out of a less-than-inspiring assignment, with clothes that were nothing out of the ordinary. On the surface, there was no fashion message, nothing to shoot other than the credits. I suppose that at the end of the day, clothes are just clothes, but it's hard to take a bad picture of couture. Some pieces need more imagination, more vision.

In this case, I was looking for the juxtaposition between this gorgeous girl and these basic garments. We wanted to push the limits somehow: the idea began there and evolved into "Let's get fake bosoms and a big fake butt."

Freja is a very cool girl, and she was game. She put on these oversized enhancements, and at first she didn't say anything. Then all of a sudden she was just grabbing her giant bosoms for the shoot. That was what made the story.

The next time I saw her, I knew our interpretation had worked too, because she whispered to me, "I miss them." And I knew she didn't mean the clothes.

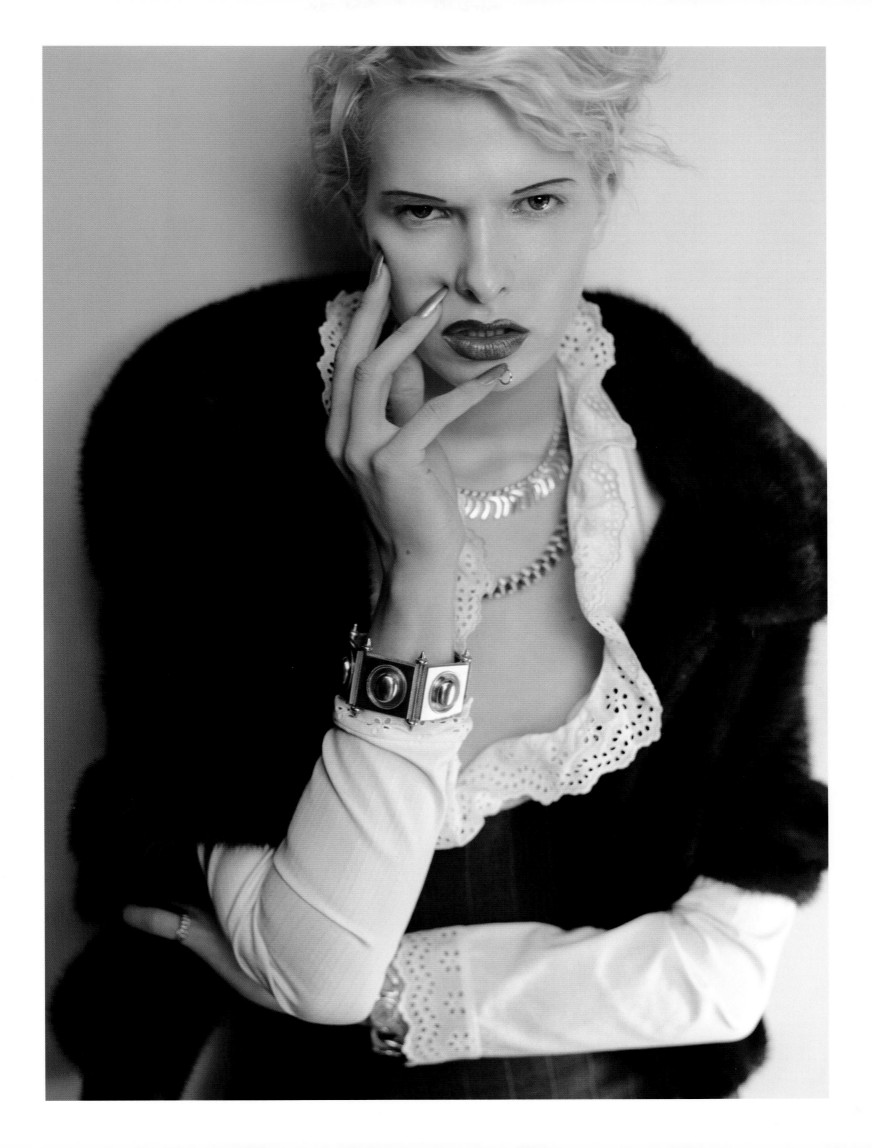

S teven and I were going to photograph Daphne Guinness, muse and very close friend of Alexander McQueen, who had just passed away, for Italian *Vogue*. I had been working hard to get my hands on a pair of McQueen's infamous armadillo shoes for the shoot, but it didn't seem likely because his press office was holding them close. After asking numerous times and receiving a string of refusals at first, I finally got them to say yes, and I was so excited. But I didn't tell anybody—not Daphne, and not even Steven.

The shoes arrived while we were eating lunch on set. I opened the box, and they were magnificent. Everyone went wild—the vibe in the room was electric.

We dressed Daphne in nude stockings with black silk fringe on the back, and they fit her like a bodysuit. She then stepped into the shoes—and became this mythological creature. The whole shoot was a pure celebration of Alexander's memory. It was incredibly special.

opposite
Steven Meisel, Italian *Vogue*, February 2010, Daphne Guinness

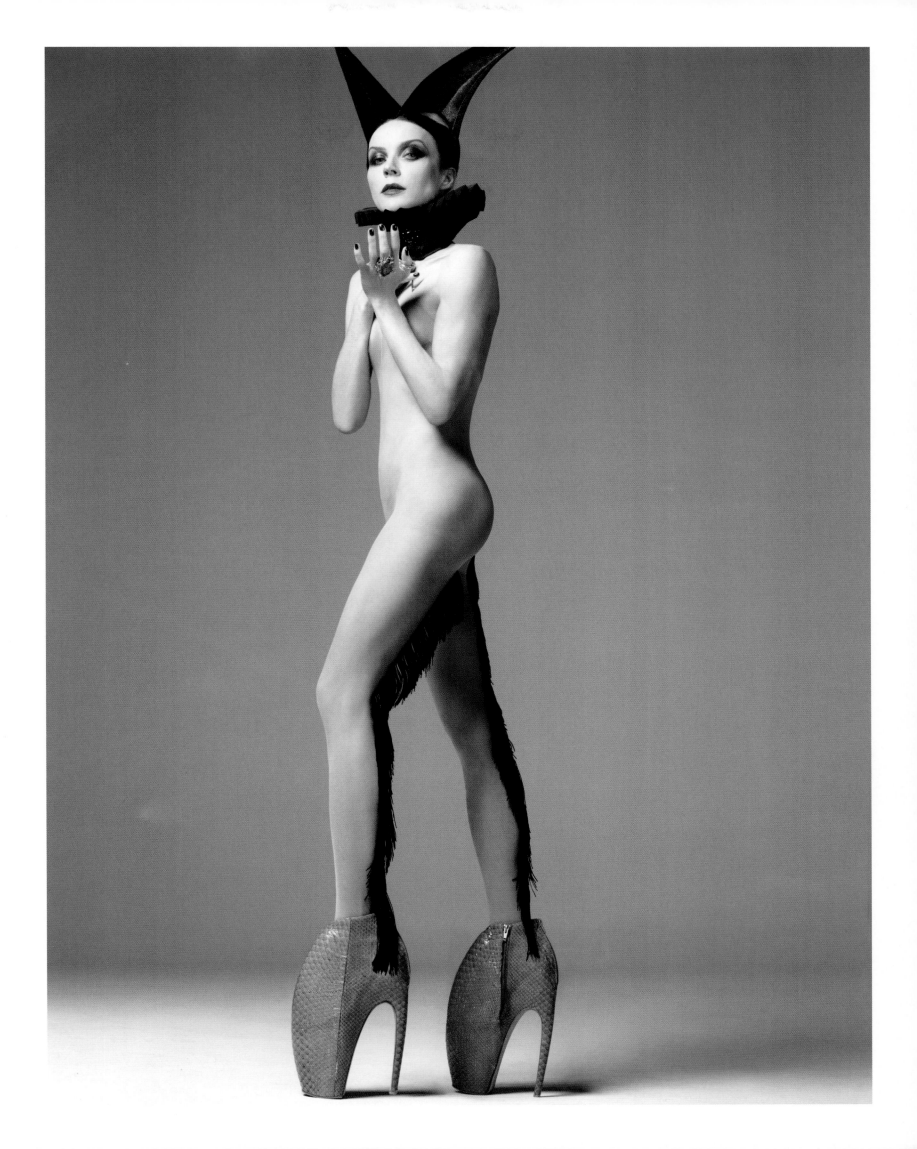

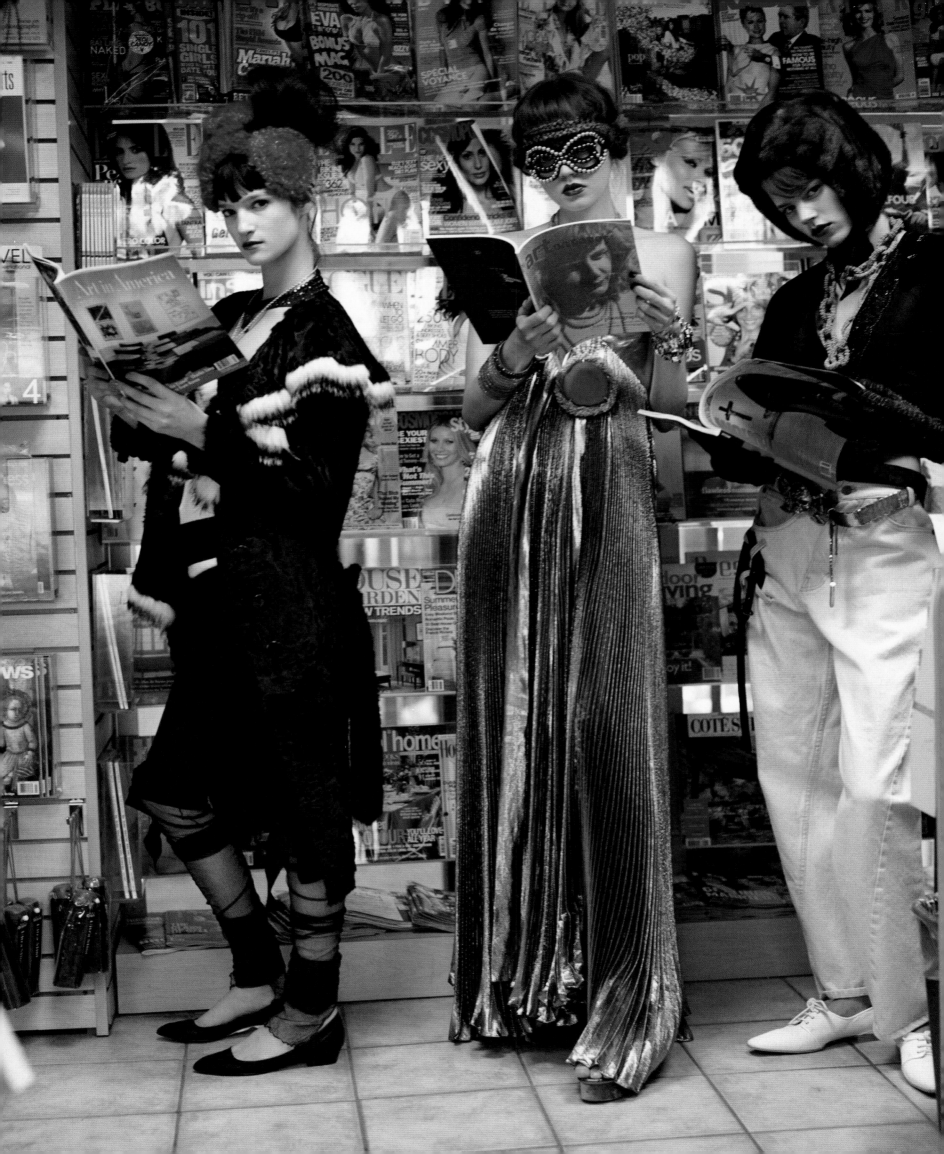

I LIKE NONSENSE. IT WAKES UP THE BRAIN CELLS.

DR. SEUSS, from *Wisdom for the Soul,* by Larry Chang, 2006

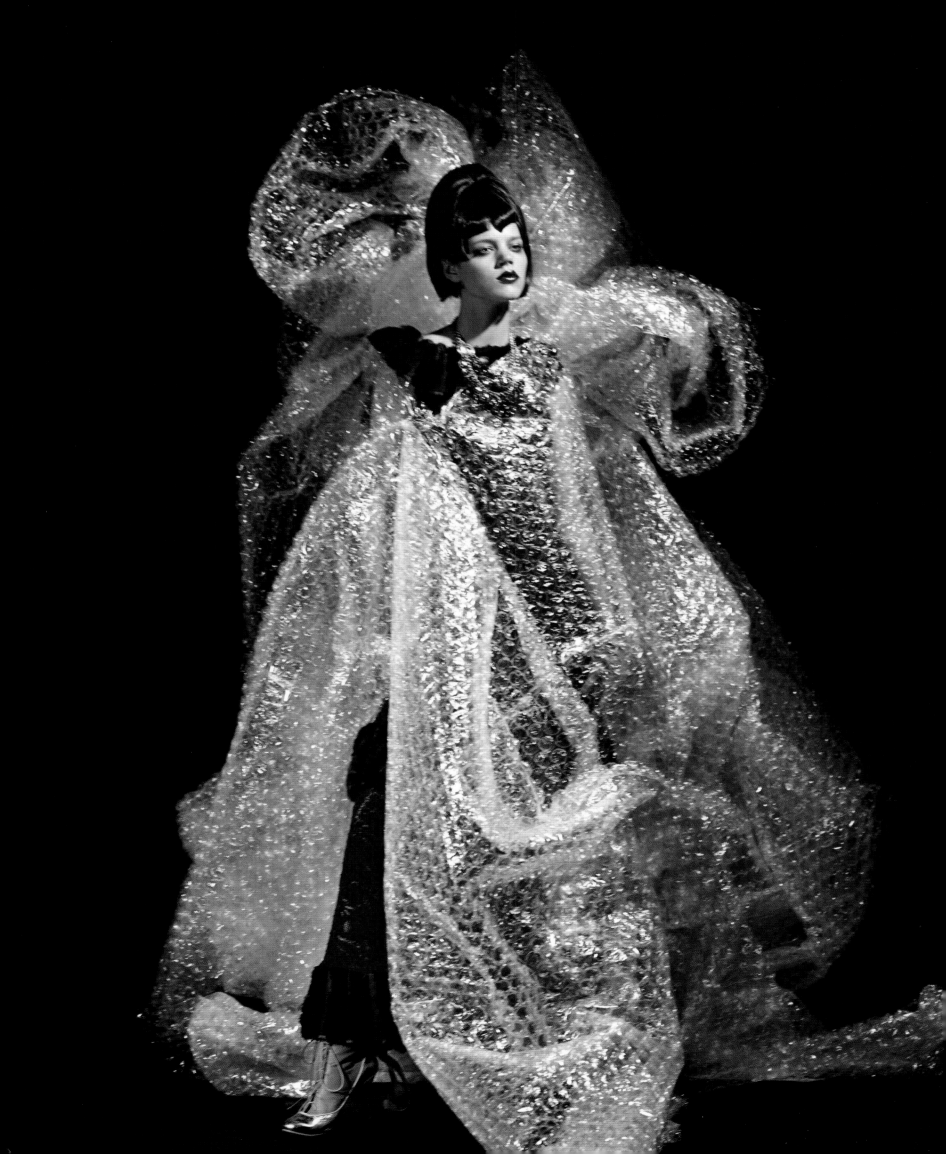

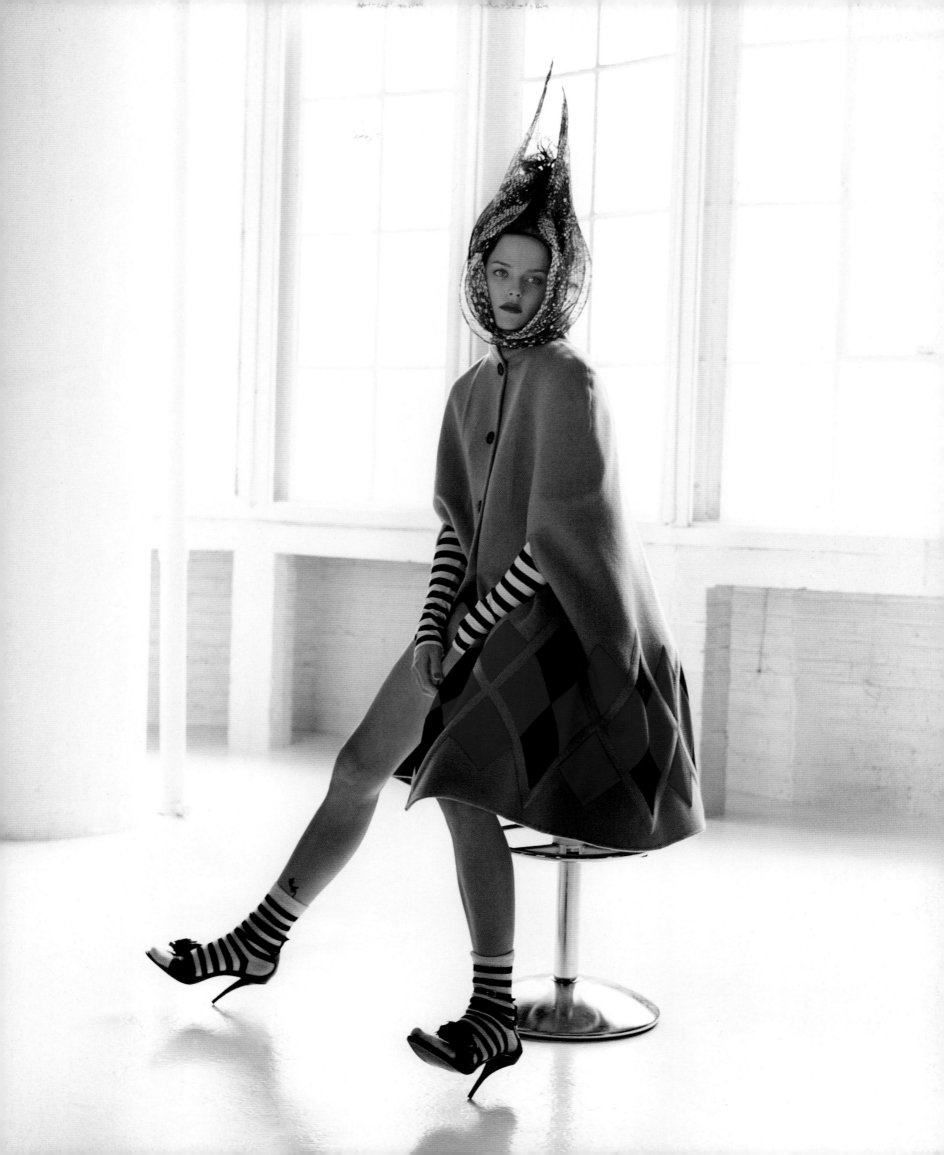

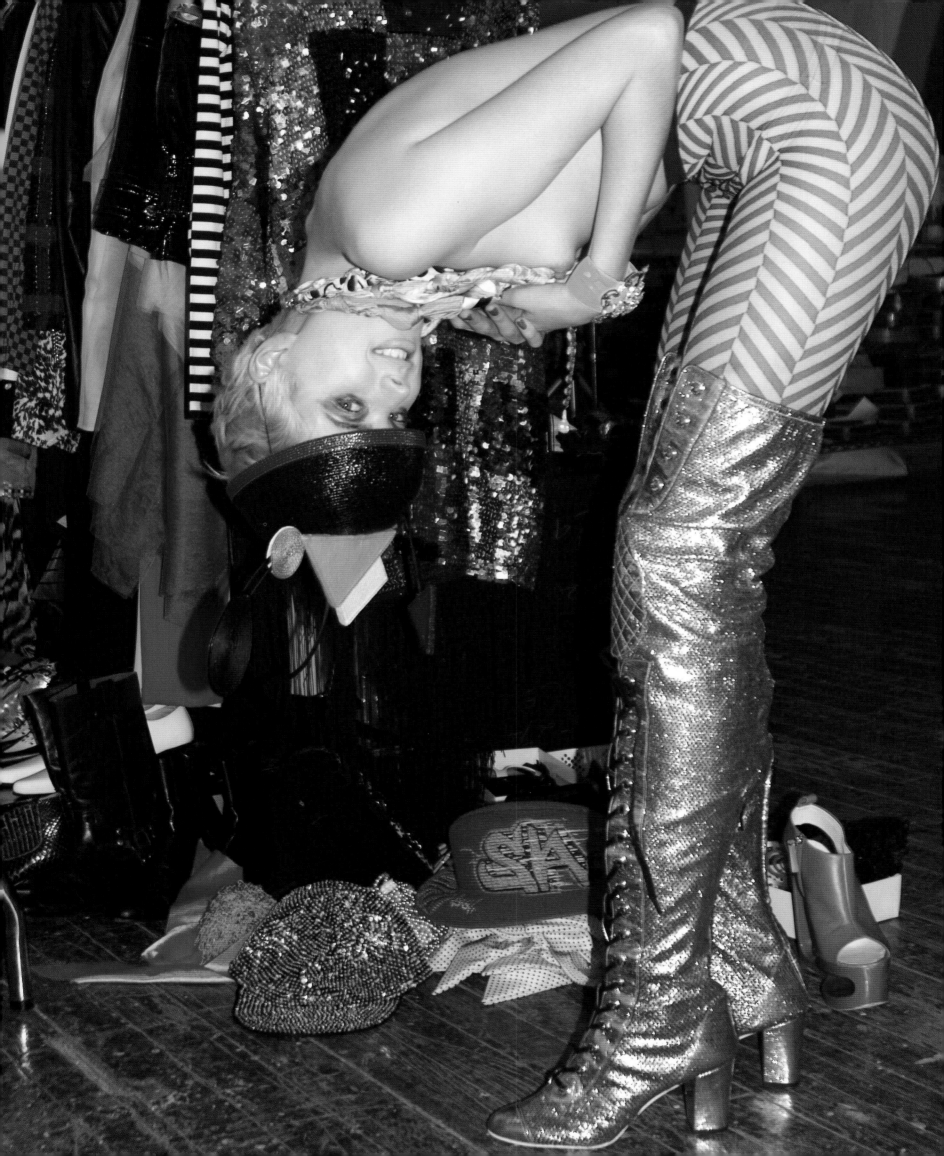

The one and only time I ever styled for *i-D* was for the Agyness Deyn issue in May 2008, which was going to be devoted to the model and her world. Her agent, my friend Louie Chaban, called me and asked if I could do a 1980s-inspired shoot with her that would be shot by the painter Billy Sullivan. By then I was used to working with large budgets for bigger magazines, and although there was absolutely no budget for this shoot, the work appealed to me because Billy is an artist, not a fashion photographer. I also liked that the shoot would bring together two fashion rebels, Agyness and me, and the rebel non-photographer.

I couldn't resist the 1980s concept. The 1980s was *the* time in New York City, and it was when I came into my own. For my friends and me, this decade was all about self-expression, rebellion, and music. The shoot made me remember the crazy days at the Mudd Club, where I first met Anna Sui, Betsey Johnson, Pat Fields, and all of the others who would ultimately remake the fashion industry in their own image.

The shoot was in Billy's third-floor walk-up, and we had to schlep all our stuff up the stairs. There was no plan for the day. I just pulled in the kinds of things I had worn in the 1980s, like vintage Betsey Johnson, and Trash and Vaudeville, and mixed it with Prada and Chanel and Marni. Each look reminded me of how all of my friends and I used to dress back then, and Agyness just got the vibe.

This was an extraordinary, memorable shoot. For me, the whole experience was just this great road trip back to a joyous period of my life.

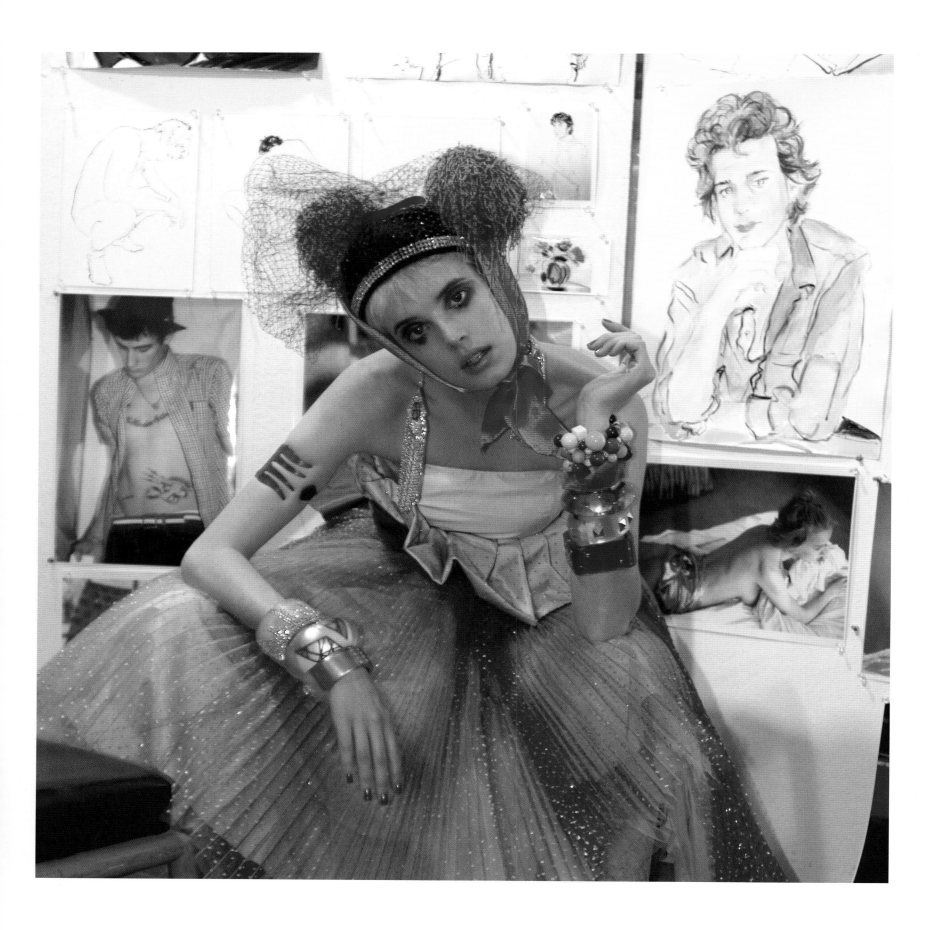

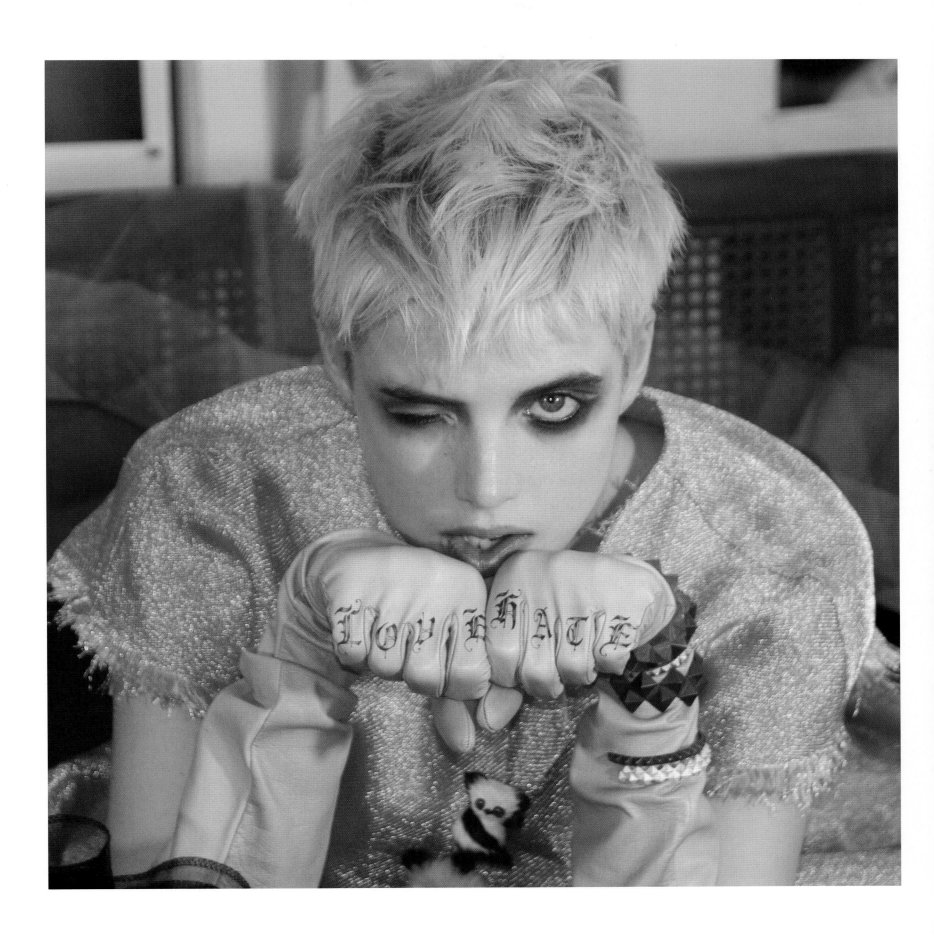

39

n early 2000, I was visiting my mother in Palm Springs, where the ladies about town at the time tended to go for big hair, enormous sunglasses, and candy-colored visors. They had me with those sunglasses. I loved huge sunglasses in the 1970s, thanks to Sophia Loren, and I really hadn't seen them since, but now I was completely reinspired. It was my guilty pleasure to visit the swap meets whenever I was in town, and lo and behold, there they were—the sunglasses, the visors—the look I had been obsessing over. I didn't know when I was going to use them. I just knew that I would.

Steven and I were spending a lot of time working in LA. There were so many terrific kids there at the time—all of the actors, musicians, and other hopefuls—they all had the dream. I was just as inspired by them as I was by the women in Palm Springs. We had this great idea to do a story using these young kids rather than models. It was also the perfect story to use my swap-meet pieces.

To complete the looks I visited Allan Pollack and Suzi Kandel at their vintage store, Allan & Suzi. They collect some of the rarest vintage pieces and are as obsessed with fashion as I am. At the time, they carried all of these eclectic hand-selected clothes from the 1960s, 1970s, and 1980s, from avant-garde Japanese designers, like Kanzai Yamamoto, to one-of-a-kind rock and roll pieces. Walking in was—and still is—like entering a time warp. I found a coat made from an American flag and a patchwork

Donald Duck jacket. Allan and Suzi were so attached to their vintage collection that most of it wasn't even really for sale. I loved them for that!

I took these pieces along with all of my swap-meet finds back to LA. We shot in the Los Angeles River in downtown LA, where the riverbed is dry for most of the year. It was the perfect place to show off this incredible layering of eras, mixing and matching vintage with designer: Americana-inspired pieces paired with Judith Leiber bags, rock and roll tees mixed with Anna Sui—and all those great sunglasses and finds from the swap meet.

This story ultimately became more than just another editorial in a magazine: I'd like to think it represented the way a generation would dress. Youth culture at the time was coming off a decade of so many different influences and subcultures, from grunge to hip-hop; there was a vivid eclecticism that was emerging. Almost anything could go. But there was also this irreverence and a total lack of self-awareness, the kind only the young can have and only in an era of economic prosperity, like we had back then. For me, that's why there's so much power in this story—using real kids conveyed that irreverence and nonchalance in a way that models could never have done.

That shoot was all about freedom in its execution and feeling: to borrow attitude and styles from different groups and eras; to mix the old with the new; to pair swap-meet sunglasses with high-end designer clothes; to be comfortable looking back, knowing you would always be going forward.

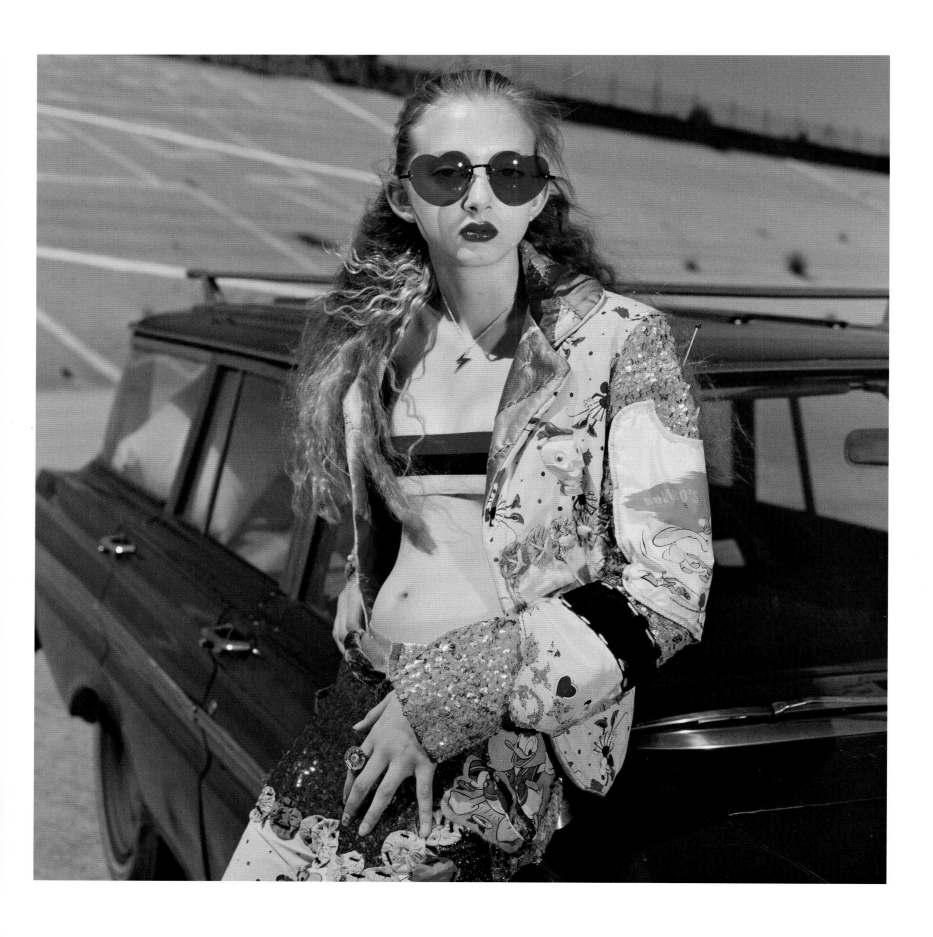

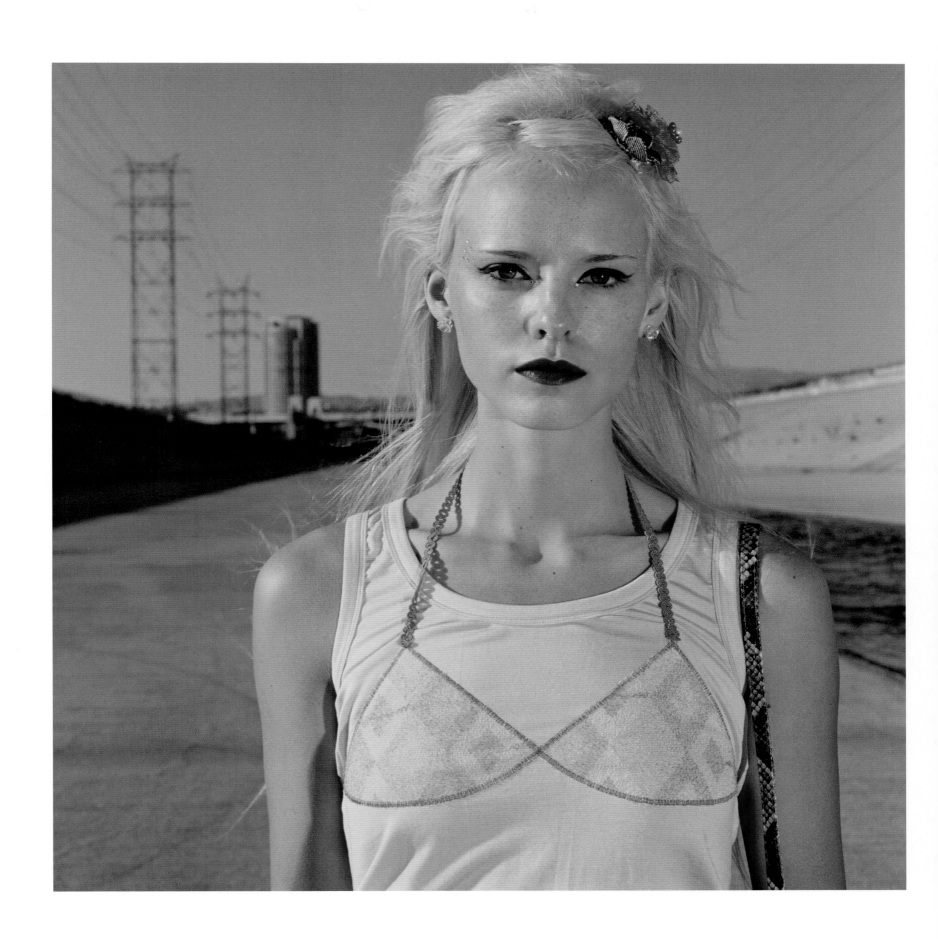

pages 42 – 43, 45
Steven Meisel, Italian *Vogue*, May 2000

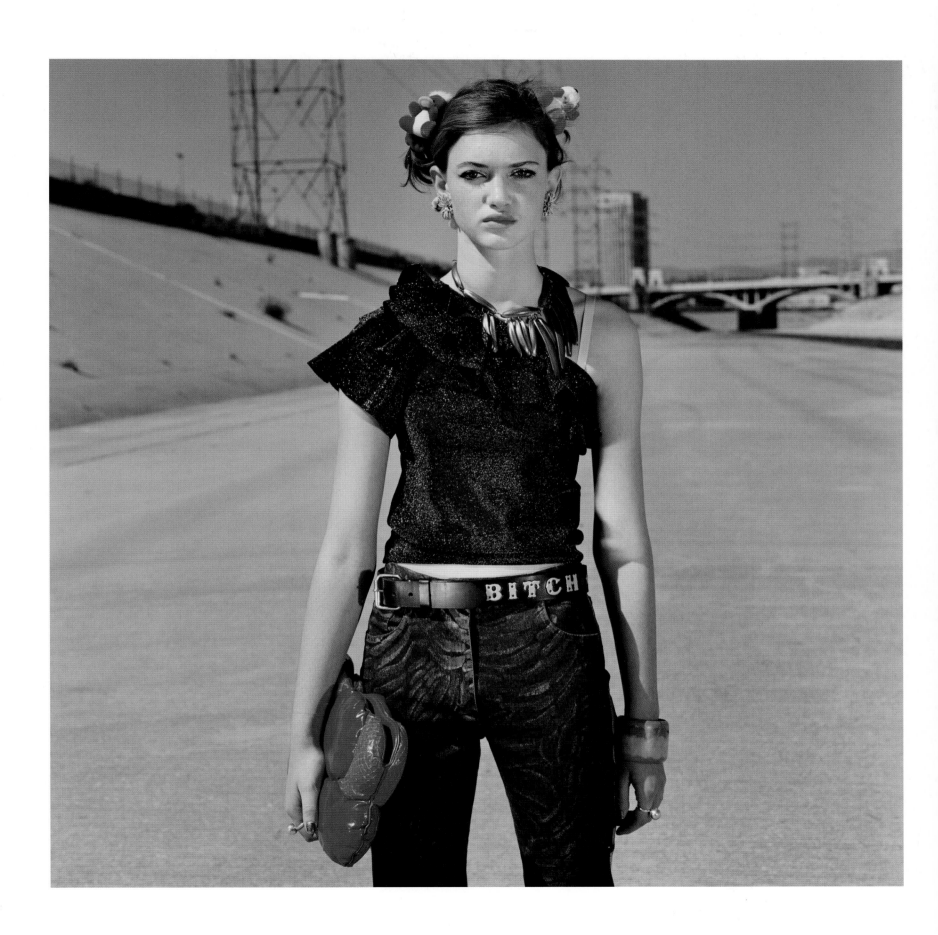

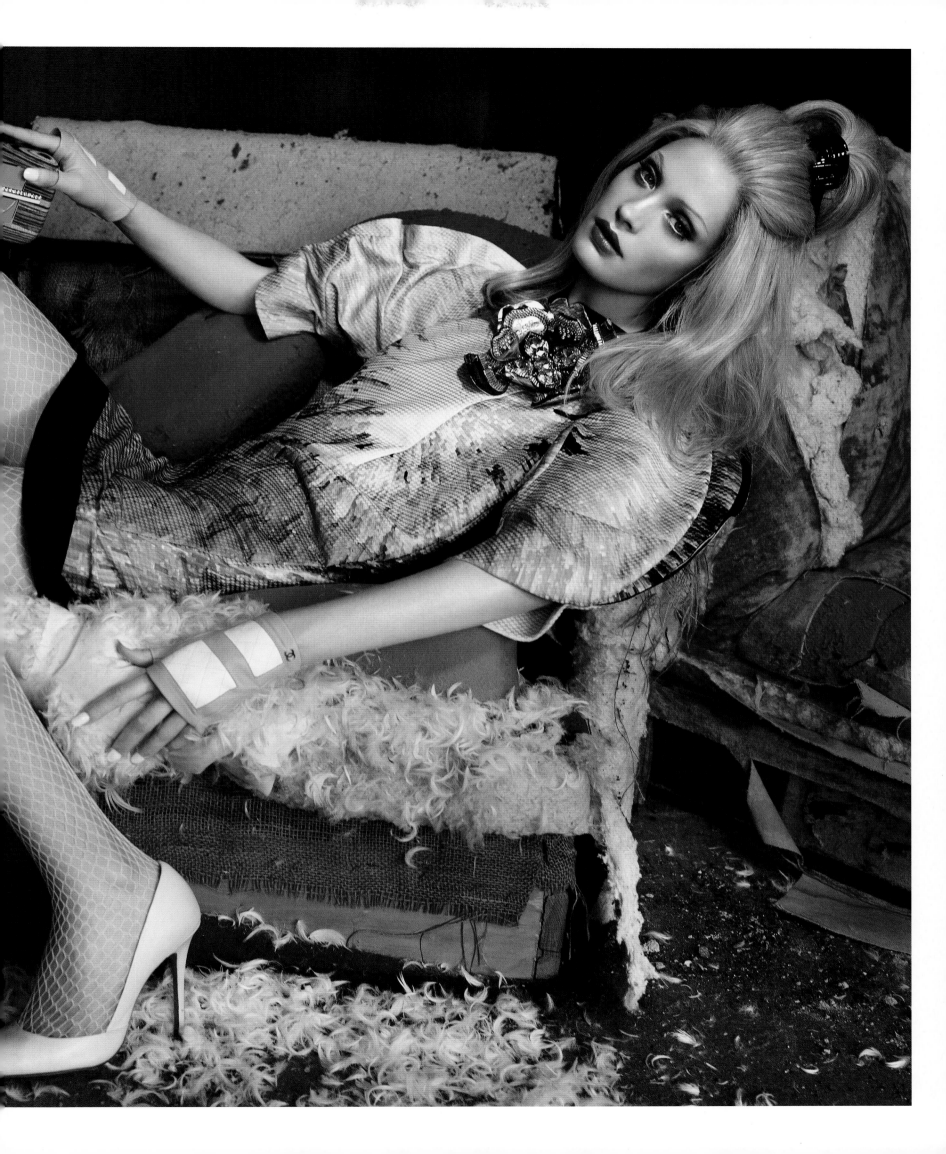

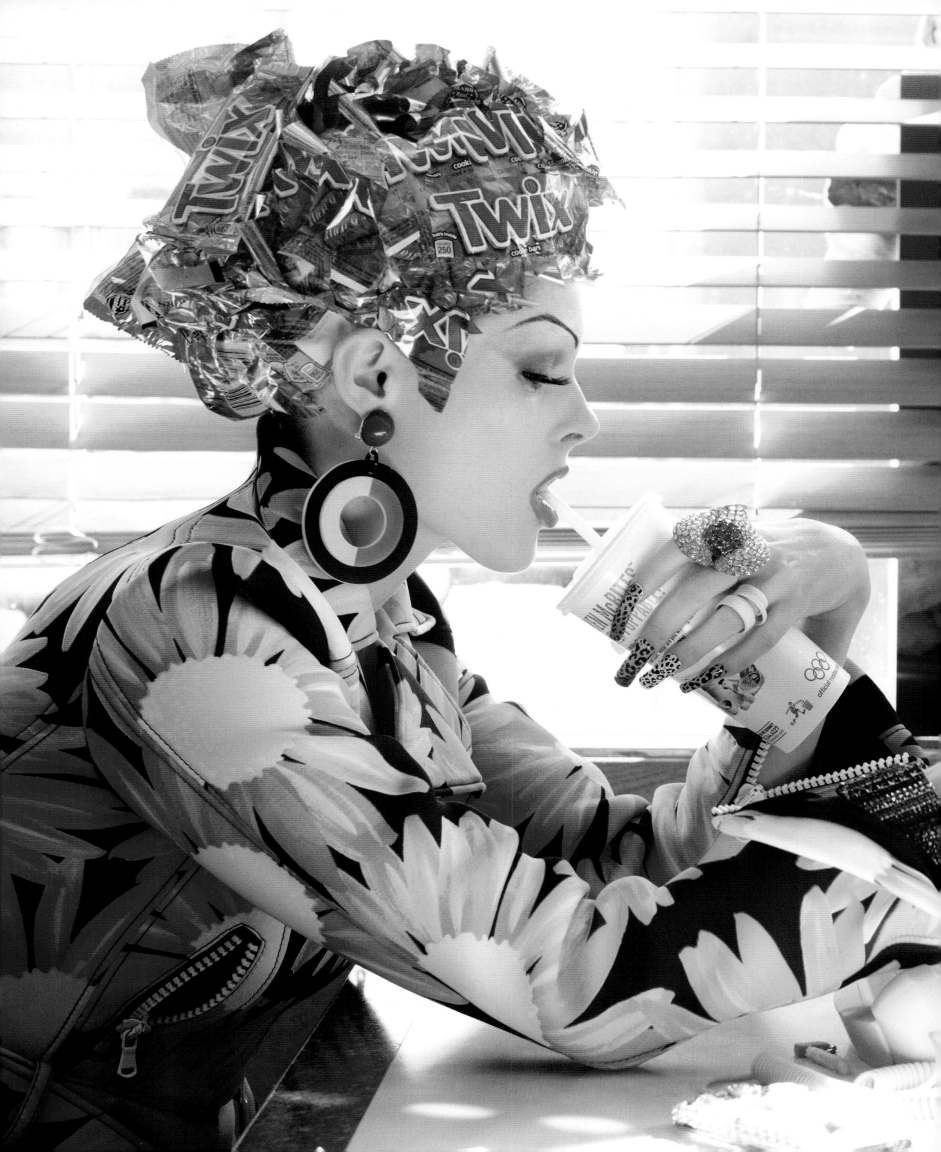

TO UNDERSTAND BAD TASTE, ONE MUST HAVE VERY GOOD TASTE.

JOHN WATERS, *Shock Value*, 1995

opposite
Steven Meisel, Italian *Vogue*, March 2012

love to prep for a shoot. I enjoy that great discovery. I bring all of my favorite finds—everything that I adore—to the set with me, knowing that I will usually end up using most of it. This is part of my method. I've learned never to "save" anything that I see for another shoot—there will always be new possibilities!

When I was commissioned to do this accessory story, I knew exactly what I wanted to do. The season was full of beautiful, rich, jewel-toned hats, bags, and shoes. I couldn't wait to use all of them. I wanted to feature these pieces with brightly colored furs. I brought in every stunning fur of the season. Fur is dramatic and exciting—it fills up negative space while adding texture and proportion to the overall composition; you're always going to have a great picture if you put a fabulous fur in it. Then the model, Guinevere van Seenus, saw the furs. She was in hair and makeup, and we were about to start shooting.

Guinevere looked at me and said, "Lori, you know I don't wear fur, right?"

I had known Guinevere for many years—since she started—but I didn't know that. She said, "I can't."

I walked away, internally freaking out. My vision had just been turned upside down. If I had been younger, if it had been earlier in my career, I would have definitely lost it. But I understood where she was coming from, and I respected it. So I thought, Okay, what do we do?

With experience, you learn that when it comes to styling you should always expect the unexpected. You just never know what might happen on set. I took a fresh look at what I had brought. I went through all of the clothes, accessories, and shoes I had on set, and began to see a new direction unfold. I started pulling together color stories until I had the one I liked best. I layered the accessories until I had the composition I wanted, including having the tailor sew a pair of Lorraine Schwartz 75-karat ruby earrings into a black beaded Julia Clancey mask.

The pictures turned out beautifully. They were completely different from what I had originally intended, and the overall narrative was stronger than it would have been otherwise. I just love this story. It's one of my favorites ever. And it didn't need that fur.

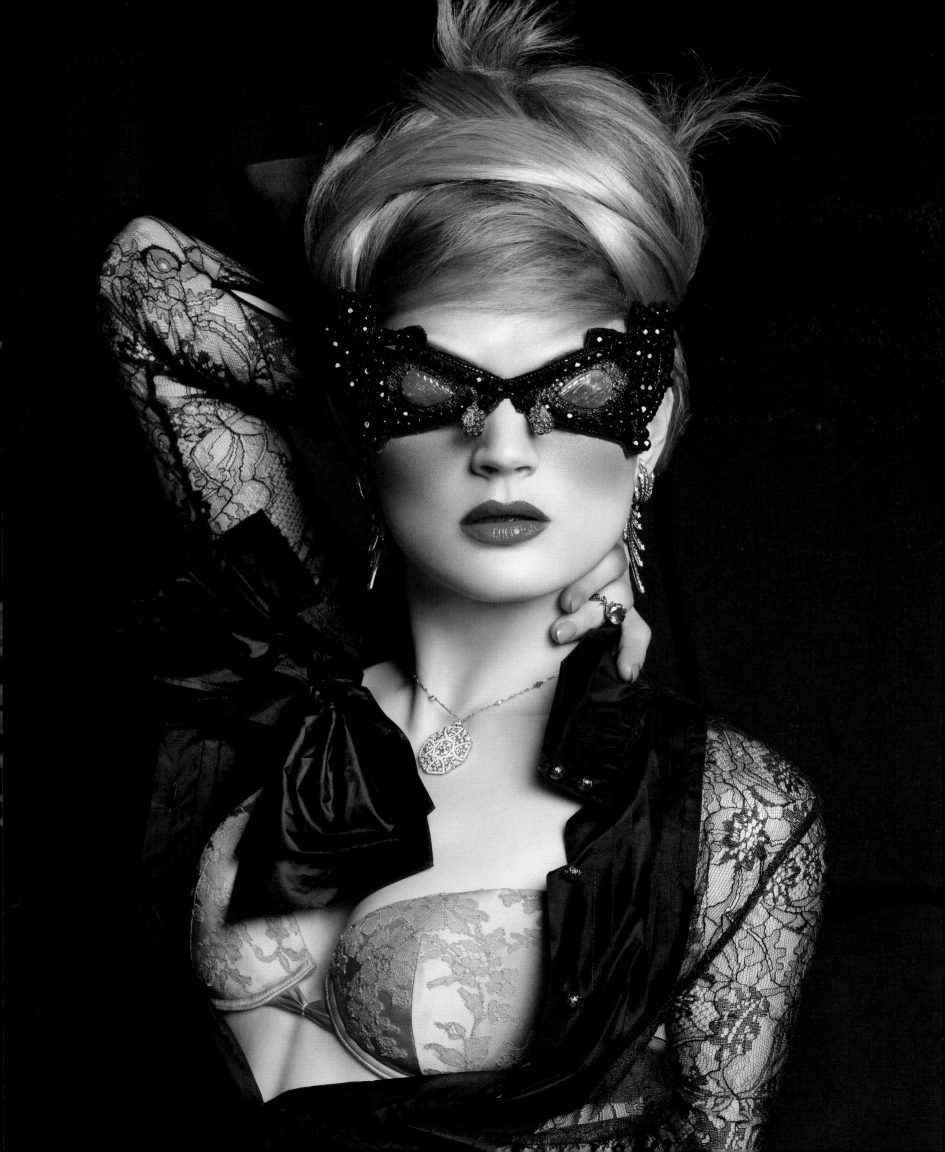

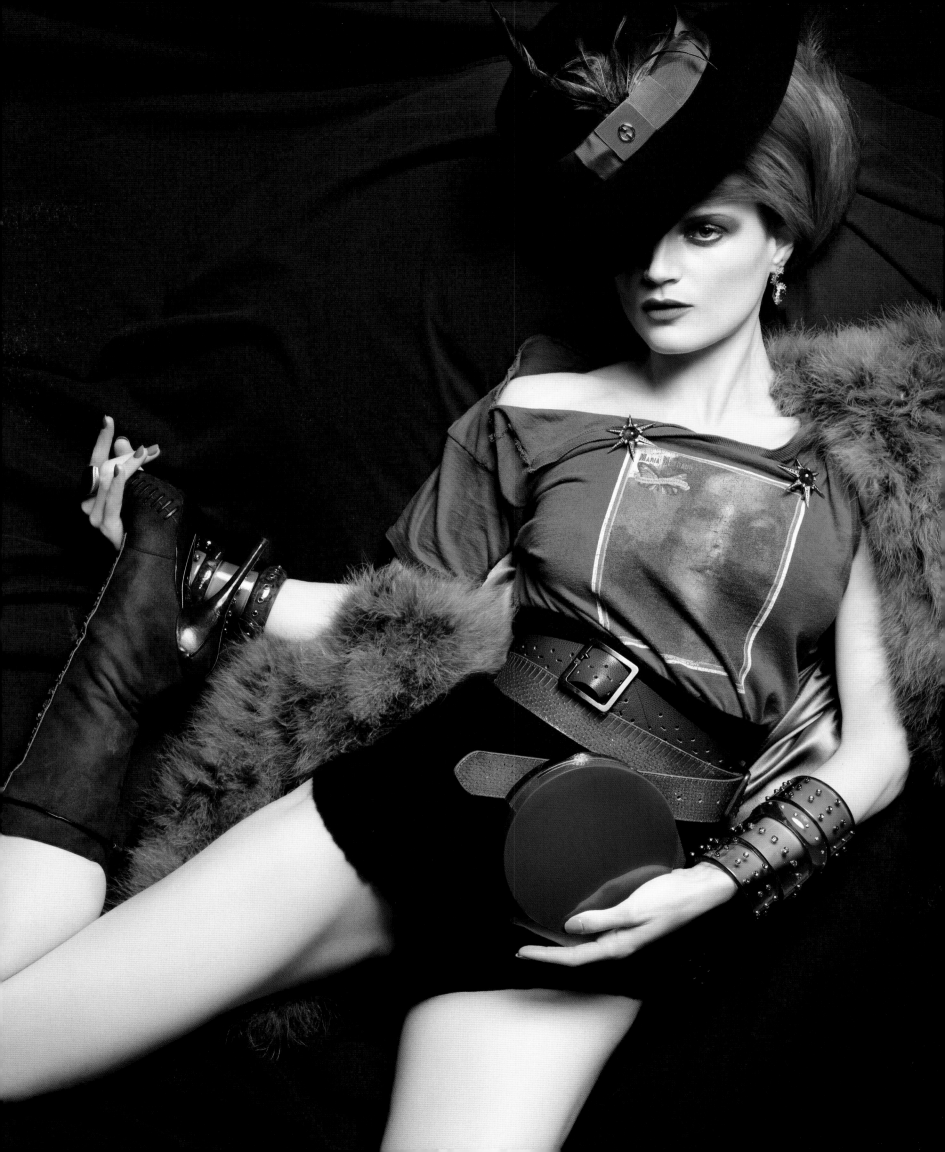

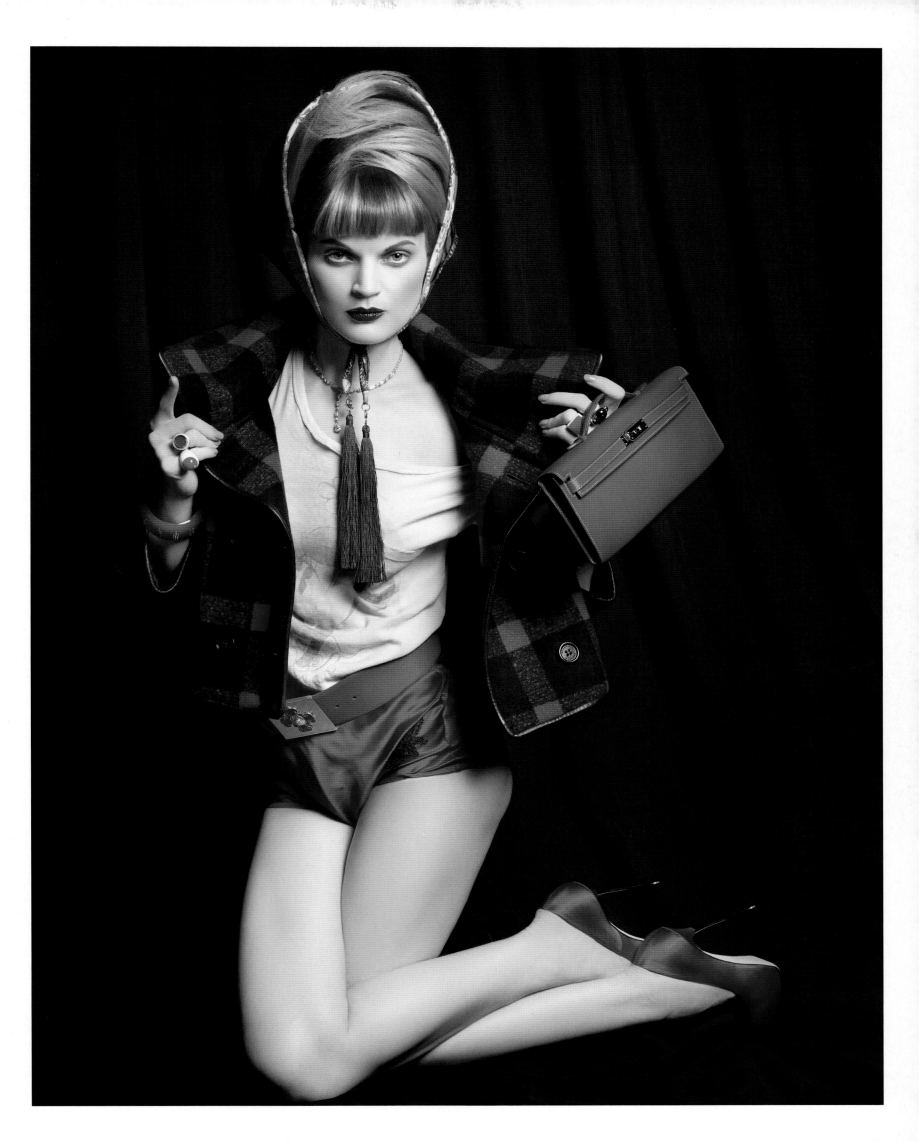

THIS IS NOT ENOUGH, I WANT SOMETHING MORE.

JACQUELINE SUSANN, *Valley of the Dolls*, 1966

One of the things I love about LA is that it's got the best vintage in the world—it's mind-blowing! Usually when we're doing a story, there are current collections that we need to feature, but since the February shows for the coming fall hadn't happened before we did this LA shoot, which was going to run in the March issue of Italian *Vogue*, I had more freedom when it came to the clothes—and I wanted to use vintage.

I went to all of the extraordinary shops, like Lily et Cie, Decades, Catwalk, The Way We Wore, and the Paper Bag Princess. I found classic Pucci print pieces, all these fantastic vintage sunglasses, belts, and little Plexiglas purses. I picked up more jewels, silk robes, and vintage Ferragamo shoes. To mix all of these great vintage finds with Missoni, Dolce & Gabbana, and Hermès really expressed the despair of the character, this desperate grasp for glamour, a kind of wicked beauty.

I felt right at home with these pieces; they made me think of my grandmother, GaGa Gladys. GaGa was an atypical and unexpected style icon for me when I was a teenager. She wore leopard, had gay friends, drank J&B on the rocks, and smoked Philip Morris non-filters. She was fabulous. She was fearless. She was the wild woman. When she passed away, I inherited all of her jewelry, mostly costume, which I later used during my first few years as a stylist.

Now, shopping for this story, I thought about the glamour of GaGa Gladys. I thought about the heady excess of the Los Angeles lifestyle and the lavishness of the Versace campaigns I had been doing with Donatella and Steven. And I thought about Jacqueline Susann, whose characters were larger than life, self-indulgent, and often materially comfortable to the point of spiritual numbness. That's what I was going for, to bring a sense of overabundance, decadence, and emotional vacancy to these pictures—a feeling of there's so much and yet there's nothing.

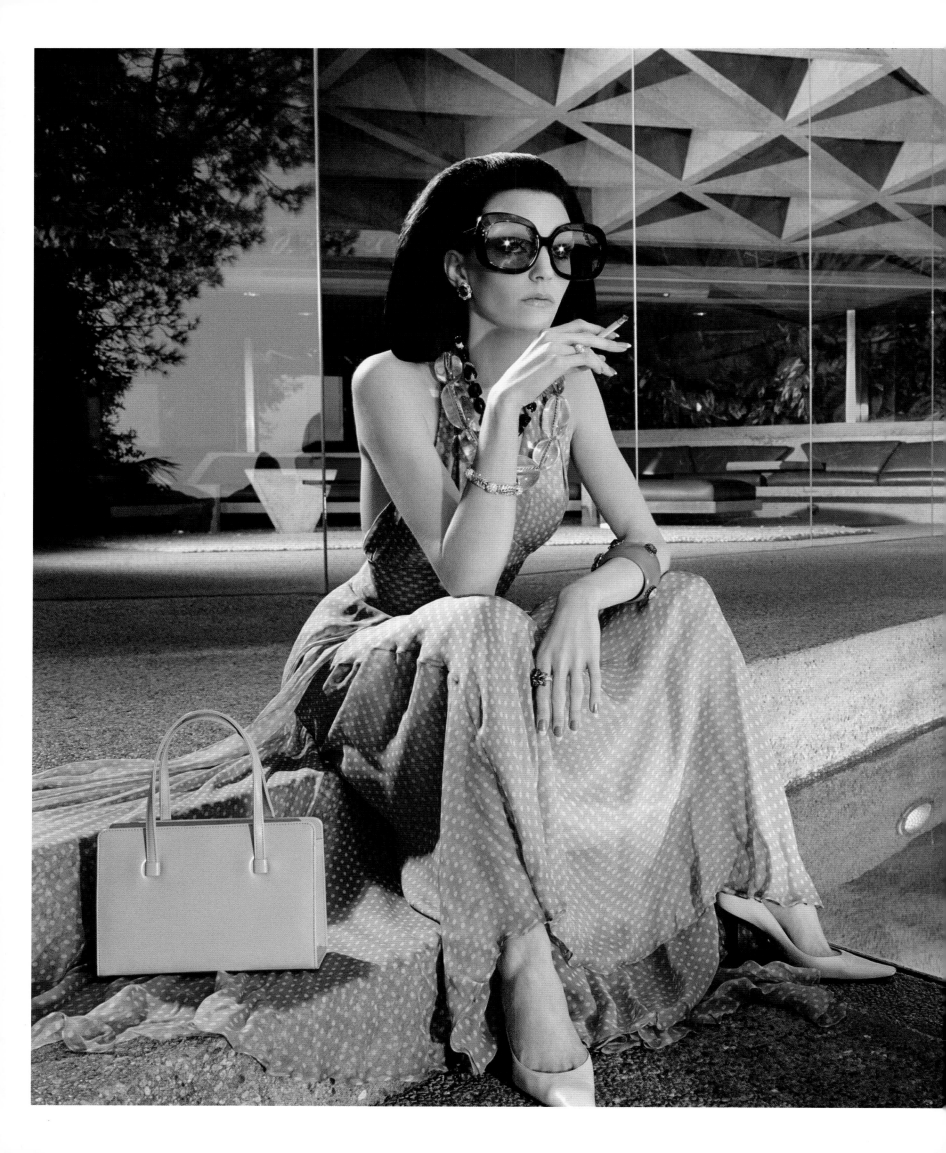

pages 56 – 59
Steven Meisel, Italian *Vogue*, March 2000

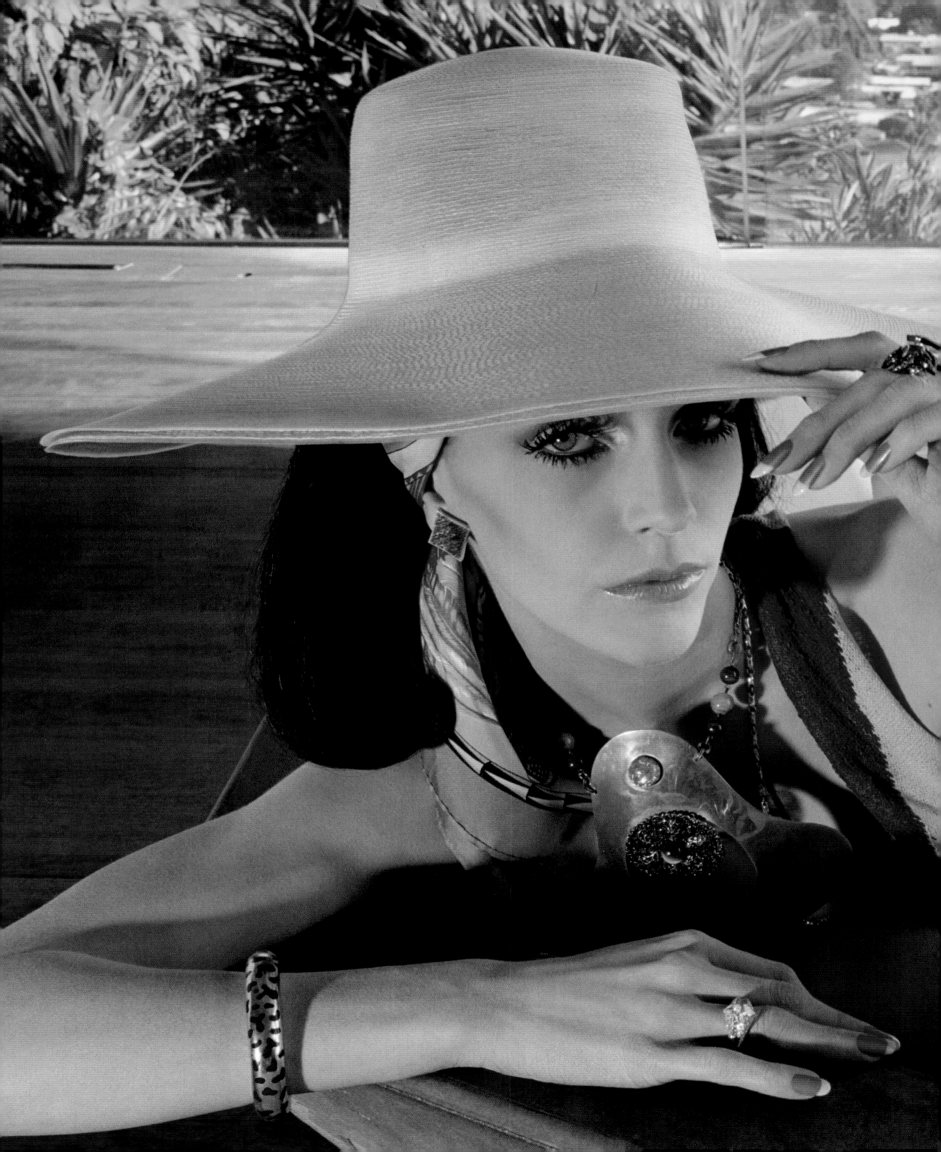

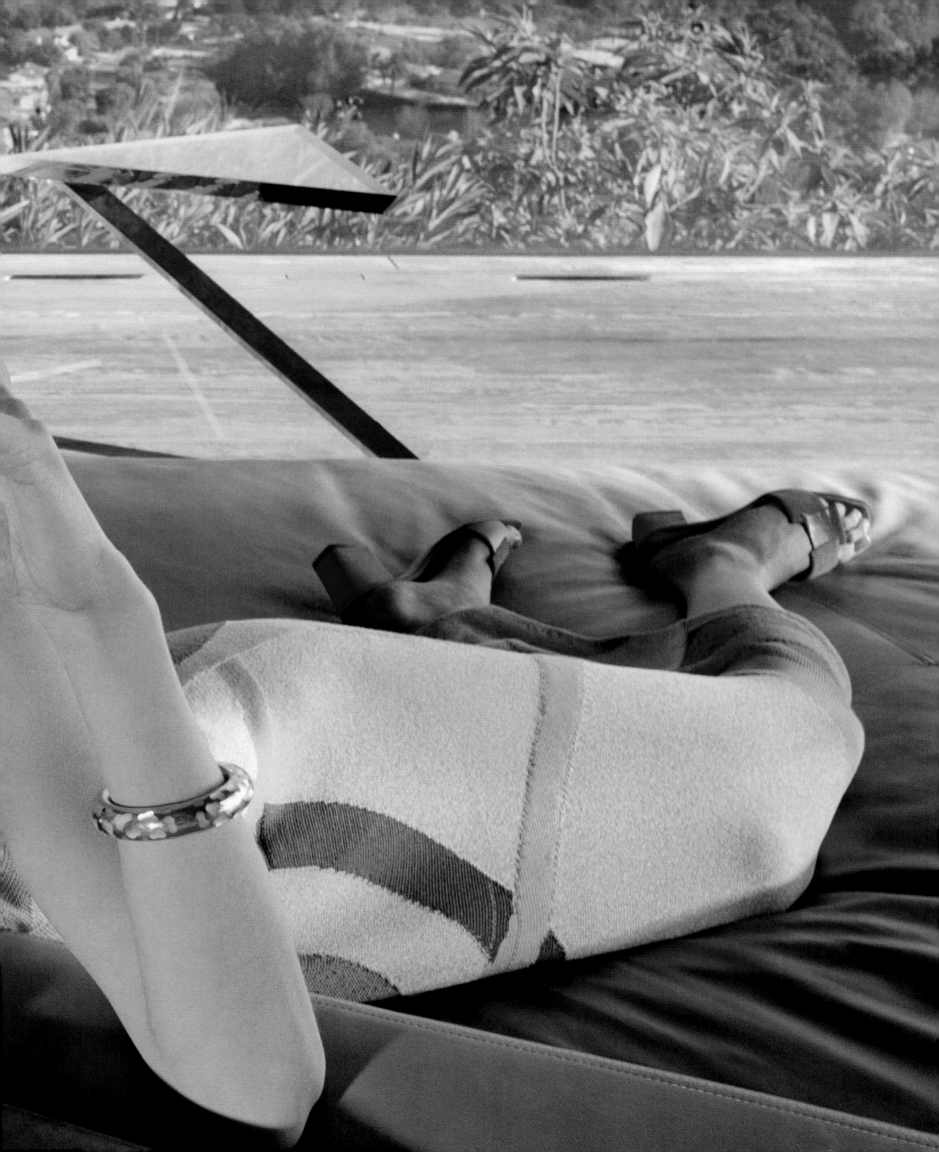

ONE SHOULD EITHER BE A WORK OF ART, OR WEAR A WORK OF ART.

SUSAN SONTAG, "Notes on 'Camp,'" 1966

The Spring 2000 collection was a celebration of the Versace woman, and it marked Donatella's settling in at the house of Versace. I love working with Donatella because she has a deep respect for the creative process. She hires people she trusts and gives them room to do their magic. She arrived on set for this particular campaign in the middle of hair and makeup; we looked up, and there she was: our inspiration! We bleached Amber Valletta's hair "Donatella blonde," and once the character came to life, everything else fell right into place. The new Versace woman was personified in every detail in those final images: the bold, saturated color palette of the clothes and accessories; the meticulous placement of each gold ring on Amber Valletta's pristine, manicured hands lightly resting on her clutch; the way the opening of her shirt is set to show us something but not too much; and the precise positioning of the amethyst and gold necklace that leads the eye right back there every time.

Steven Meisel, Versace, Spring 2000

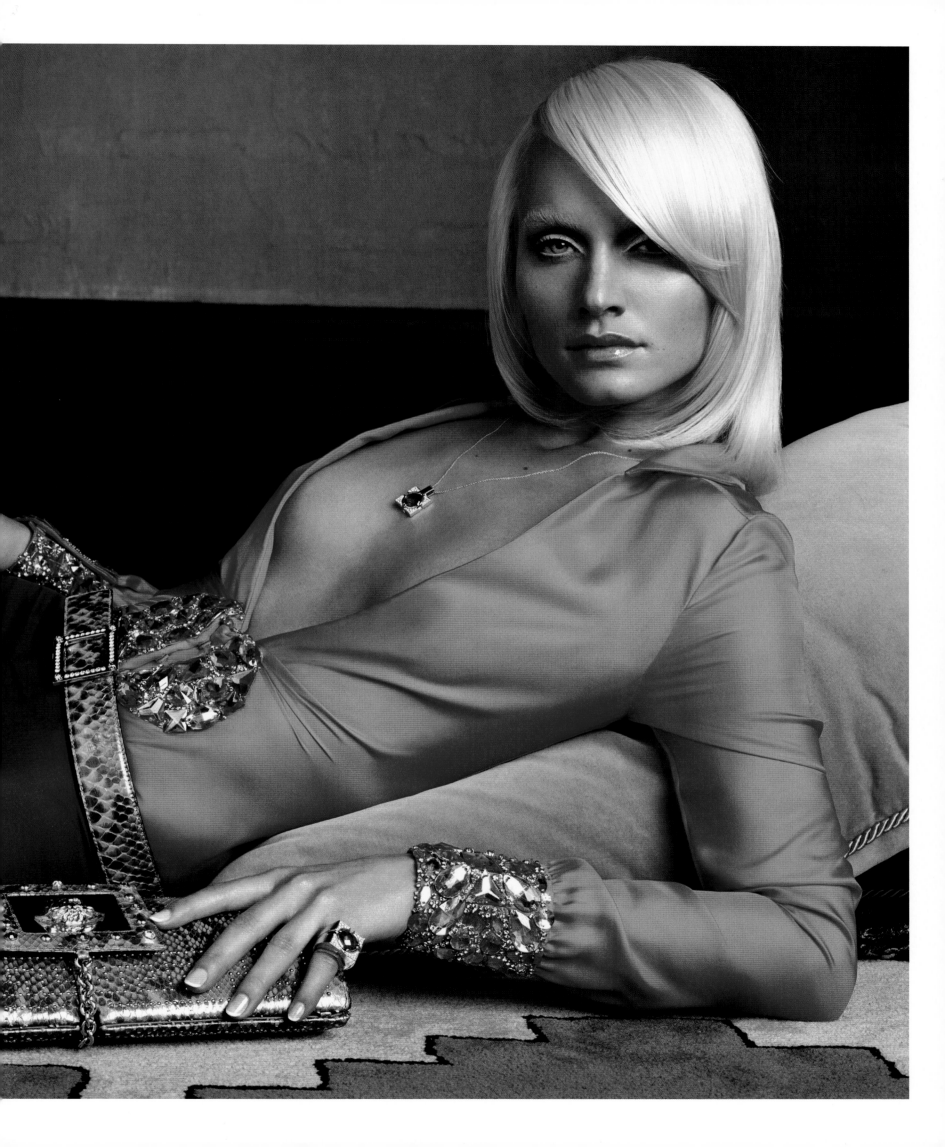

WHEN PEOPLE

talk about my signature style, they are usually referring to clashing colors, multihued layers, and vibrant prints. The uniqueness of the small things is what makes me smile, and the intricacy of details is what draws my eye. But there is another critical aspect to my aesthetics: yin must have yang.

So comes this chapter, "The Divine," the counterpoint to "The Sickness." Here is where the sacred balances the profane, and light illuminates dark. Expressing divinity through fashion is not what I'm known for, but it is very much a part of my style and life.

The images here have no relationship to a cynical reality. They are unspoiled and intimate, honest portraits that ask you to climb into someone's soul. Transcending materialism and time, they are ethereal, inspired by the organic grace of nature, a vulnerable heart, a joyous spirit. They invite us to breathe, temporary witnesses to the serenity of beauty.

When I look at these pictures, I don't see clothing. I see purity and simplicity.

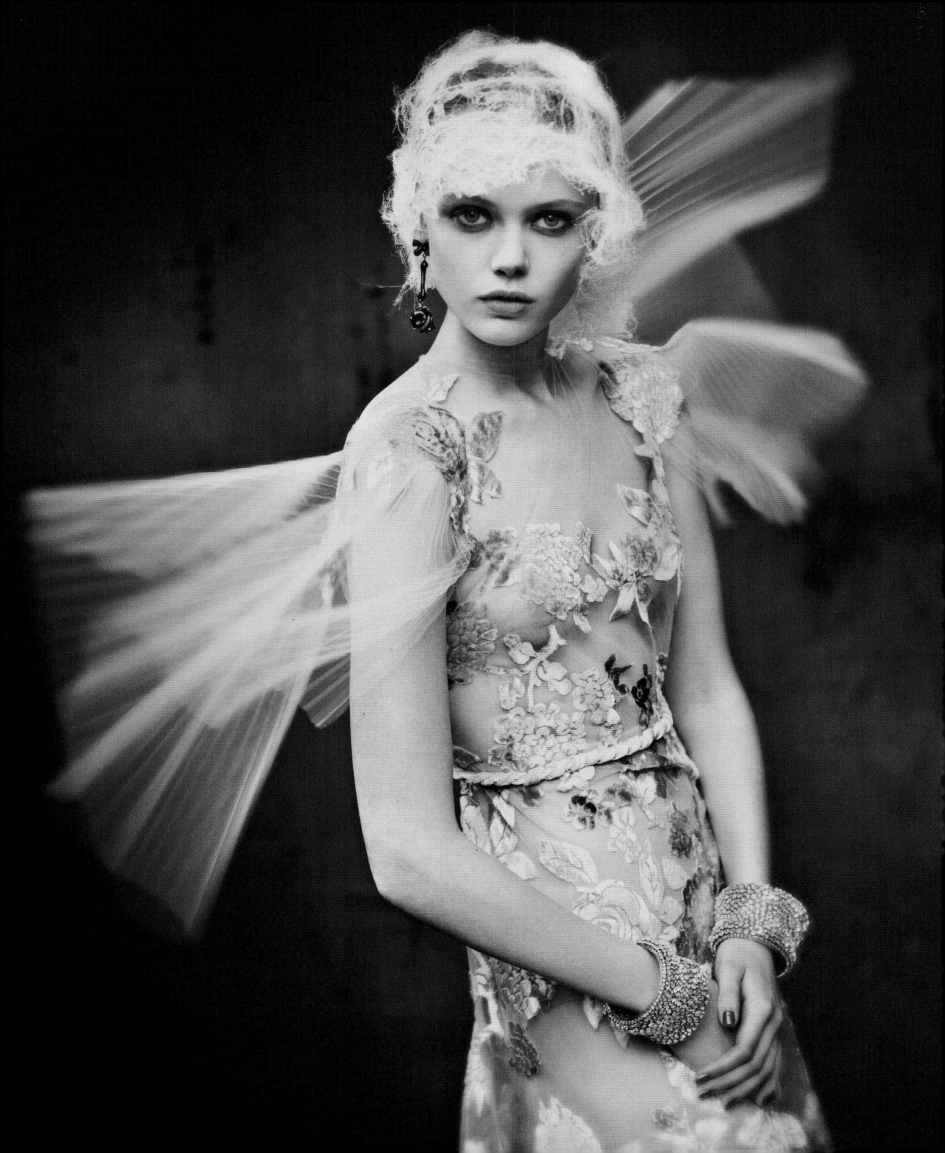

Once upon a time, fashion shoots were romantic, languorous affairs, but when I started working, the industry in America had already adopted a fast-paced, deadline-driven attitude. I would listen to great stylists like Polly Allen Mellen rhapsodize about the way things used to be, about the old style of shooting. Then I'd fantasize about doing shoots like those, shoots that would never be. At least I thought so, until I worked with photographers like Paolo Roversi.

This story was shot in Paris in the summer, my favorite time to be there, in Paolo's wonderful old studio on the outskirts of the city. Paolo is one of the photographers who has brought the Old World, European sensibility to the modern age of fashion, who captures the glamour without losing the romance or the relevance. Shooting with him was magical. You might wander into his studio at 11:00 AM and stay until midnight. You might break for two-hour lunches in the gorgeous yard with homemade Italian food, wine, and cigarettes.

When I see these images I imagine Man Ray in his studio. I remember Paolo shooting and Julien d'Ys sculpting hair, painting and shaping . . . and the set . . . and the mirrors . . . and the clothes! We used couture gowns that we had plucked off the runway and had hand-delivered through the Paris traffic so that we could spend two hours shooting them before they were whisked away. The wardrobe was in the atelier's attic. I climbed the three steep flights of stairs to the room, then spent hours sitting on a broken chaise waiting for the clothes to come.

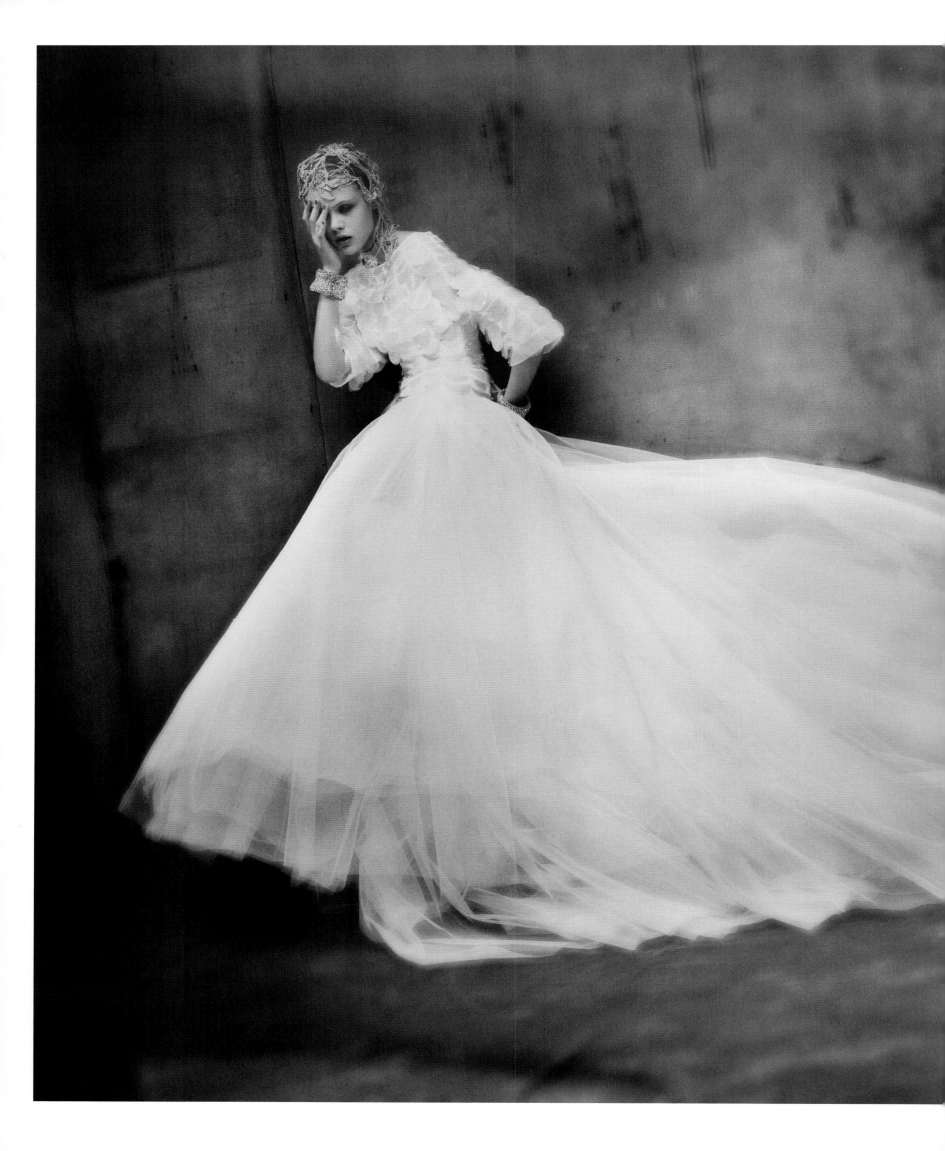

pages 68, 70 – 72
Paolo Roversi, Italian *Vogue*, September 2011

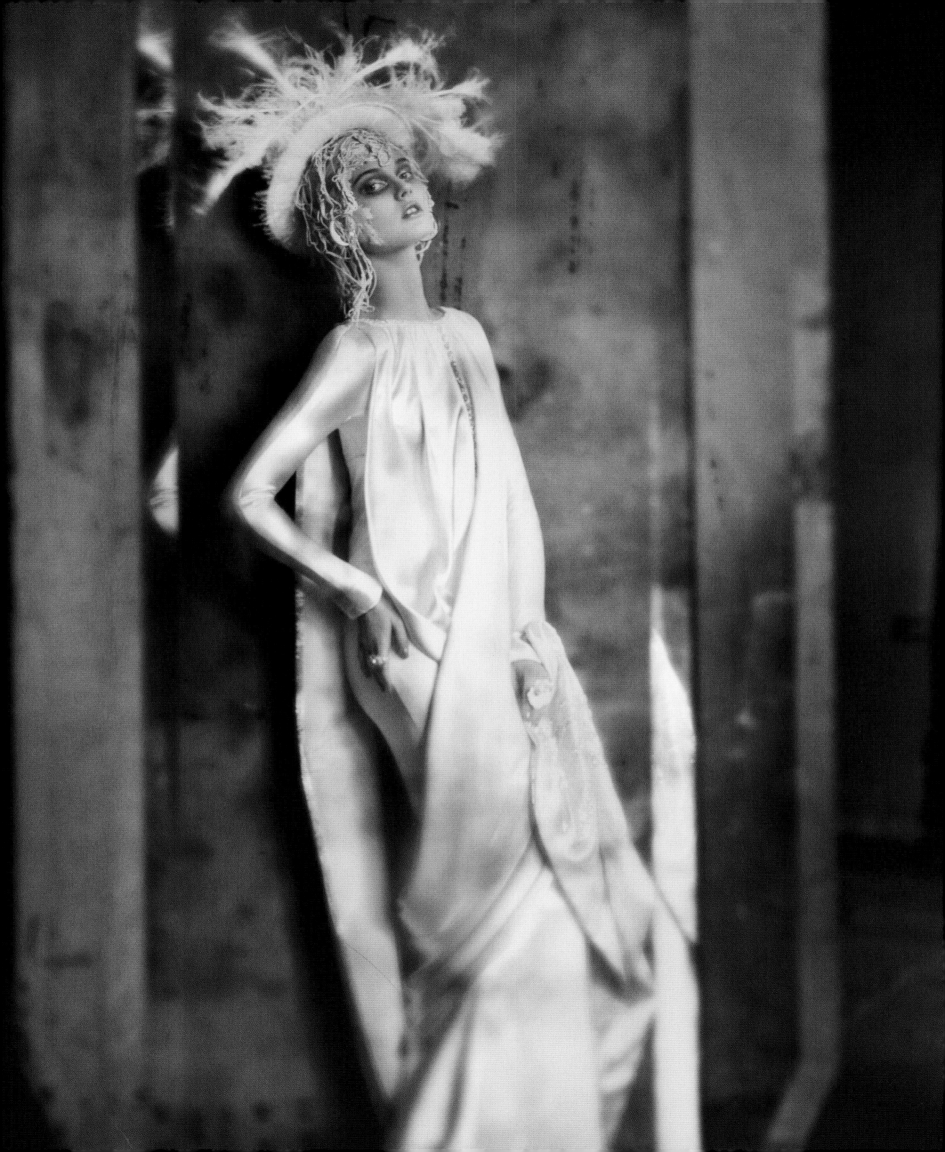

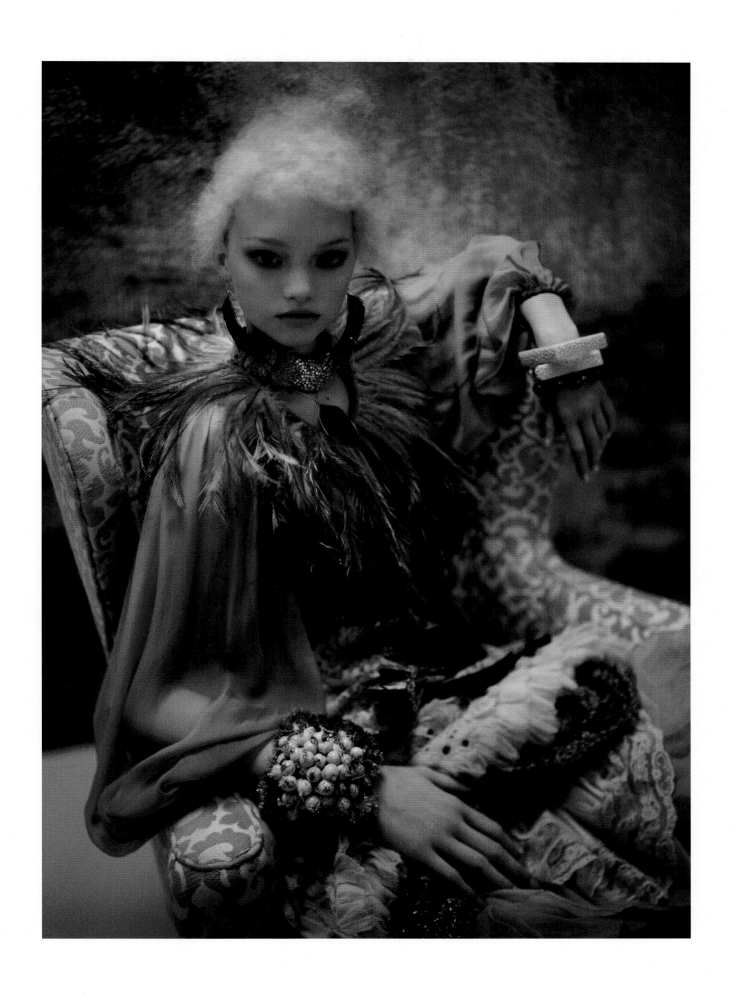

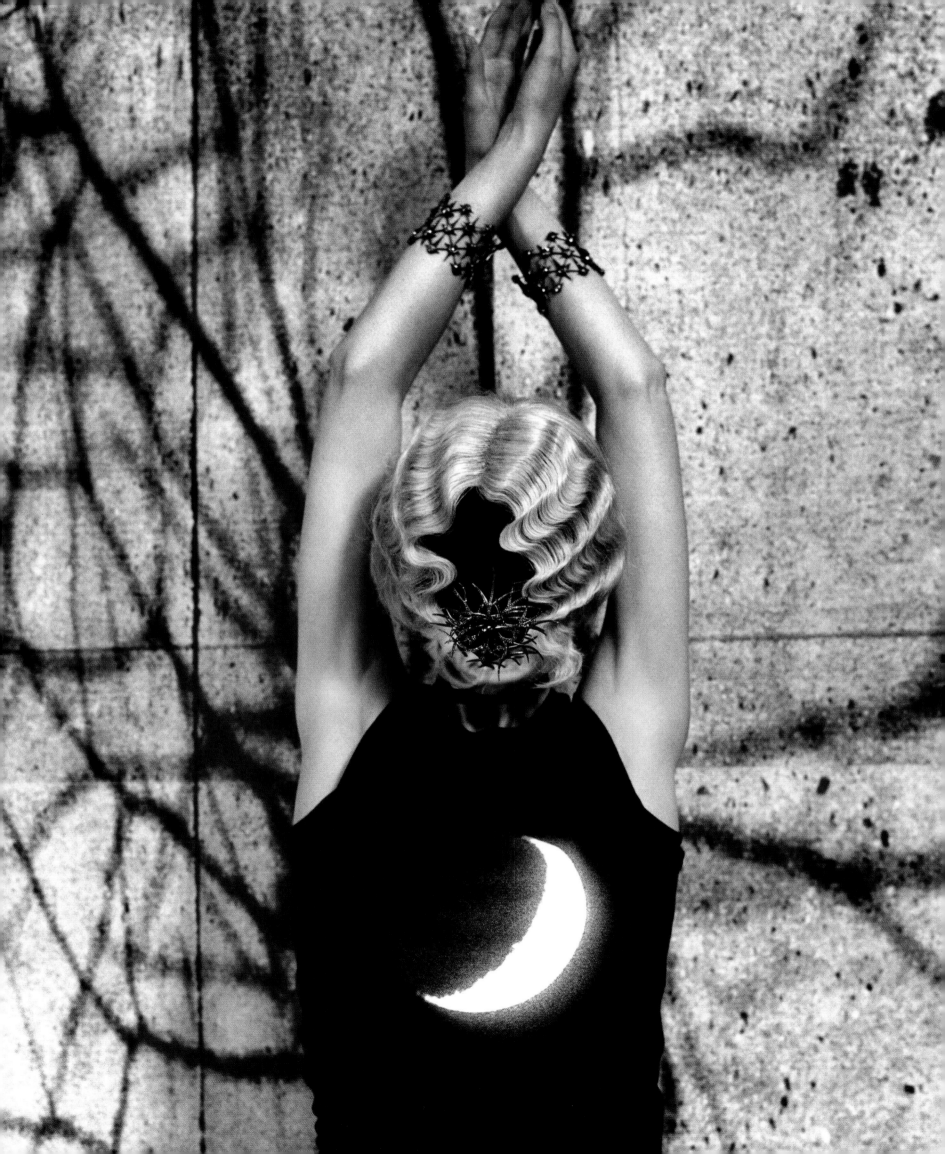

IMAGINATION IS EVERYTHING. IT IS THE PREVIEW OF LIFE'S COMING ATTRACTIONS.

ALBERT EINSTEIN, from *Introducing Psychology of Success,* by Alison and David Price, 2011

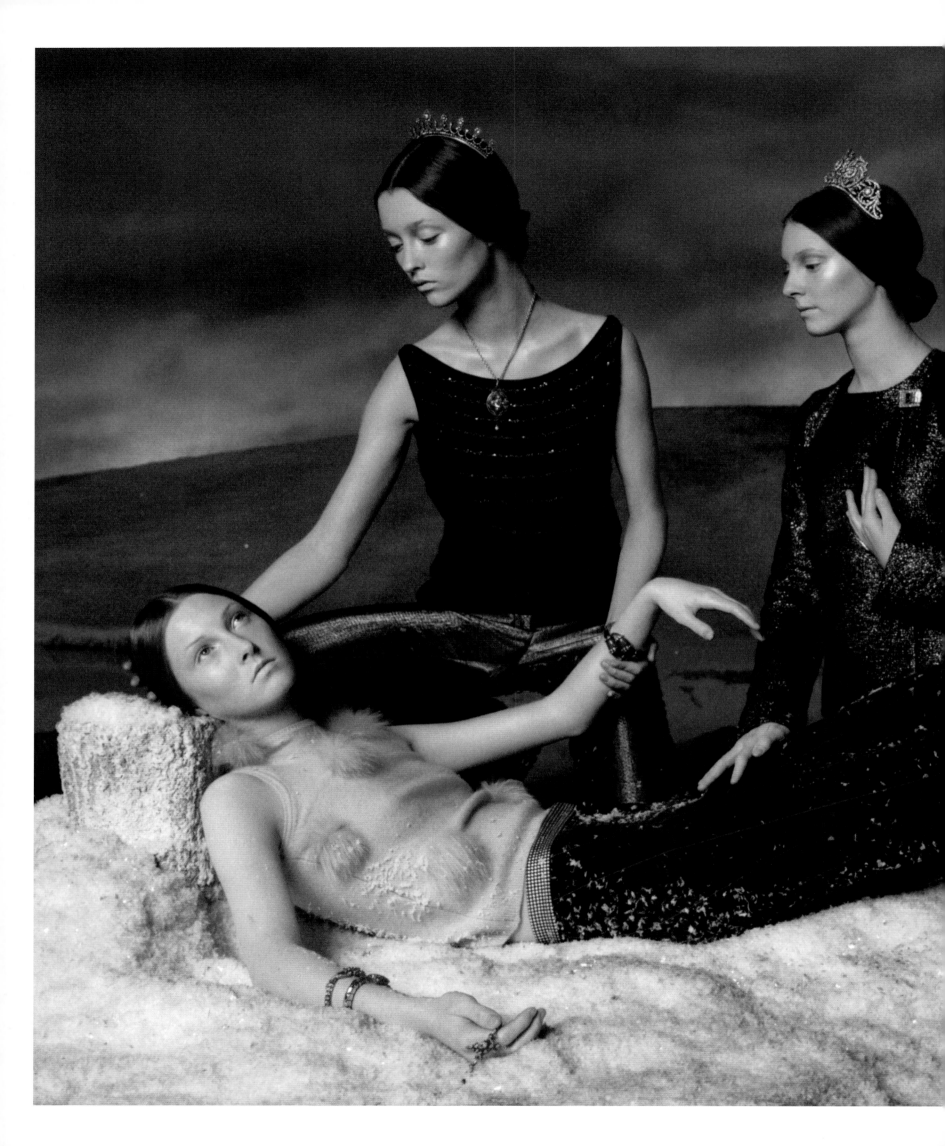

Steven Meisel, Versace, Fall 1998

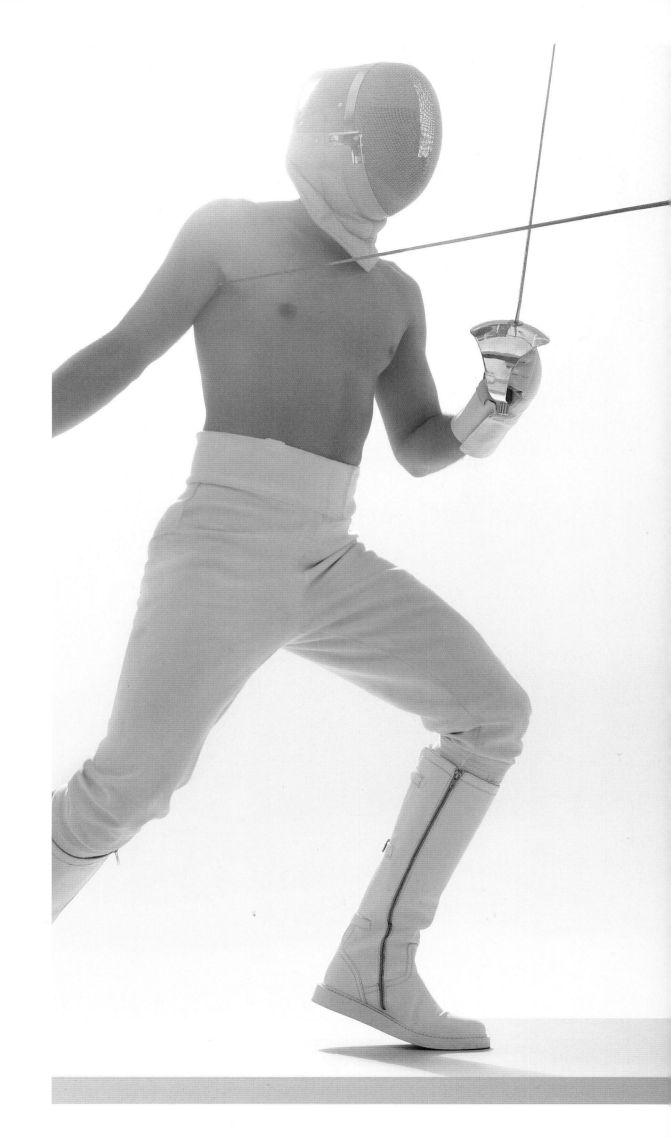

Jean-Baptiste Mondino, *W,* April 2011, Mia Wasikowska

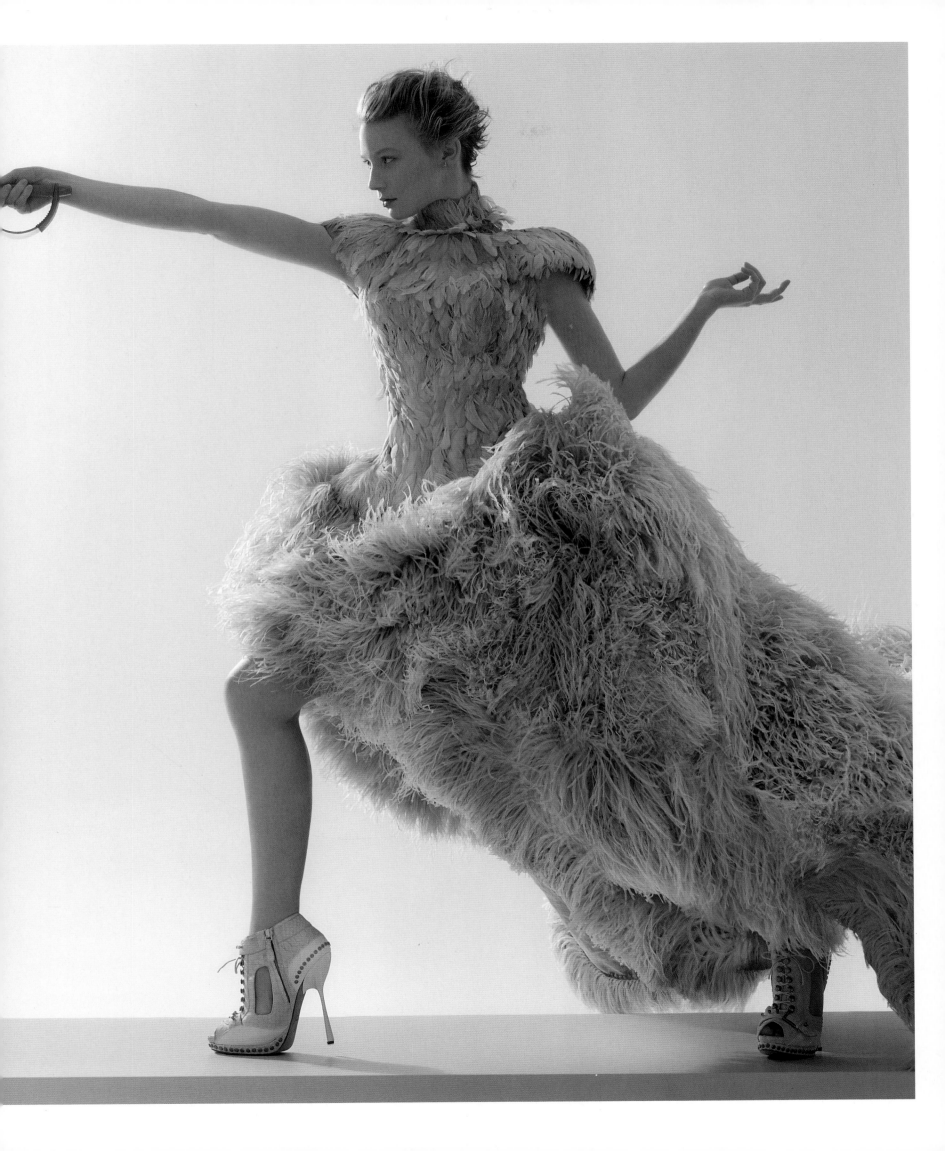

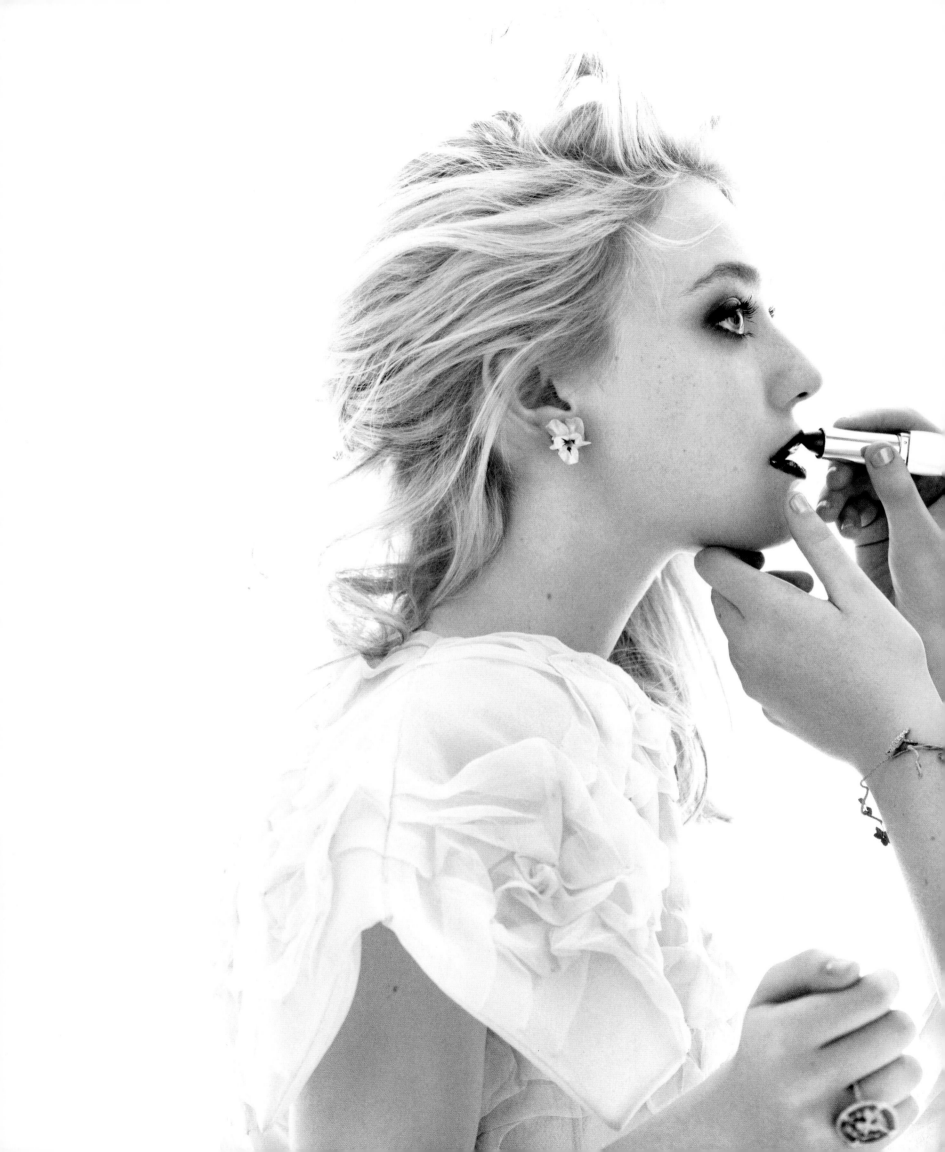

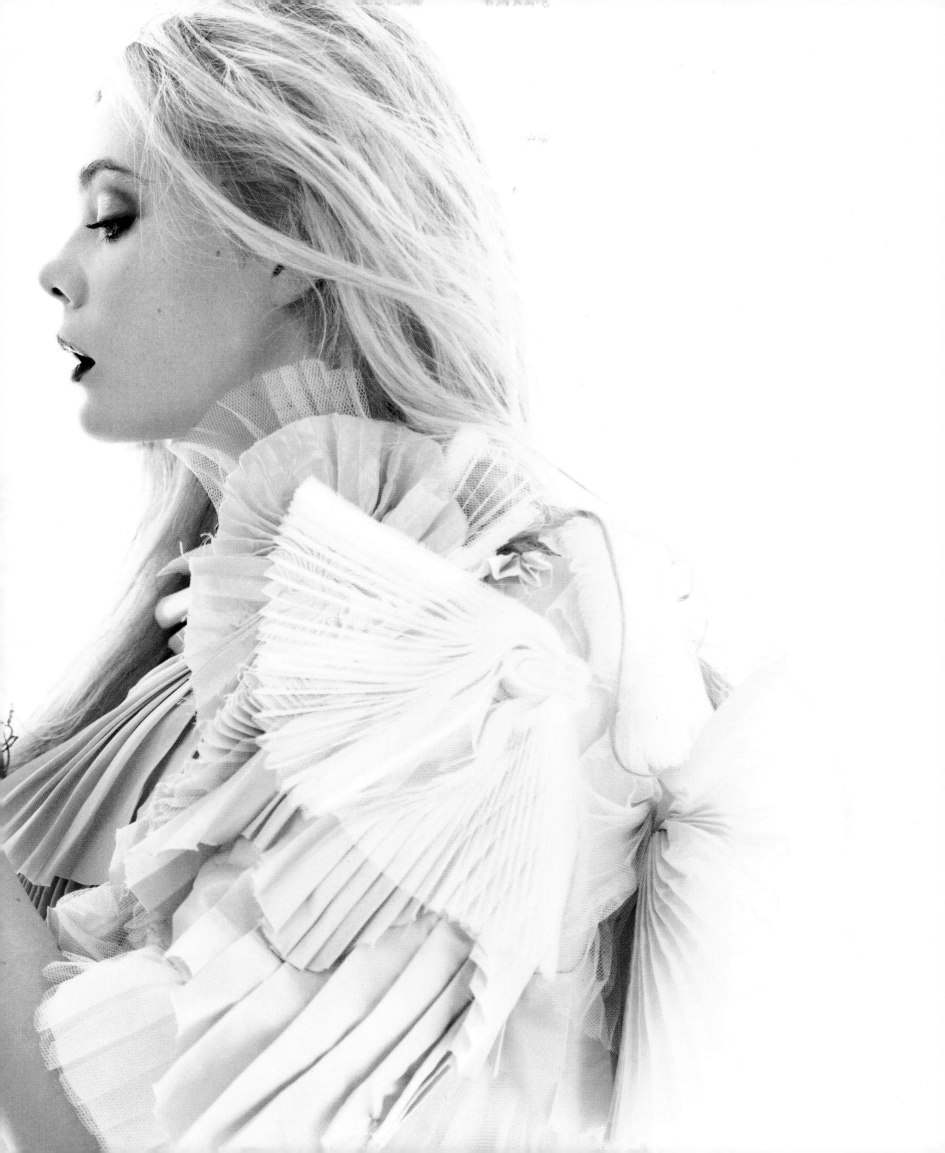

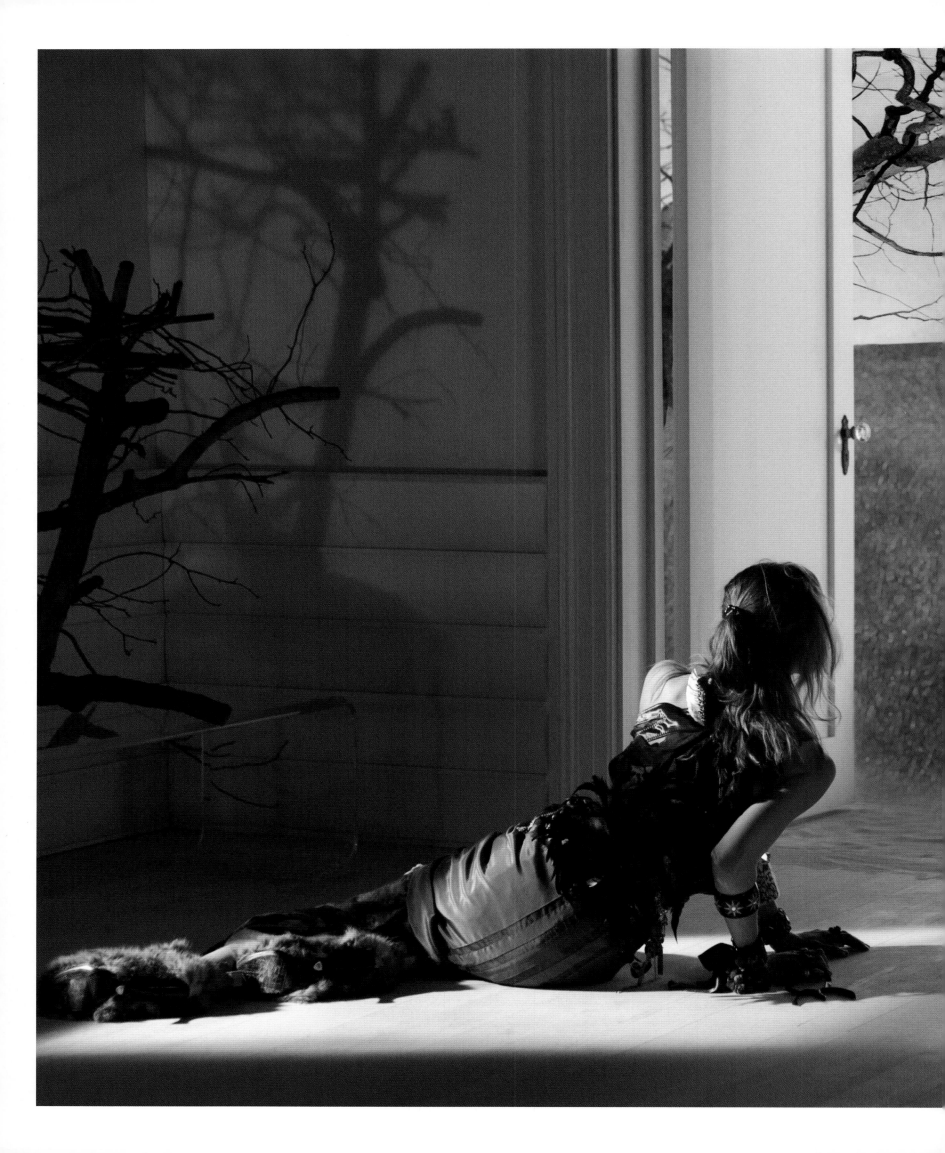

pages 80 – 81
Mario Sorrenti, *W*, December 2011, Dakota and Elle Fanning

opposite
Mario Sorrenti, *W*, February 2005

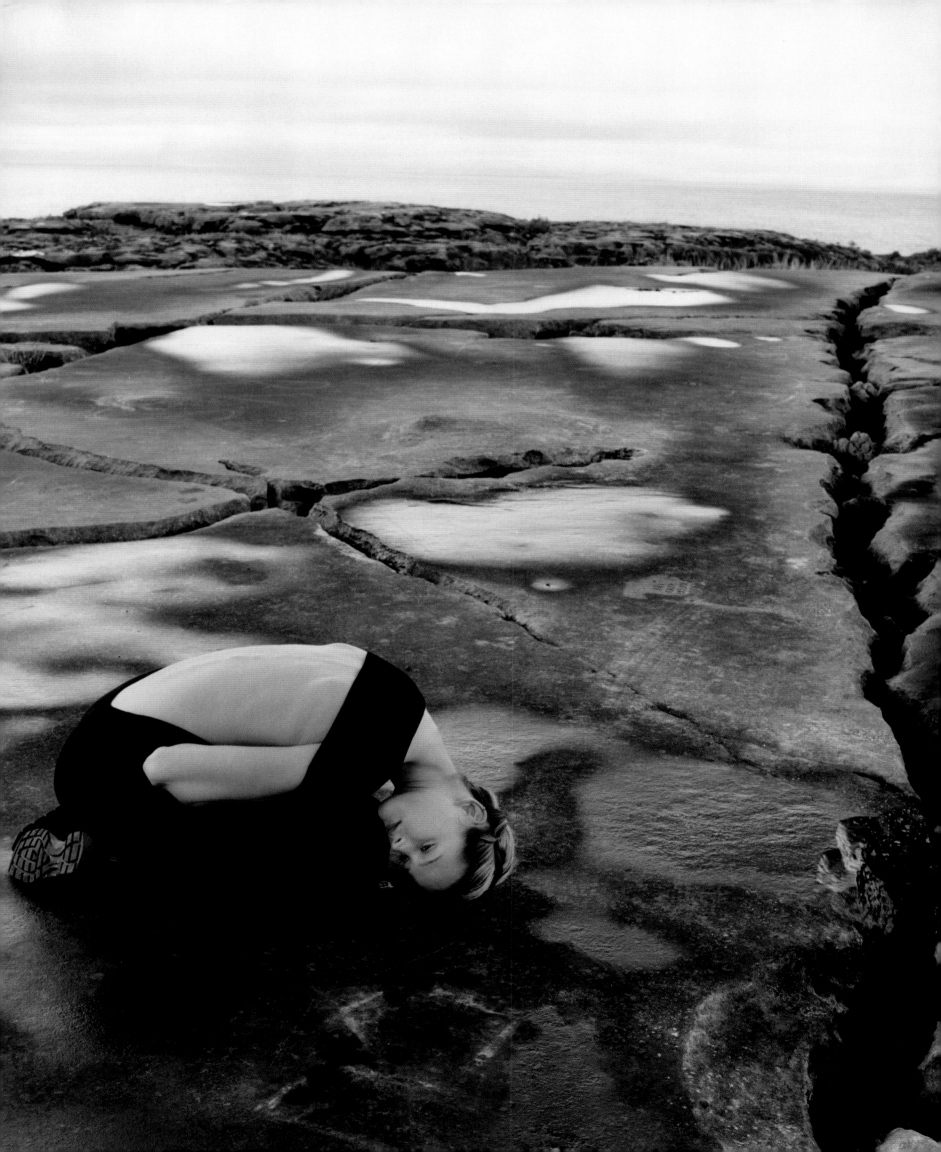

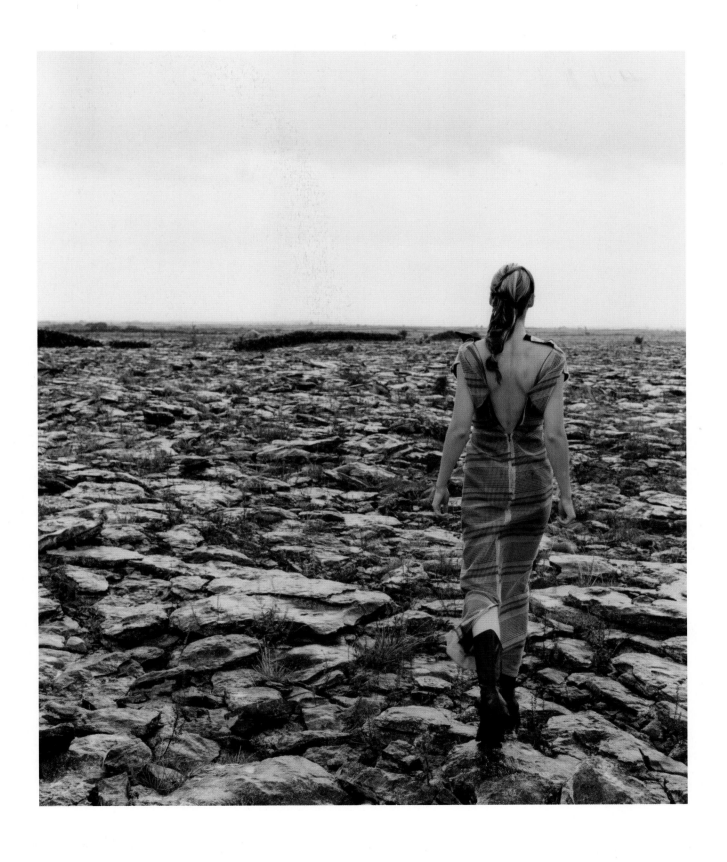

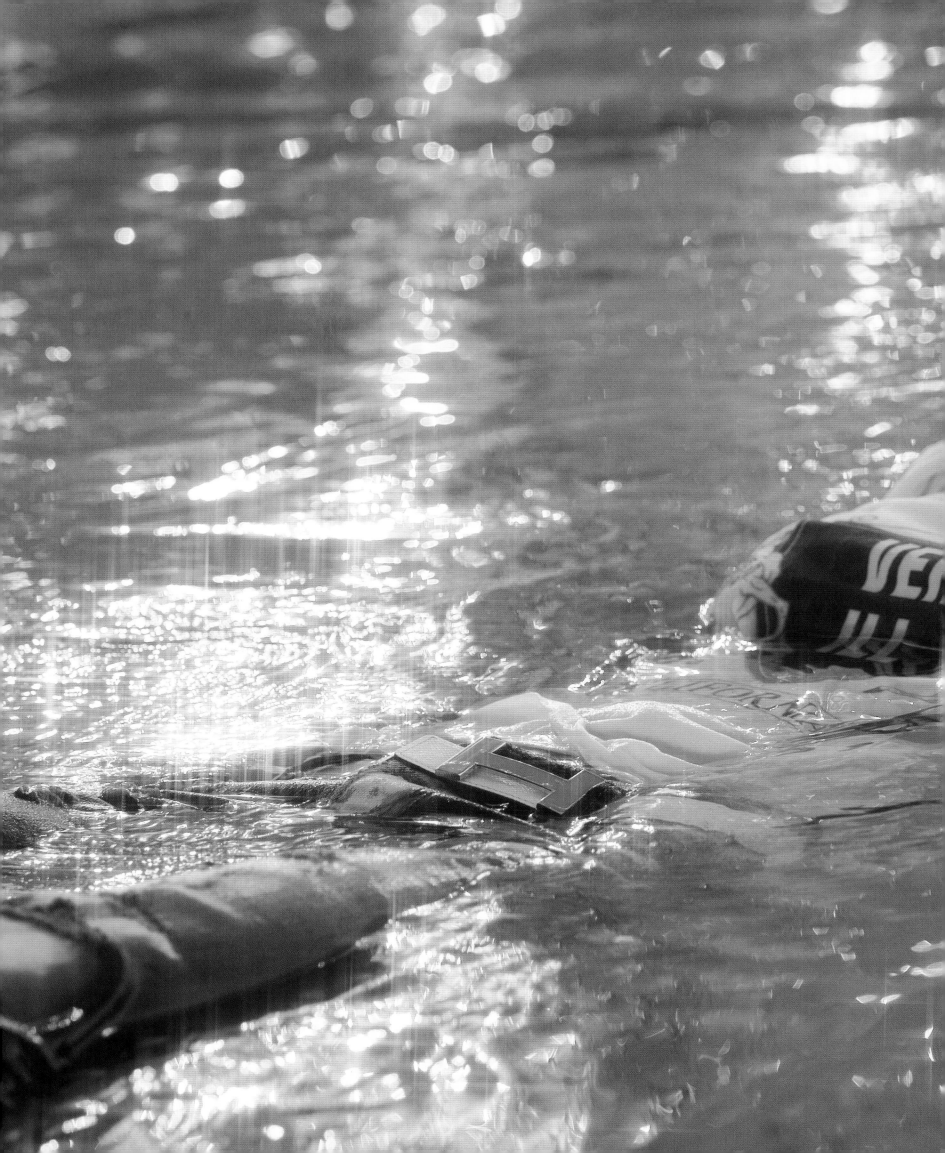

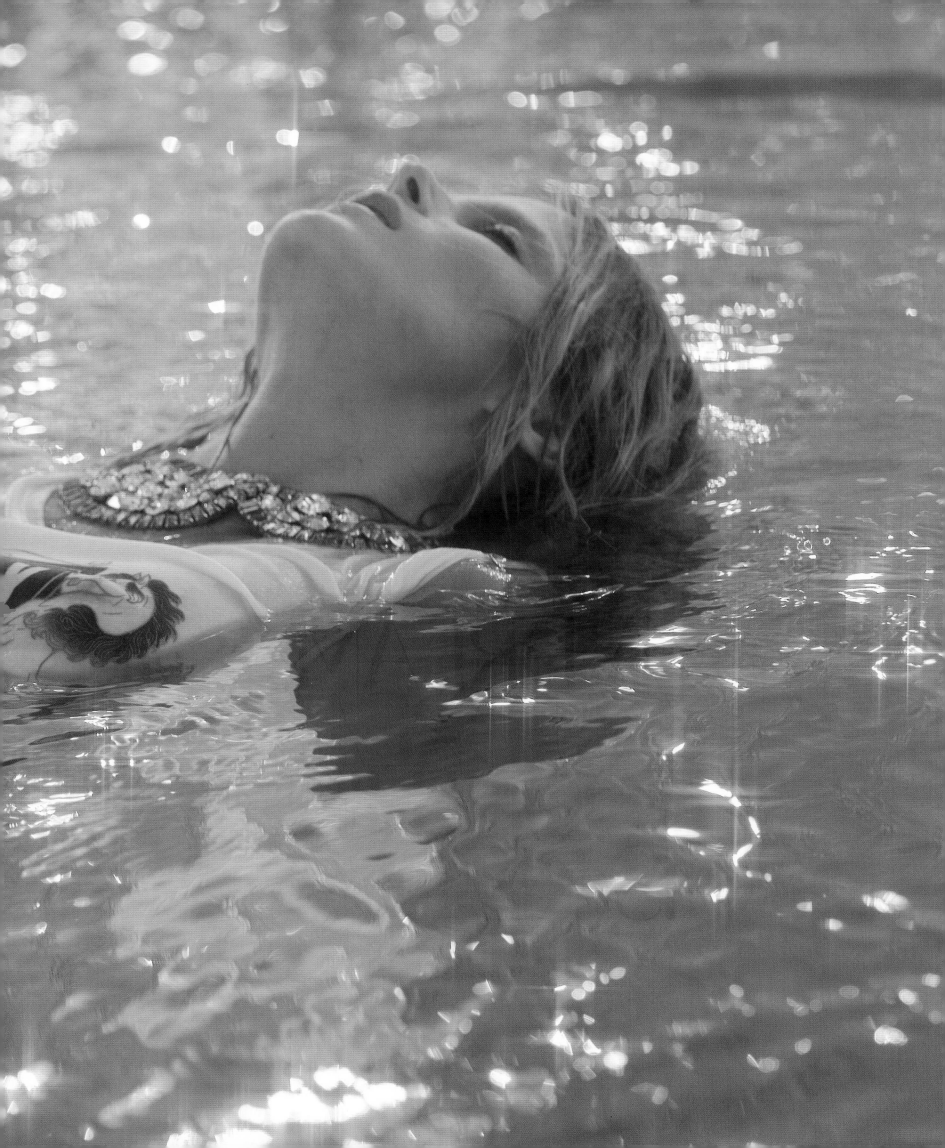

A DREAM. YOU DREAM ALONE IS ONLY A DREAM. A DREAM YOU DREAM TOGETHER IS REALITY.

YOKO ONO, from *All We Are Saying,* by David Sheff, 2000

t had been many years since Annie and I had worked together, and when Nina Ricci suggested that we collaborate again, I was thrilled. This shoot was one of the few times I've done fashion with Annie. The plan was to shoot on her property in upstate New York, a beautiful estate with a dense, dark, divine thicket of woods. I had been married there some years back, and that connection lent the shoot an immediate emotional resonance.

On a Monday morning in late spring, we arrived at Annie's to begin work, and it was pouring. An absolute downpour. A deluge. So we waited. We sat, and sat, and sat.

When it was nearly evening and Mother Nature was still refusing to cooperate, we decided we just had to get out there and shoot. We armored ourselves with raincoats and hats and pushed into the woods. We put the model in this incredible dress and shot the picture.

In the end, the images are proof that Mother Nature wasn't refusing to cooperate: she was offering to collaborate. This shoot is just one of the many examples of how embracing circumstance can make for a more spectacular result than you could have ever imagined.

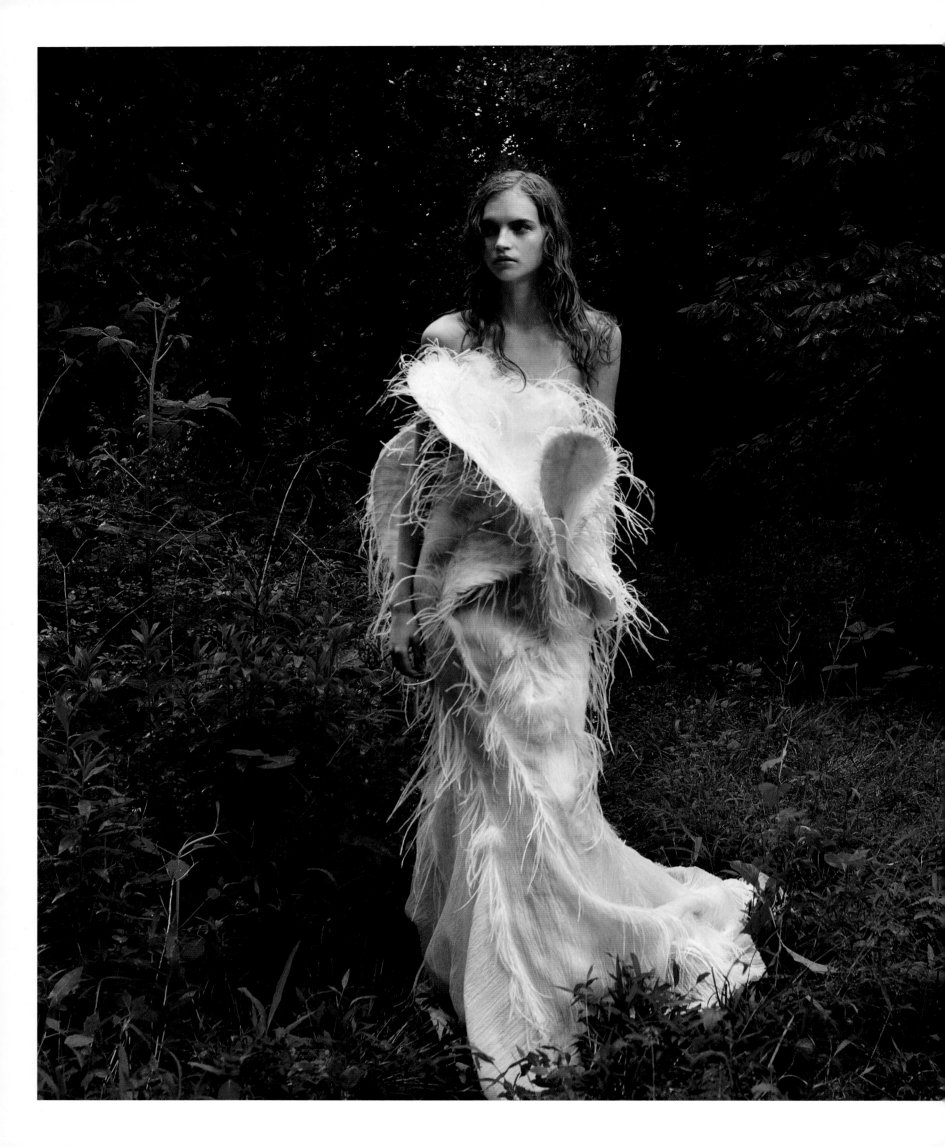

Annie Leibovitz, Nina Ricci, Fall 2007

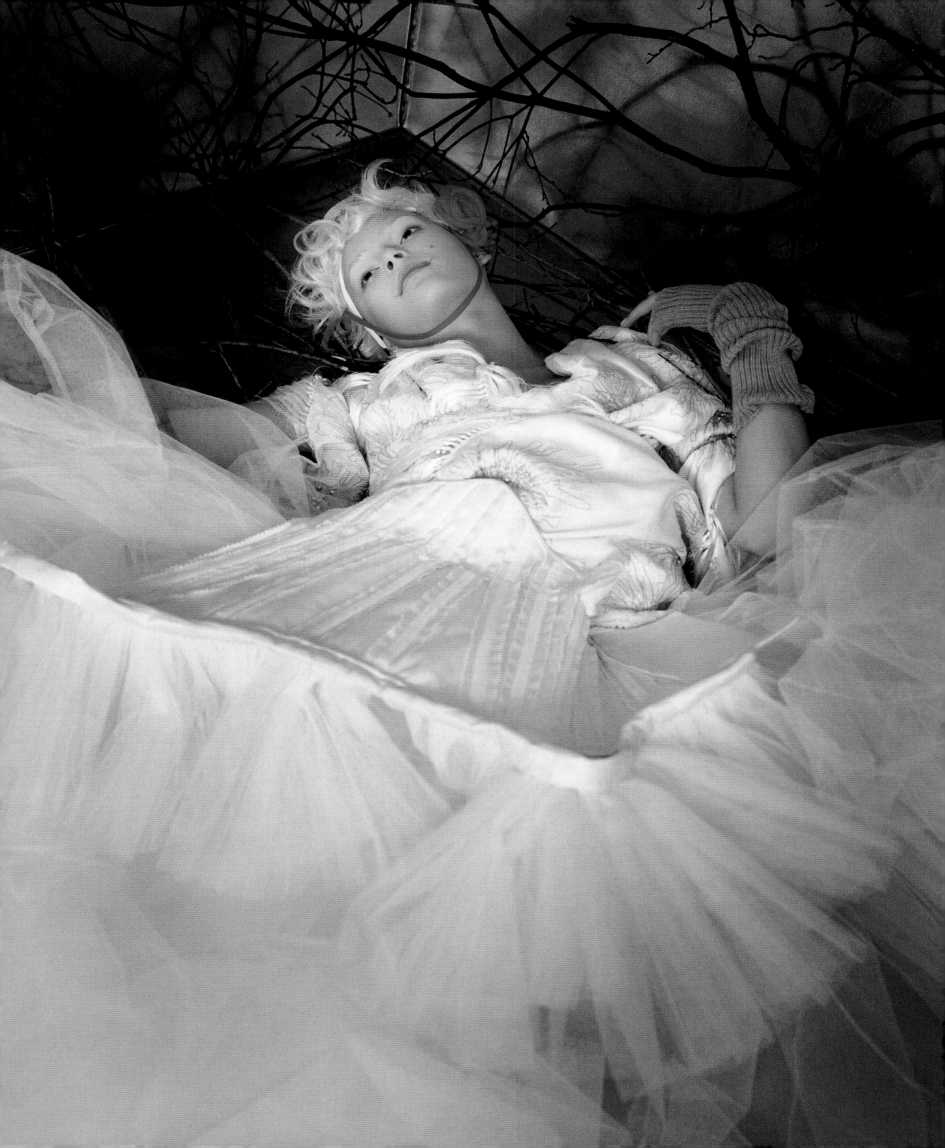

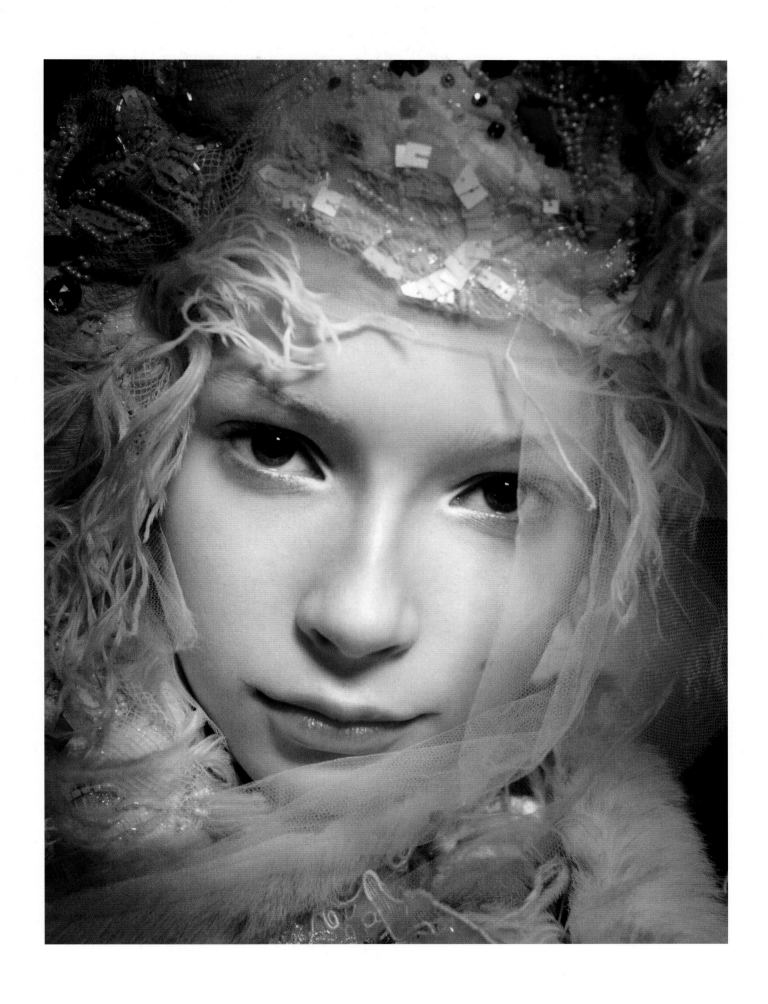

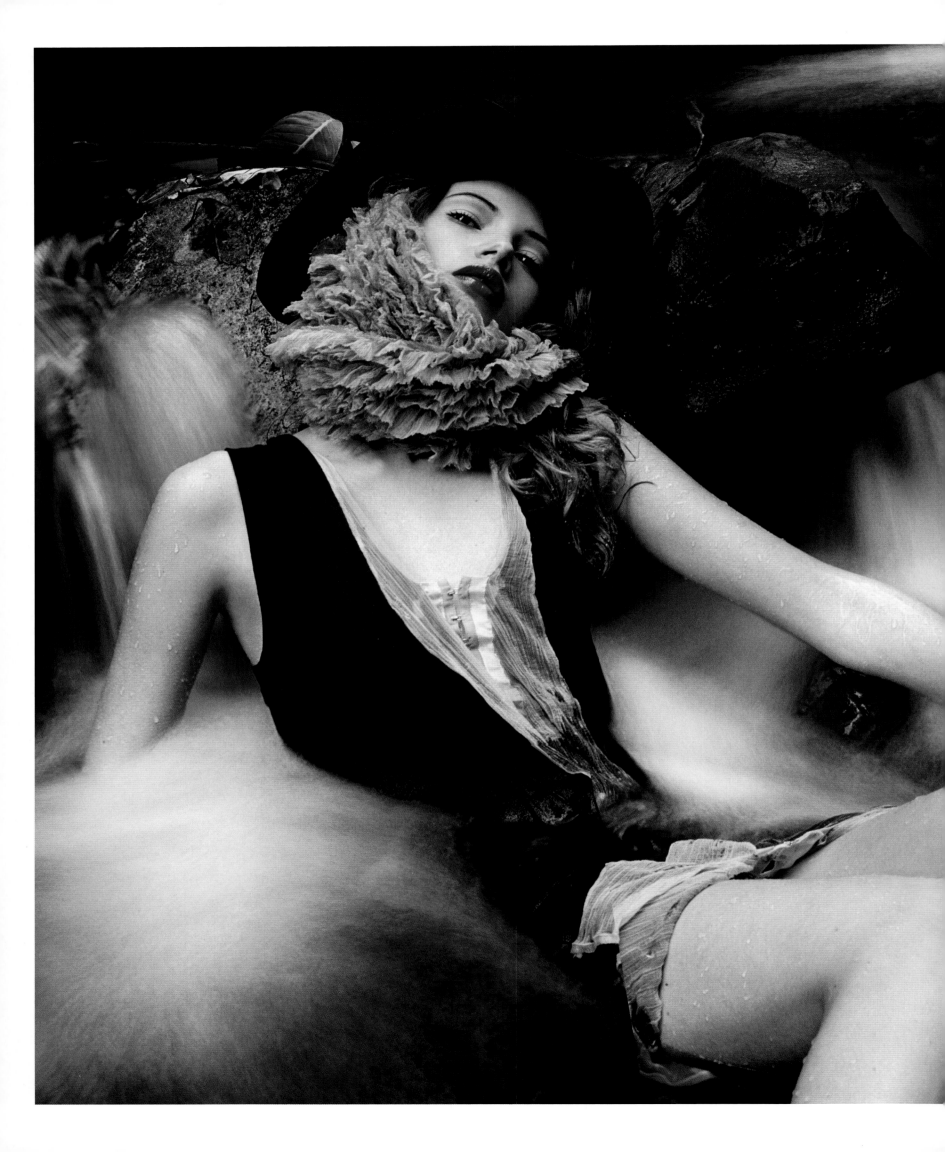

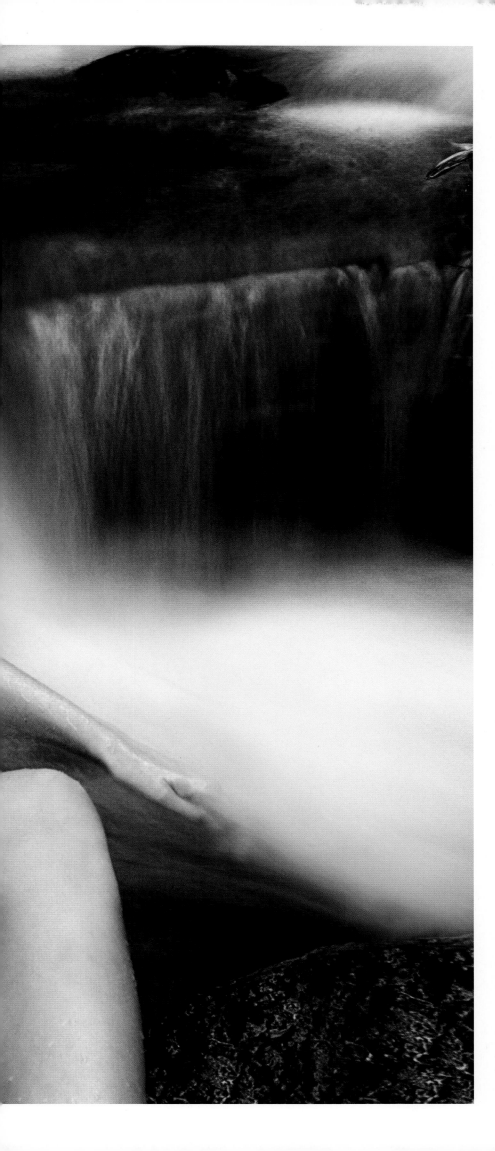

A LITTLE STARDUST CAUGHT, A SEGMENT OF THE RAINBOW WHICH I HAVE CLUTCHED.

HENRY DAVID THOREAU, *Walden,* 1854

Michael Thompson, *W, April 2005*

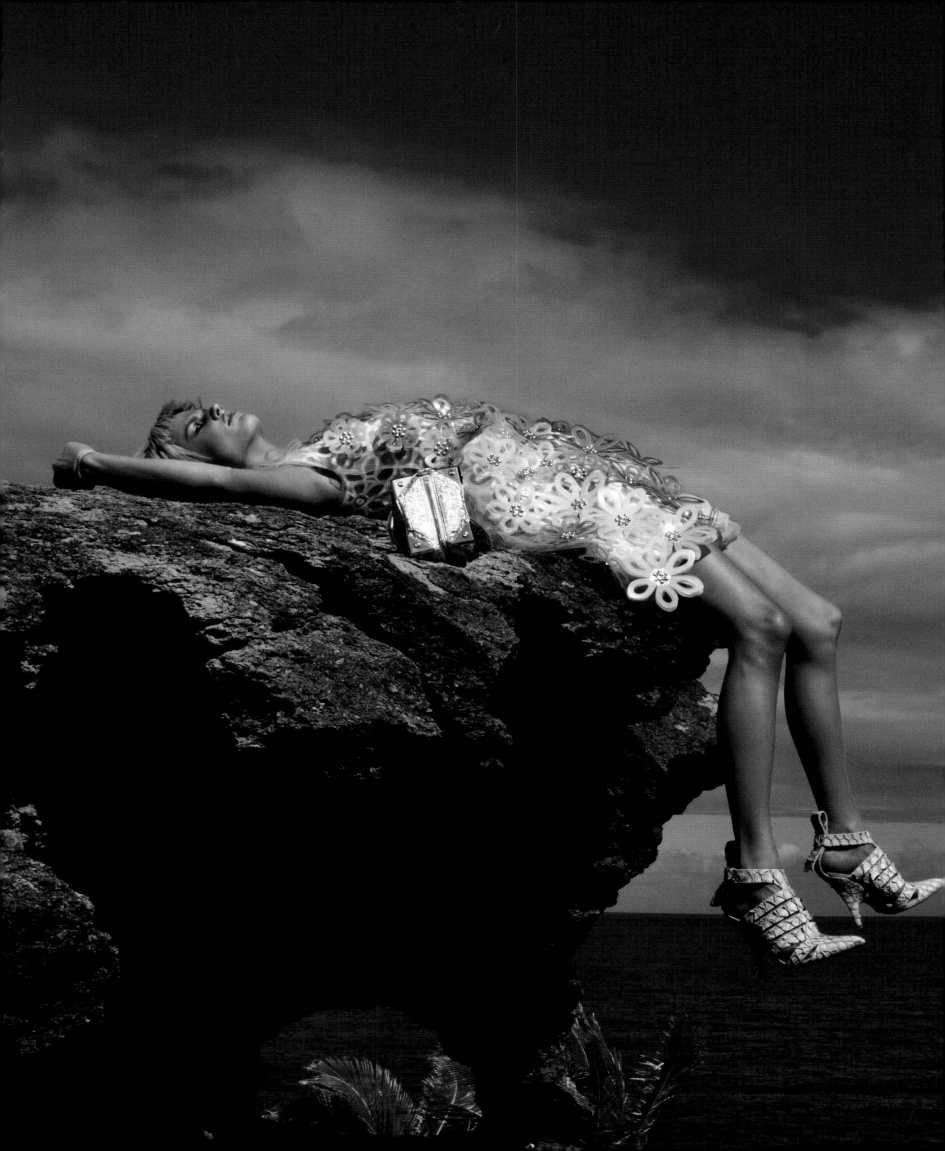

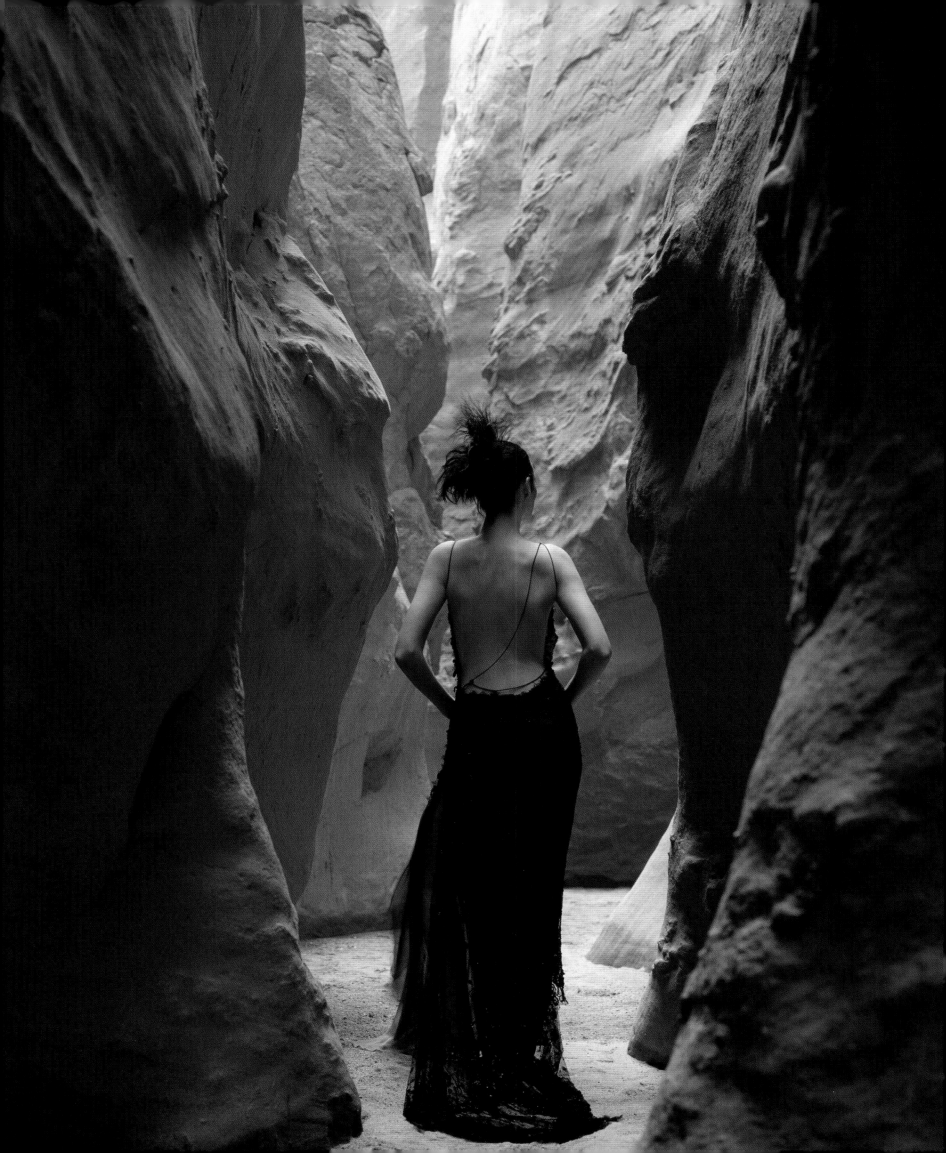

I GO TO NATURE TO BE SOOTHED AND HEALED, AND TO HAVE MY SENSES PUT IN ORDER.

JOHN BURROUGHS, *The Gospel of Nature,* 1912

pages 96 – 97
Patrick Demarchelier, Japanese *Vogue,* May 2012

opposite
Herb Ritts, *Allure,* October 1997

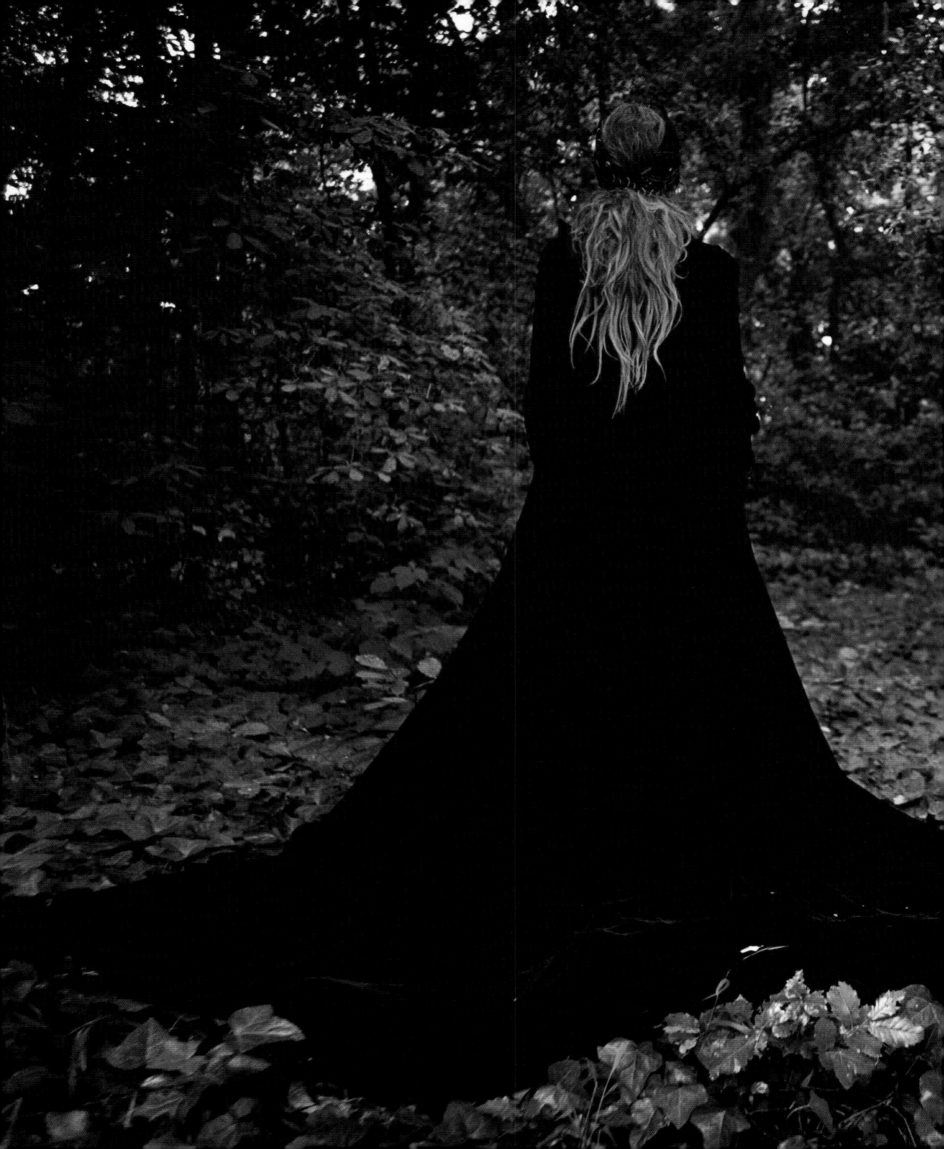

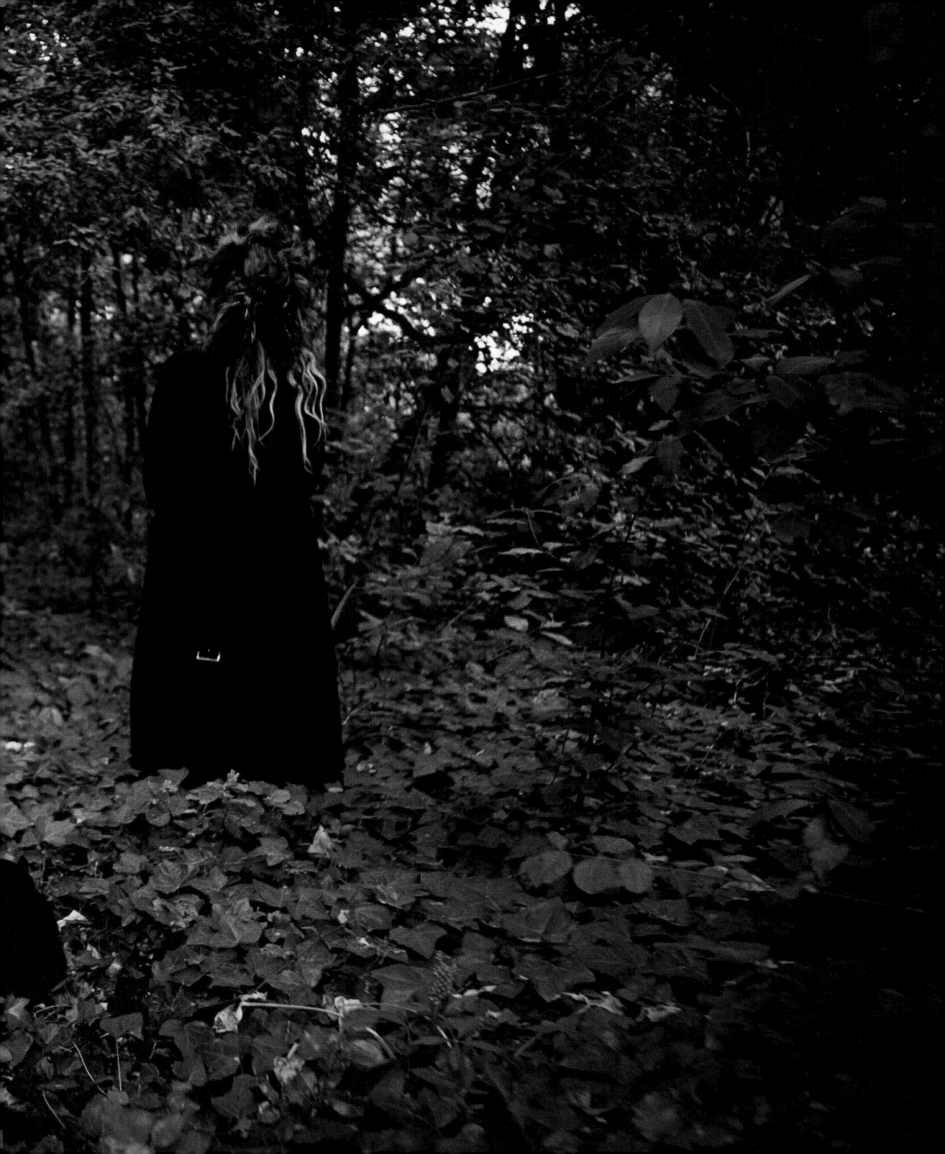

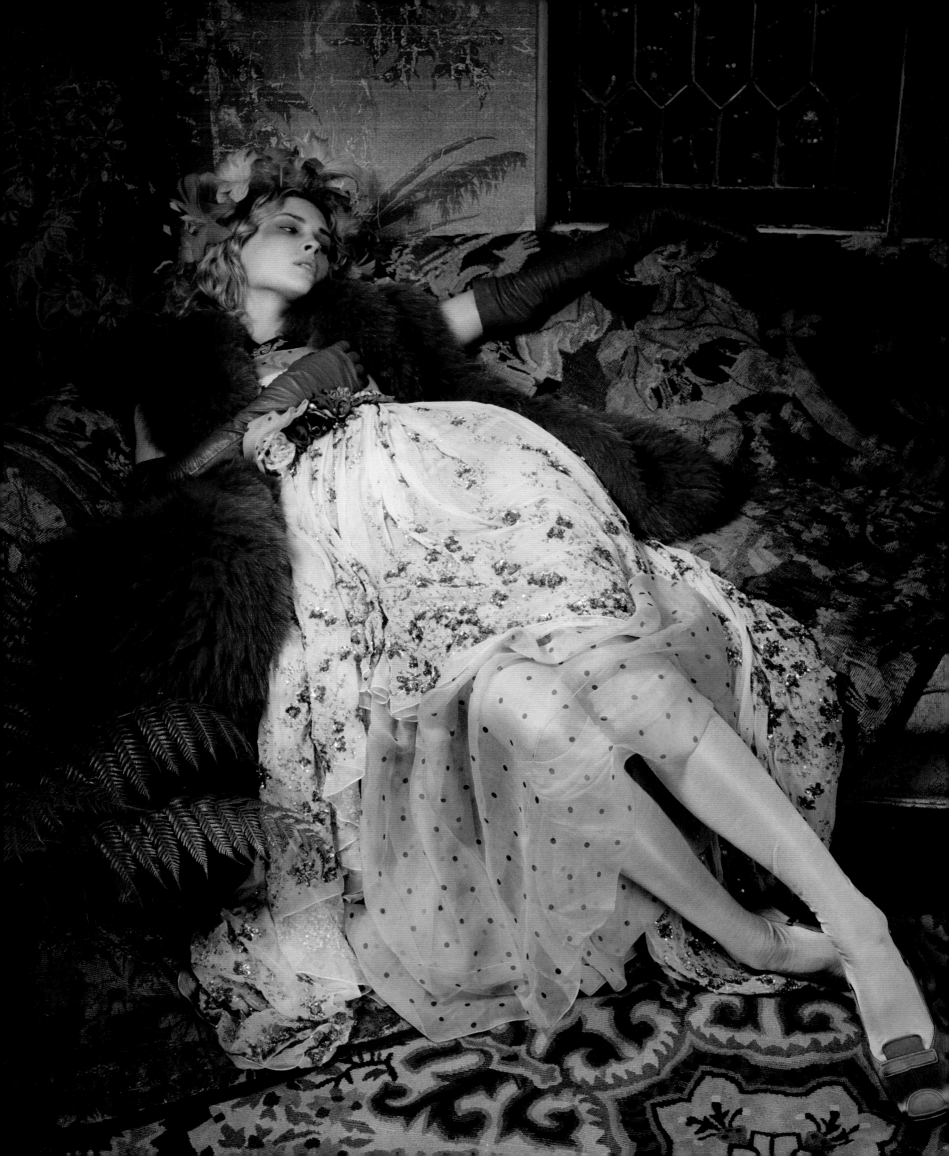

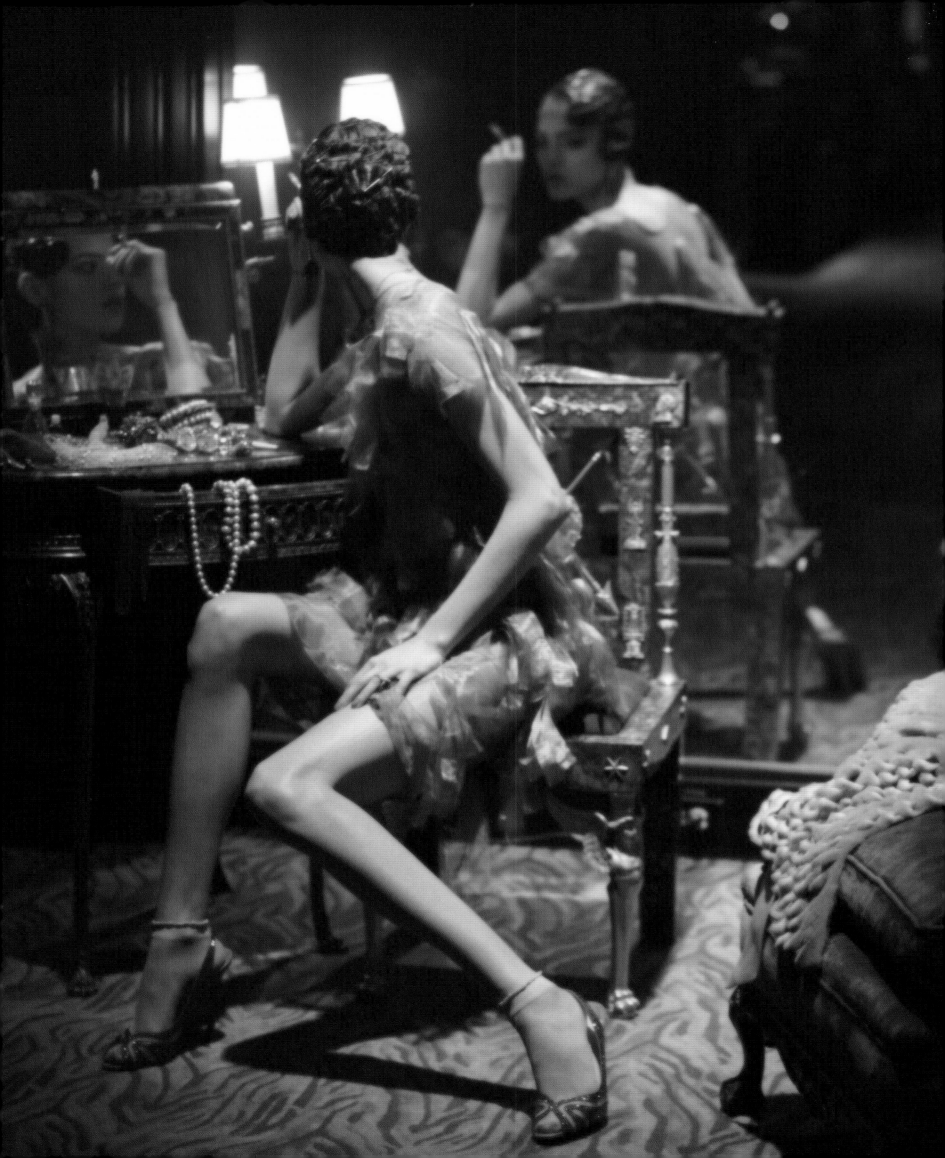

These images are stills from a film that never existed. Each scene is so potent, so alluring, so laden with suggestion, that it is impossible not to wonder what preceded it or what will come next. The pictures take their power from cinematic devices: costume, setting, location, makeup, and positioning.

The inspiration for these shots was, in fact, a film: *The Damned.* Steven loves this movie and told me to watch it. And I did, but I really only half-watched, taking in bits and pieces and visualizing other scenarios it conjured in my imagination.

Later, when I started prepping this shoot for Italian *Vogue,* my mind wandered back to the afternoon when *The Damned* wove itself into my psyche and became a reference for my work, much in the way you hold on to the soft fragments of a good dream.

pages 104, 107
Steven Meisel, Italian *Vogue,* March 2010

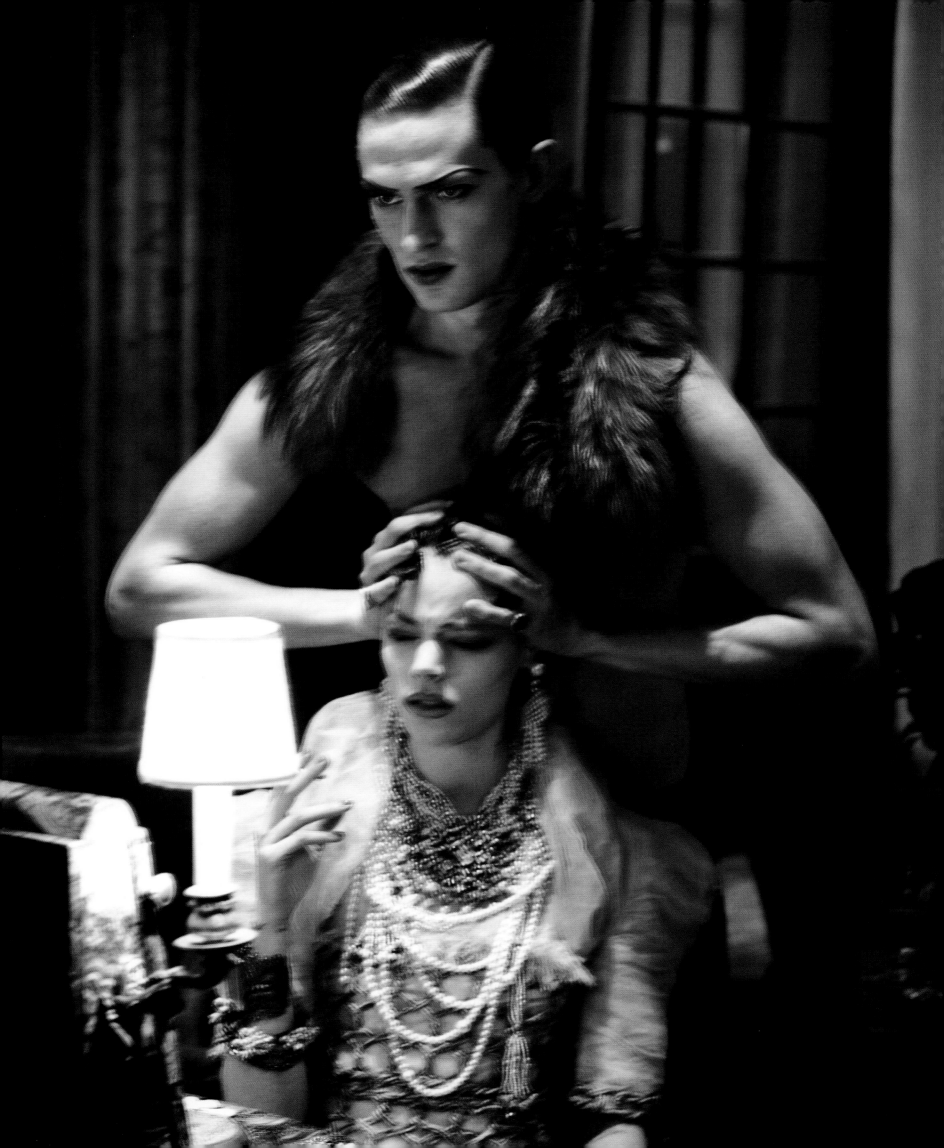

I've worked with Bruce only a few times, and each shoot has been a pleasure, full of surprise and wonder. Bruce loves people and characters, and he loves a story. He's got a romantic side, and a whimsical side, too—and it's the combination of heart and imagination that makes him so divine. Bruce goes for it and gives me room to go for it, so when we work together, I know I can bring incredible pieces of fashion and that they will get used. Like me, he loves the extreme object, and embraces weirdness in a way that feels like a real celebration of life. That attitude kicks my spontaneity into overdrive.

As it did for this story: we started working in a studio in New York City, and before we knew it, we were outside shooting on Twenty-sixth Street with a model in a Viktor & Rolf dress with a huge built-in pillow at the back inside of the collar.

opposite
Bruce Weber, *W*, September 2005

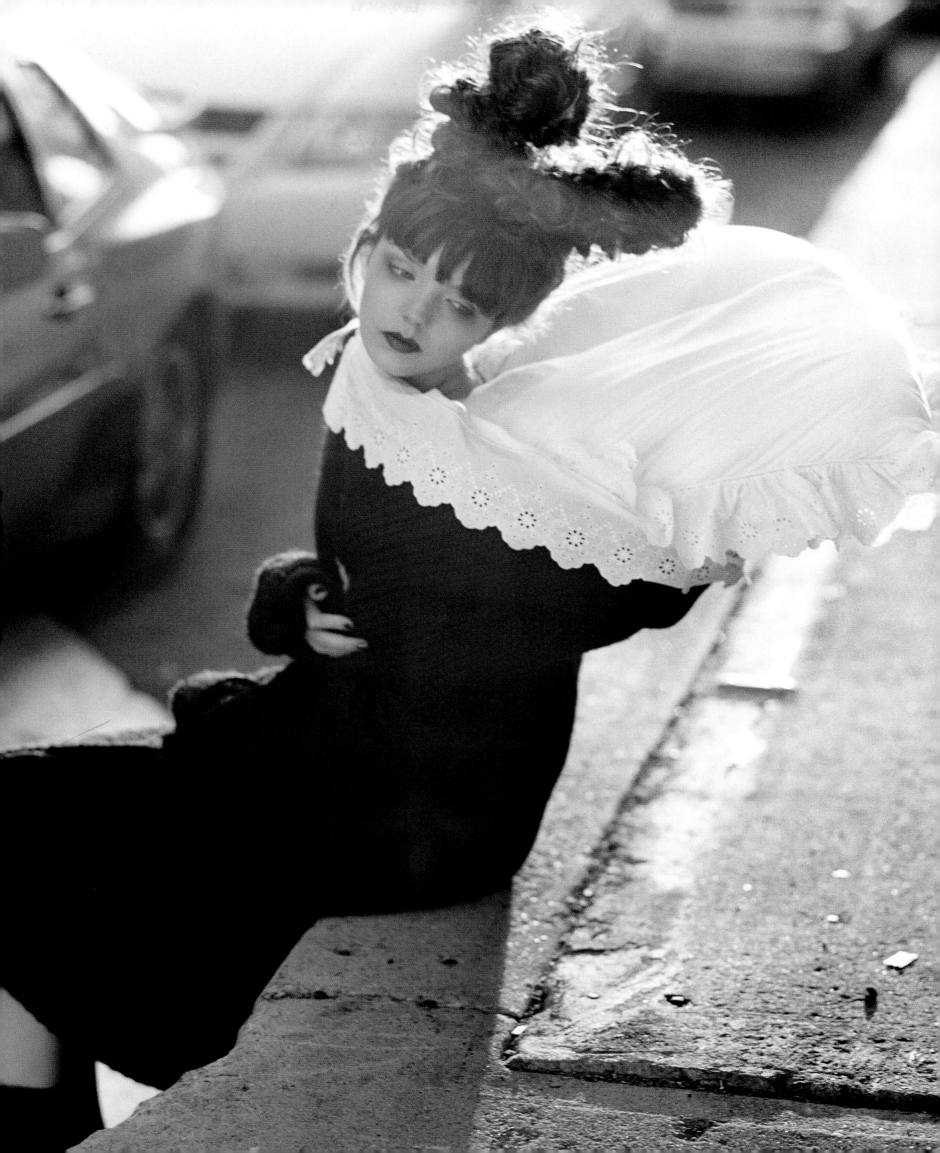

HARMONIOUS DISCORD

THE UNEXPECTED

mix of pattern and color. The juxtaposition of texture and form. Pitting opposites against each other and finding a common ground. That's what my work is at its core.

My fashion does not create a look but a world where that look can exist. My rules are not about separating—they're about bringing together. That's how I see the world: ripe with diversity—different ethnicities, cultures, religions, art, and fashion—and united by it. And it is all a source of inspiration. I believe that if handled correctly, if given the chance, anything can go with everything.

Taking elements that are unlike and making them like is part intuition and part practice. When I'm on a shoot, the way I look at every detail matters. If the final photograph is a painting, then every aspect of that image is a brushstroke. Each element must have intent. When I create a look, I am in a constant dialogue with myself about color, texture, and proportion. I do the math—literally adding, subtracting, multiplying, and dividing—until I get there.

What's missing? What doesn't belong? How much is too much? Everything contributes to the whole. A woman can wear nineteen items of clothing at once, and it can work perfectly if the patterns and layers complement each other. And in that case, twenty elements would have been too many, and eighteen, too few.

Intention is the difference between thrown together and put together.

The work in these pages derives from a jumble of influence. In viewing these images, you can't always be sure what something is or where it came from, and the point is, perhaps, that it doesn't matter. The excitement is in the differences—and knitting them together into one gorgeous cohesive whole, into a single idea made up of the parts of many, into one great harmonious discord.

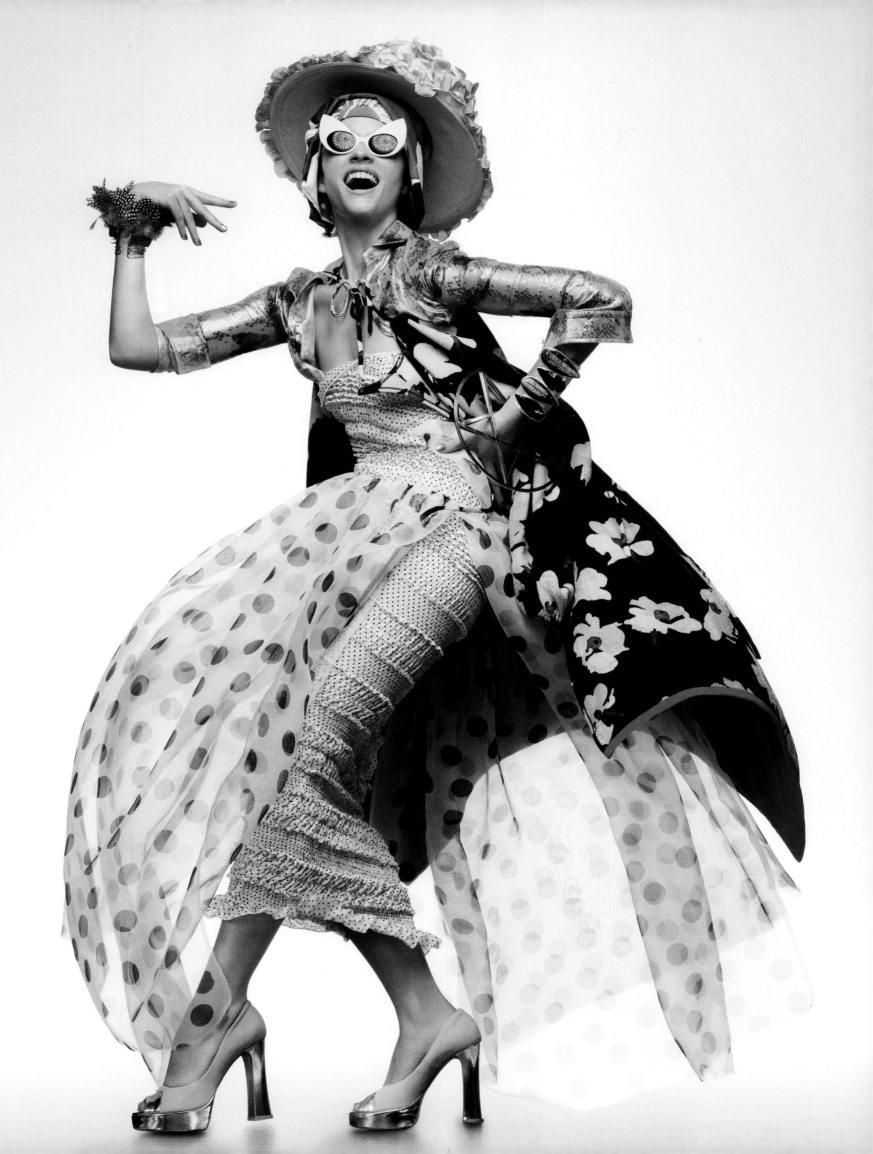

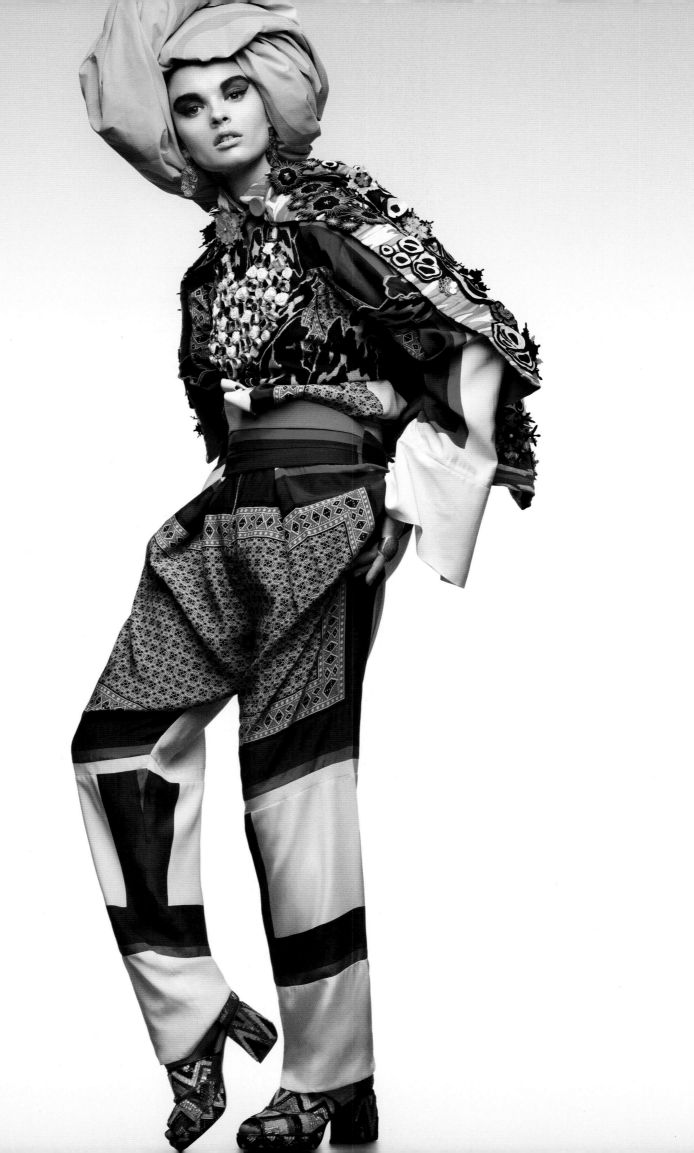

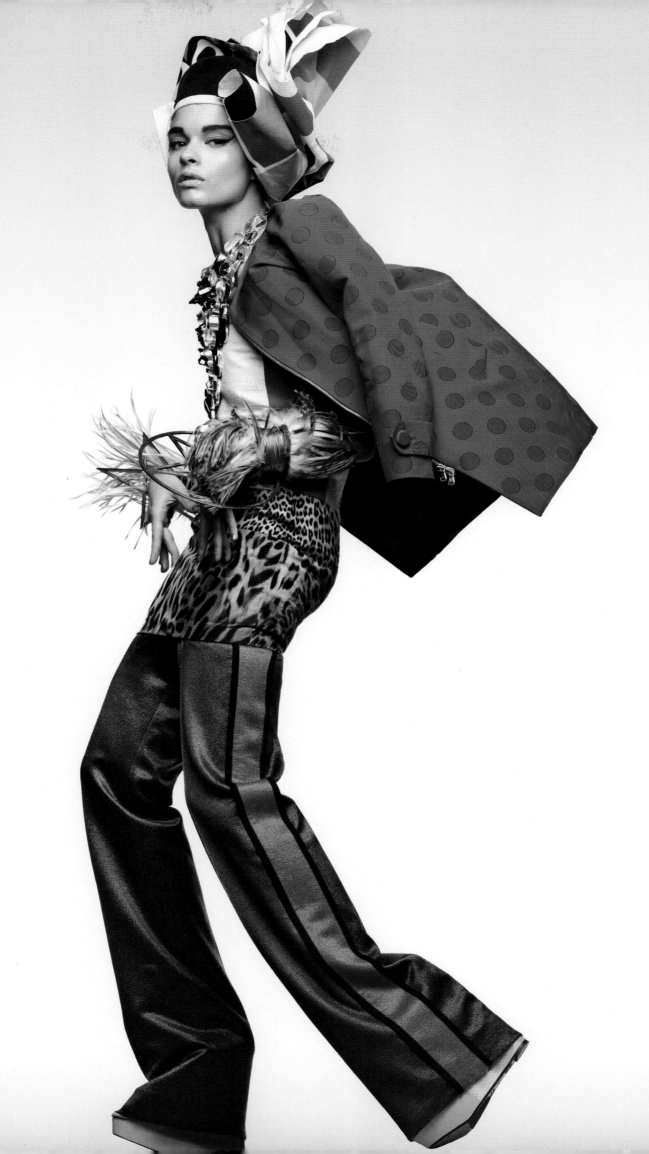

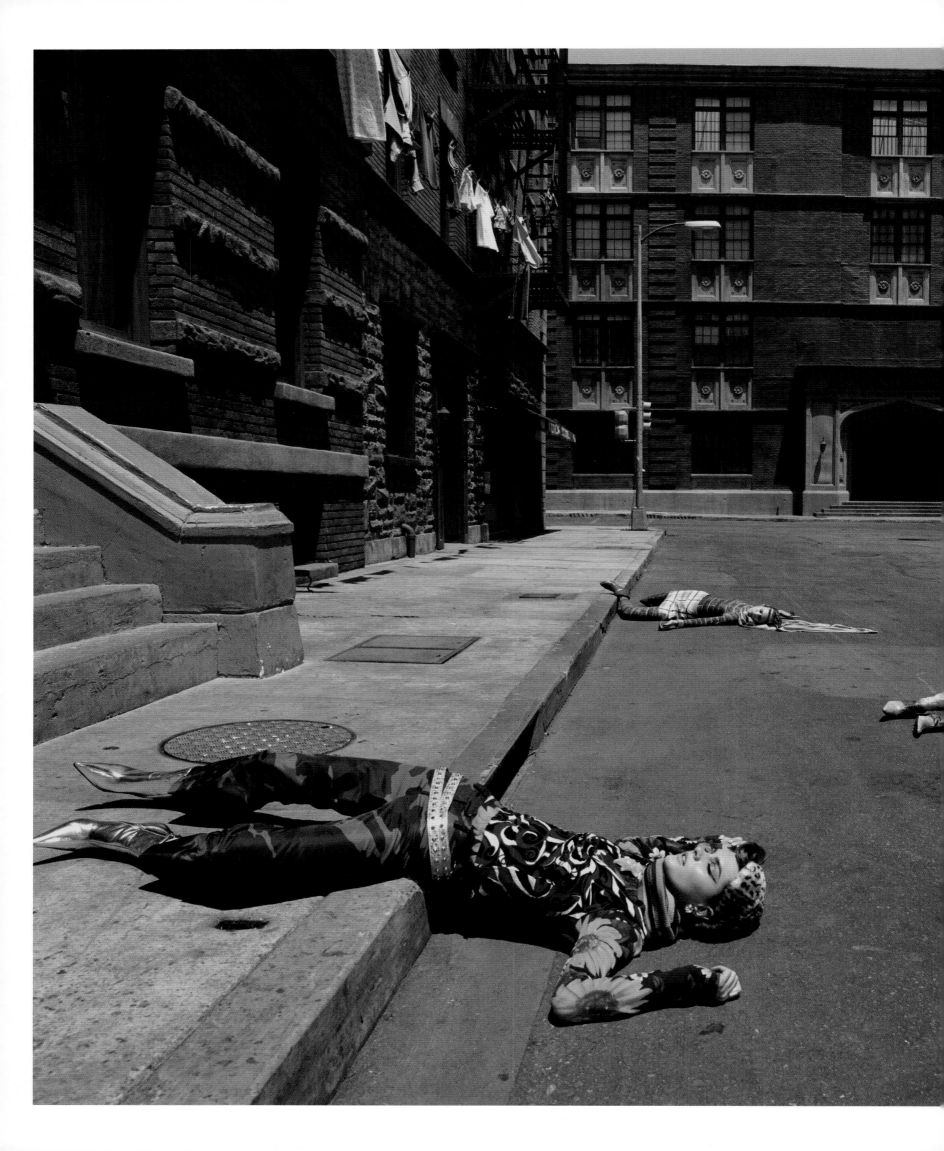

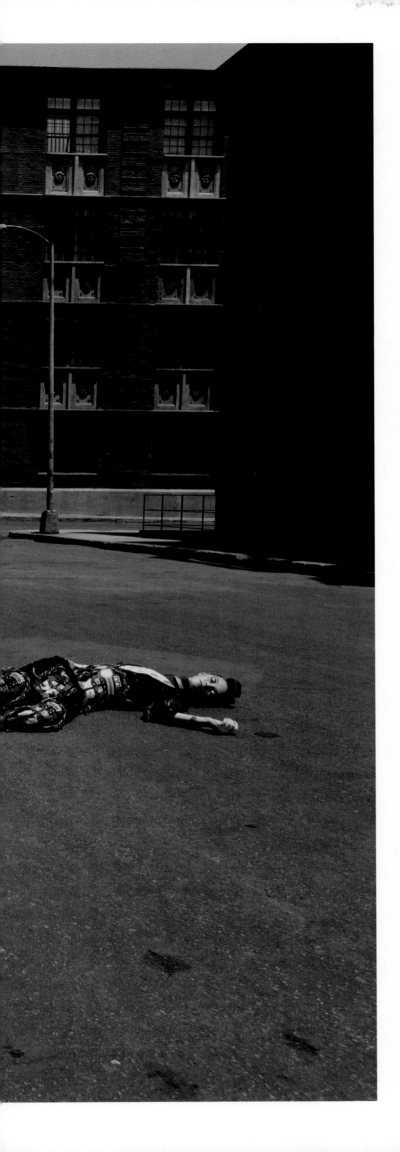

Steven Meisel, Italian *Vogue*, August 2000

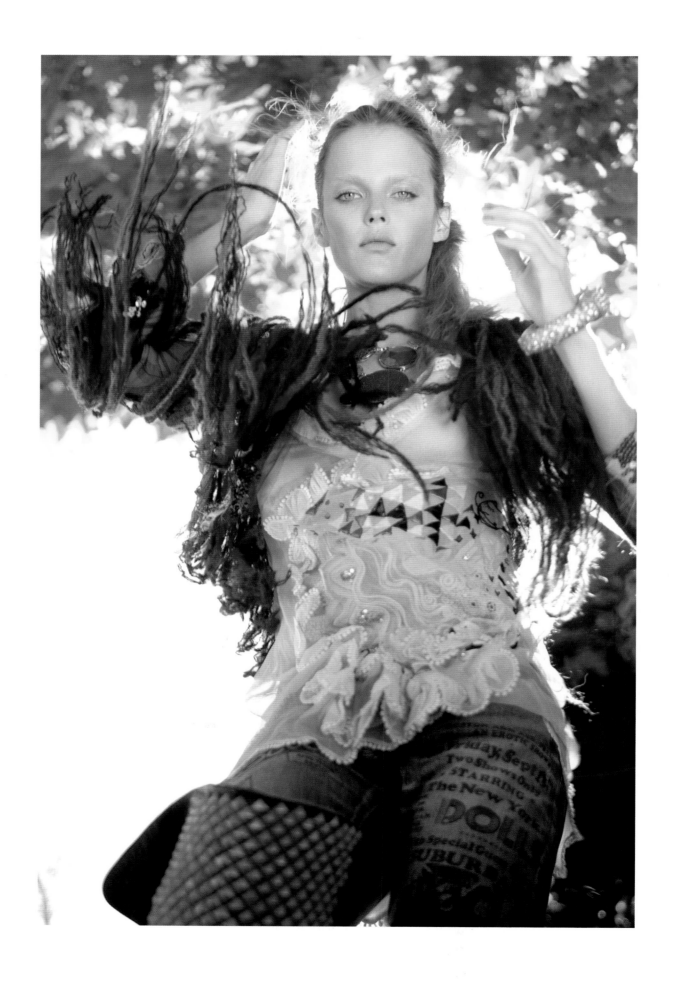

pages 120 – 121
Jeff Burton, *Los Angeles Times Magazine*, Fall 2008

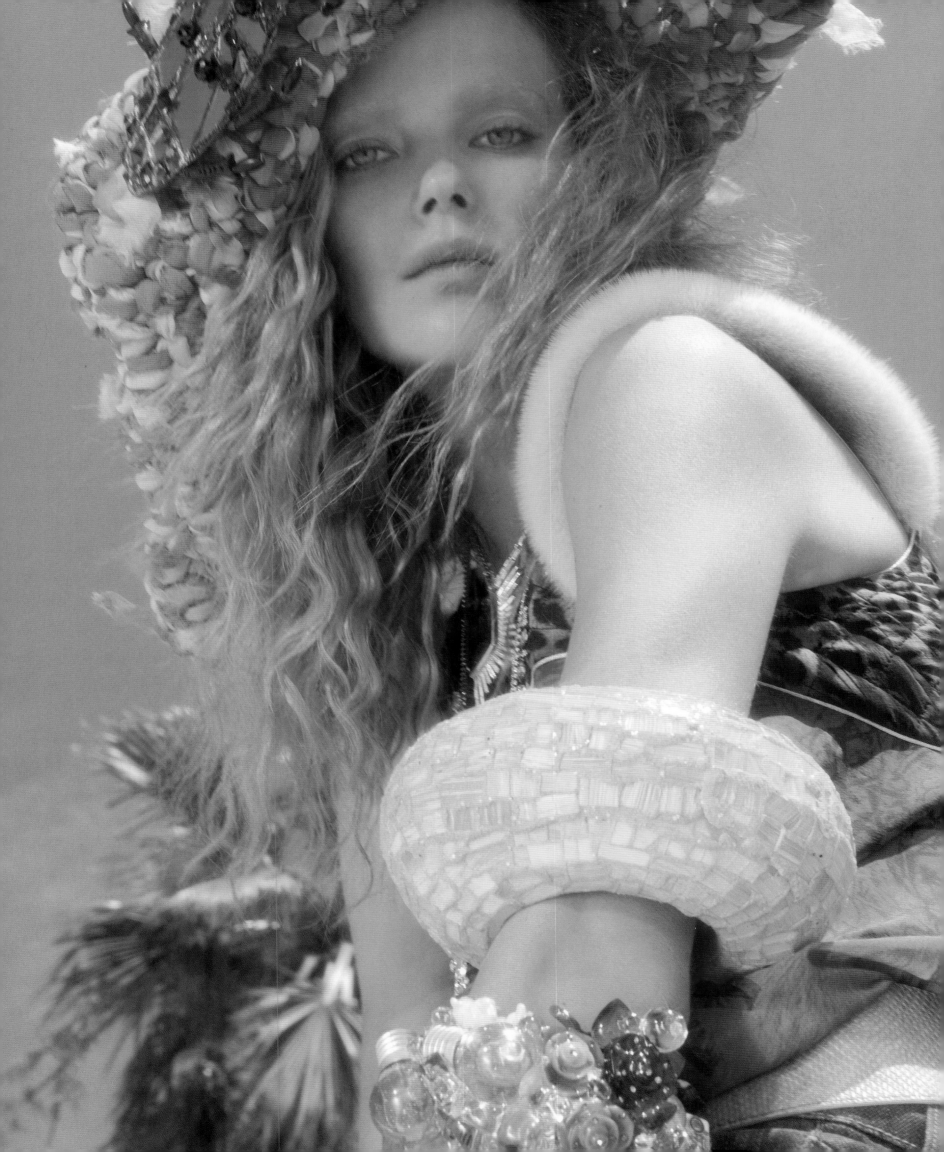

EXCESS ON OCCASION IS EXHILARATING. IT PREVENTS MODERATION FROM ACQUIRING THE DEADENING EFFECTS OF A HABIT.

W. SOMERSET MAUGHAM, *The Summing Up*, 1938

first discovered the divine world of Tony Duquette through his jewelry, and I was immediately obsessed. So when I learned that the location of my next Italian *Vogue* editorial would be at his former home in Beverly Hills and at his ranch in Malibu, I was ecstatic! Duquette was the king of maximalism, a set and interior designer who created opulent, fantasy worlds. Every room that he designed had its own energy and personality; I had never before been to a location so resonant with my own style. It was one of those instances of discovering a kindred spirit, a stranger who was my aesthetic doppelgänger.

The beautiful and bizarre mixture of colors and materials in the rooms perfectly complemented the lush colors of the vintage clothes that we were shooting. Each element in the photograph is so odd and so distinct, from the paintbrushes to the horse sculpture and other objects, but pulled together, they work flawlessly. It's almost as if everything in the space had just grown there that way organically, like a mysterious garden. That's the magic of Duquette's work.

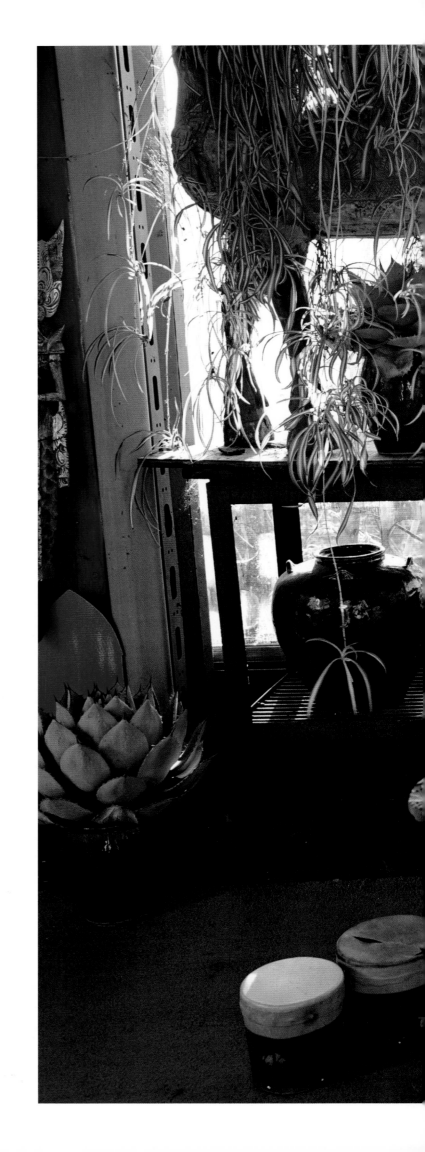

Steven Meisel, Italian *Vogue*, June 2000

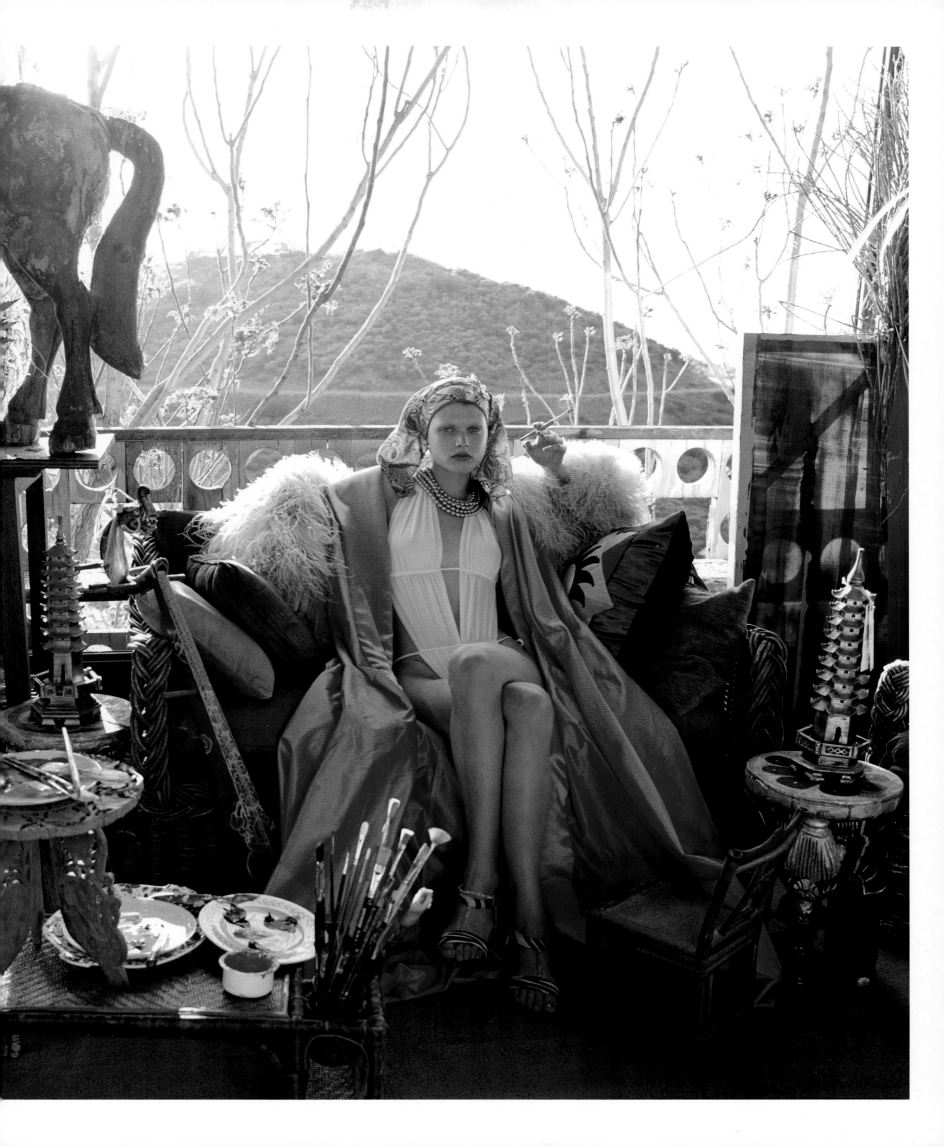

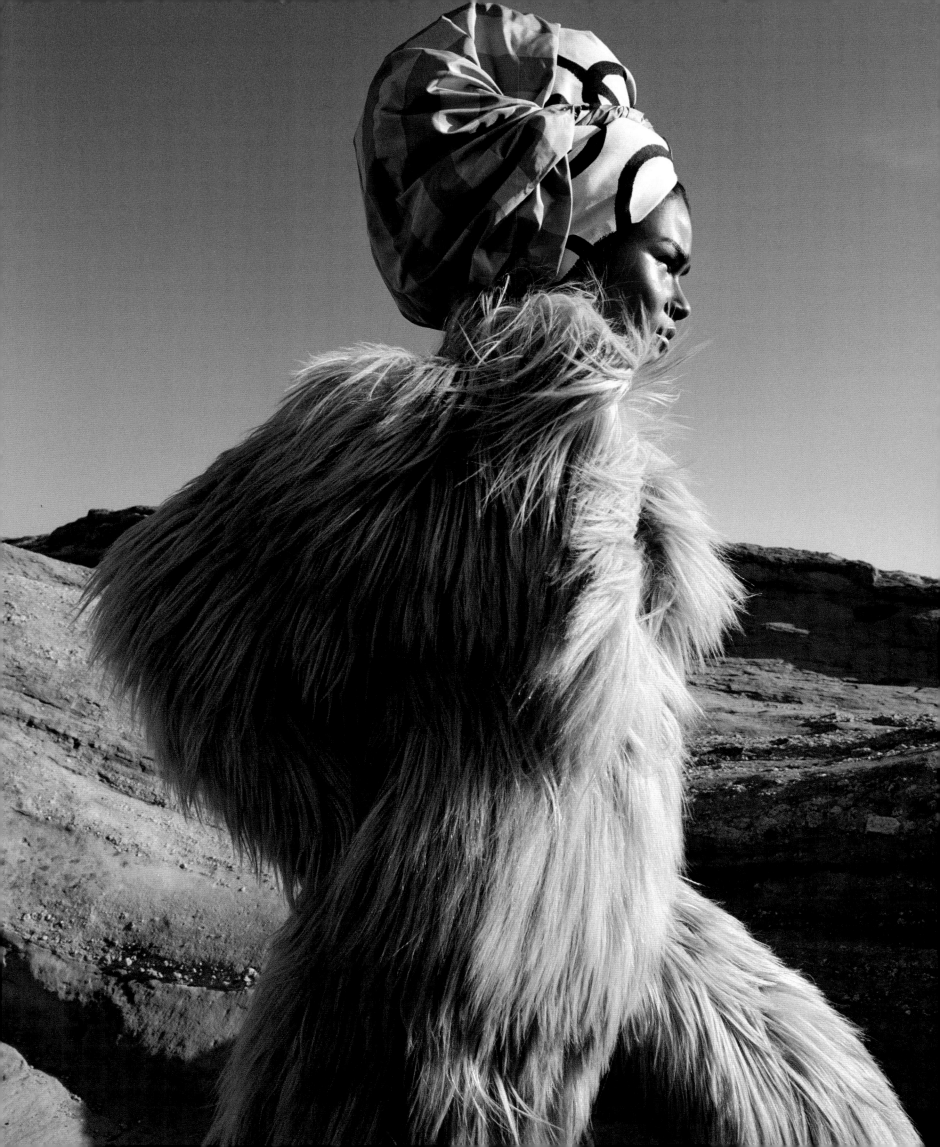

T he "New Fantasy" shoot was intended to showcase a diverse group of Italian designers. Taking advantage of the beauty of the landscape around LA, we shot at the Vazquez Rocks, in northern Los Angeles County, where many Hollywood Westerns have been filmed over the years.

Before the shoot, all of these old Marimekko prints popped into my head. The company's fabric and clothing had been very trendy in the 1960s and would become popular again about a decade after this shoot, but at the time nobody was using Marimekko. When the shoot came up, I had the idea to use their bright, bold graphics in a wide-open, arid, almost monochromatic natural space. I called their studio in Finland and asked if we could buy some fabric for the shoot. They sent bolt upon bolt of different fabrics, all of these punchy graphic designs that were definitively Marimekko, from big bold flowers to intense geometrics.

Orlando Pita created magnificent turbans out of the fabric, as only he could do, and the story took on an exotic quality, echoing the classic *Vogue* stories that Norman Parkinson and Franco Rubartelli did in the Diana Vreeland days. With those turbans, we were suddenly transported to this faraway land, a bit outside of real time. I love that fashion has the power to do that.

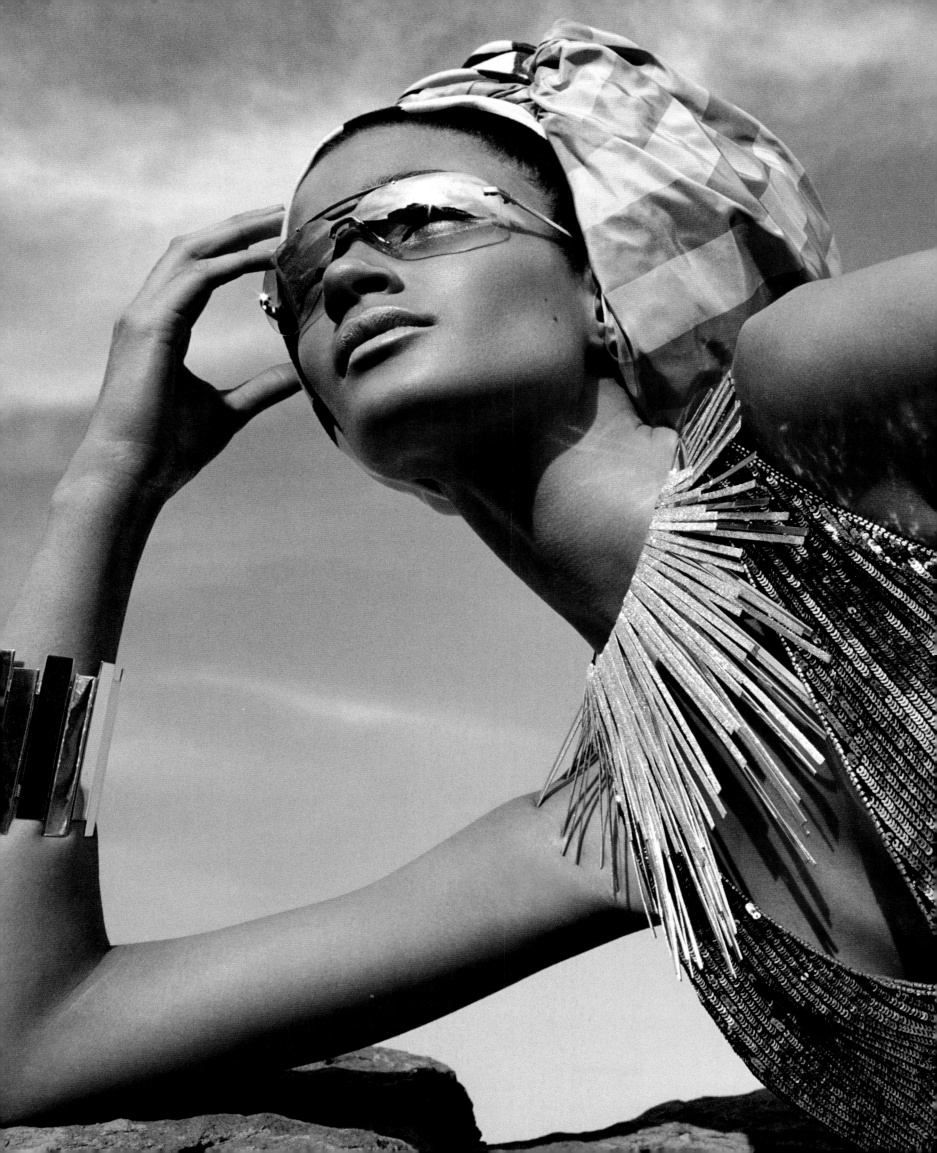

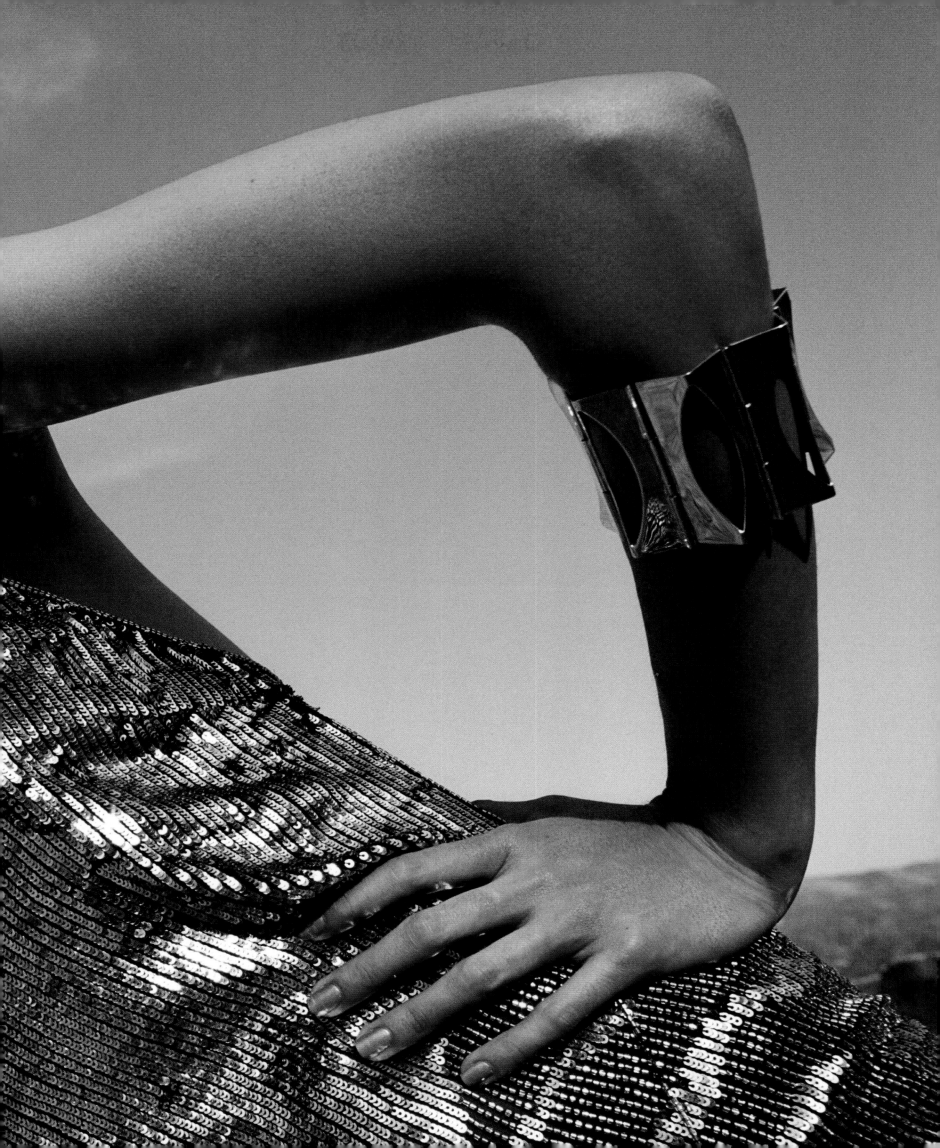

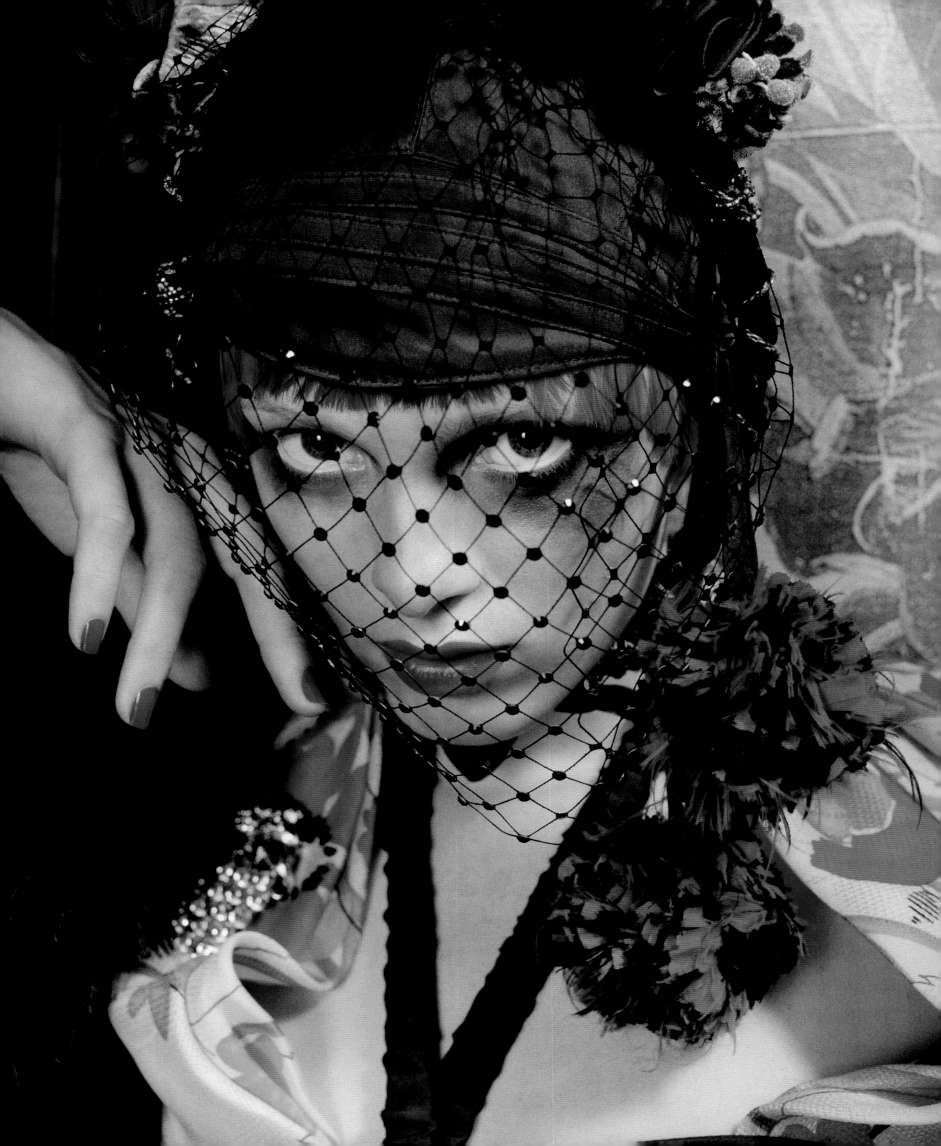

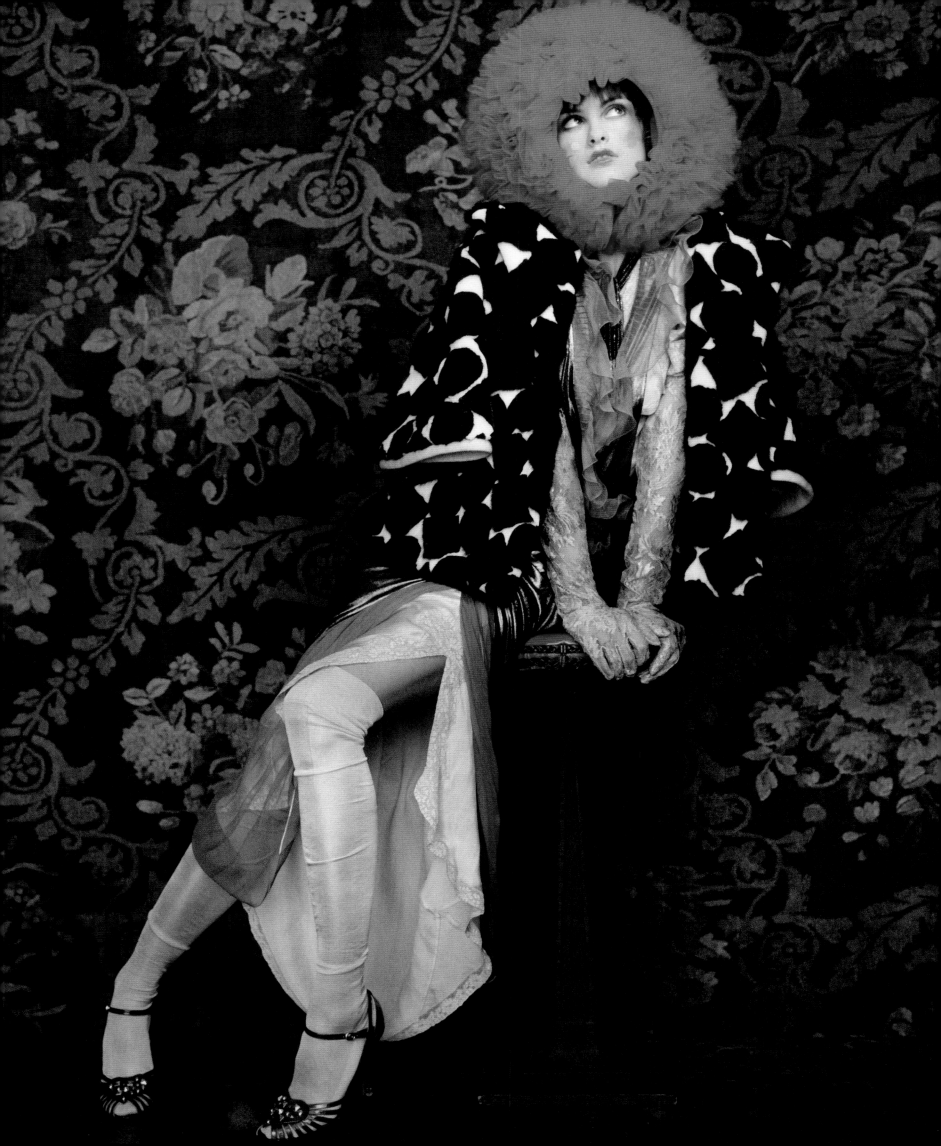

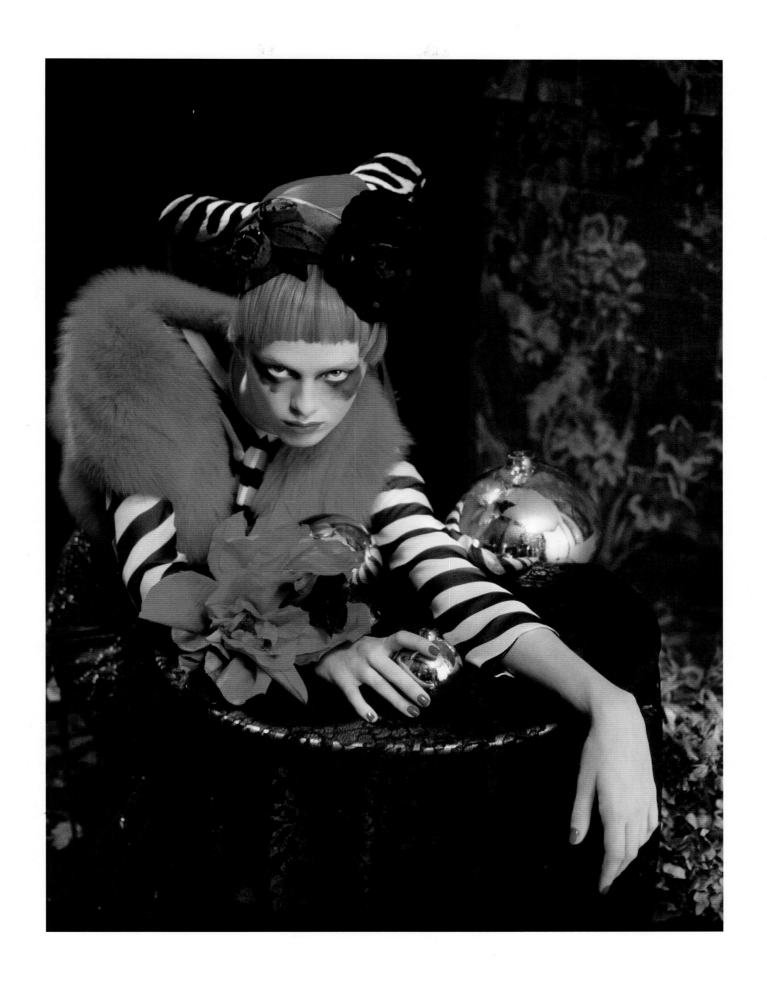

pages 131 – 133
Yelena Yemchuk, Japanese *Vogue*, August 2003

When it comes to collaborations, what comes first, the idea or the inspiration? Neither. The two grow alongside each other, pushing and pulling the concept to its fullest point of completion. The sartorial focus of this shoot for *W* was the pre-collections for the upcoming fall. The set, by designer Stefan Beckman, was crafted out of bended and fractured mirrors, creating an environment of infinite abstract reflections. We had spent hours on the phone talking about what the set would look like, but when we got there, we had to figure out how to use it to best effect.

It was when all of the clothes, shoes, and accessories arrived in the studio that I could see what I was working with and the ways in which I could bring together the fashion and the space. Then the concept really took shape. I layered colors and patterns, bags over bags, skirts over jeans, and let the mirrors add layers and abstraction. The result was surreal, trippy yet transcendent—a fashion fun house. Even though we didn't know exactly where we were going, the process got us there.

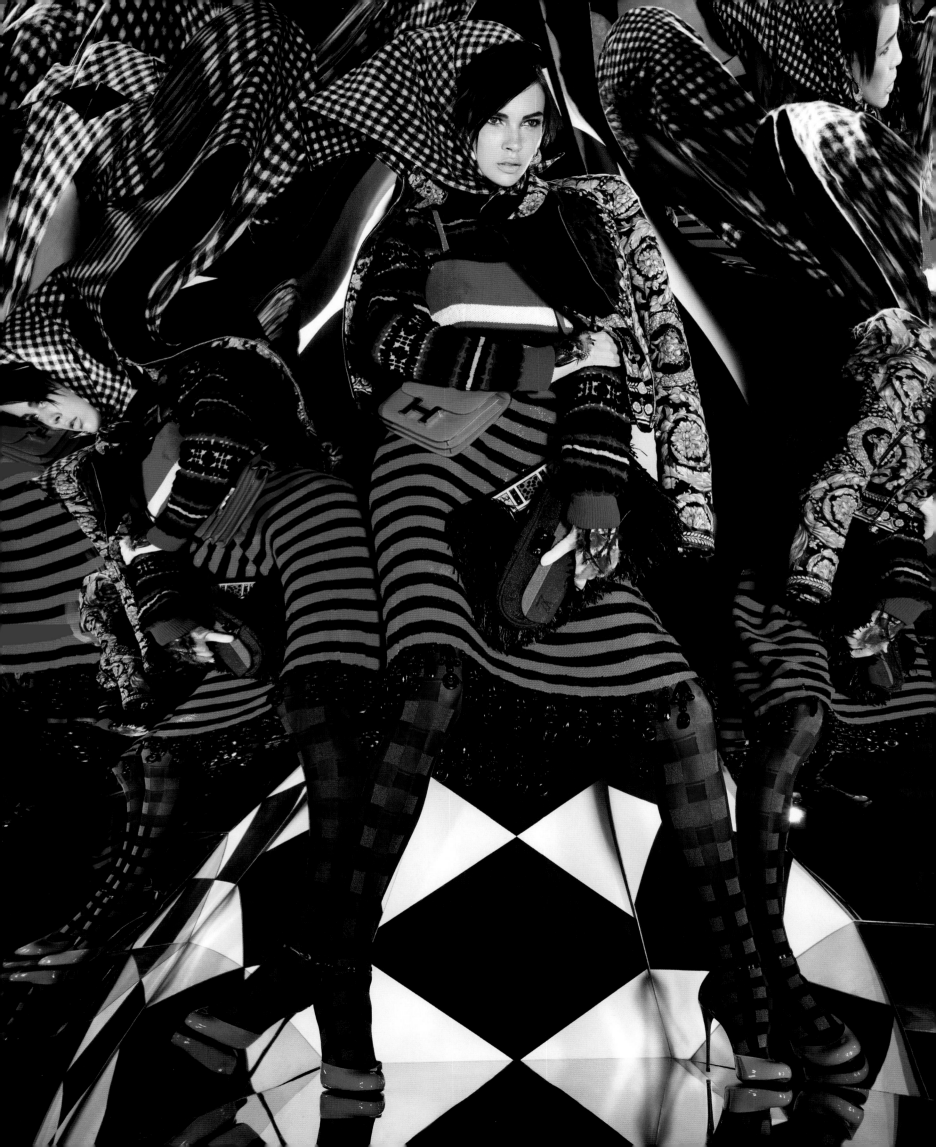

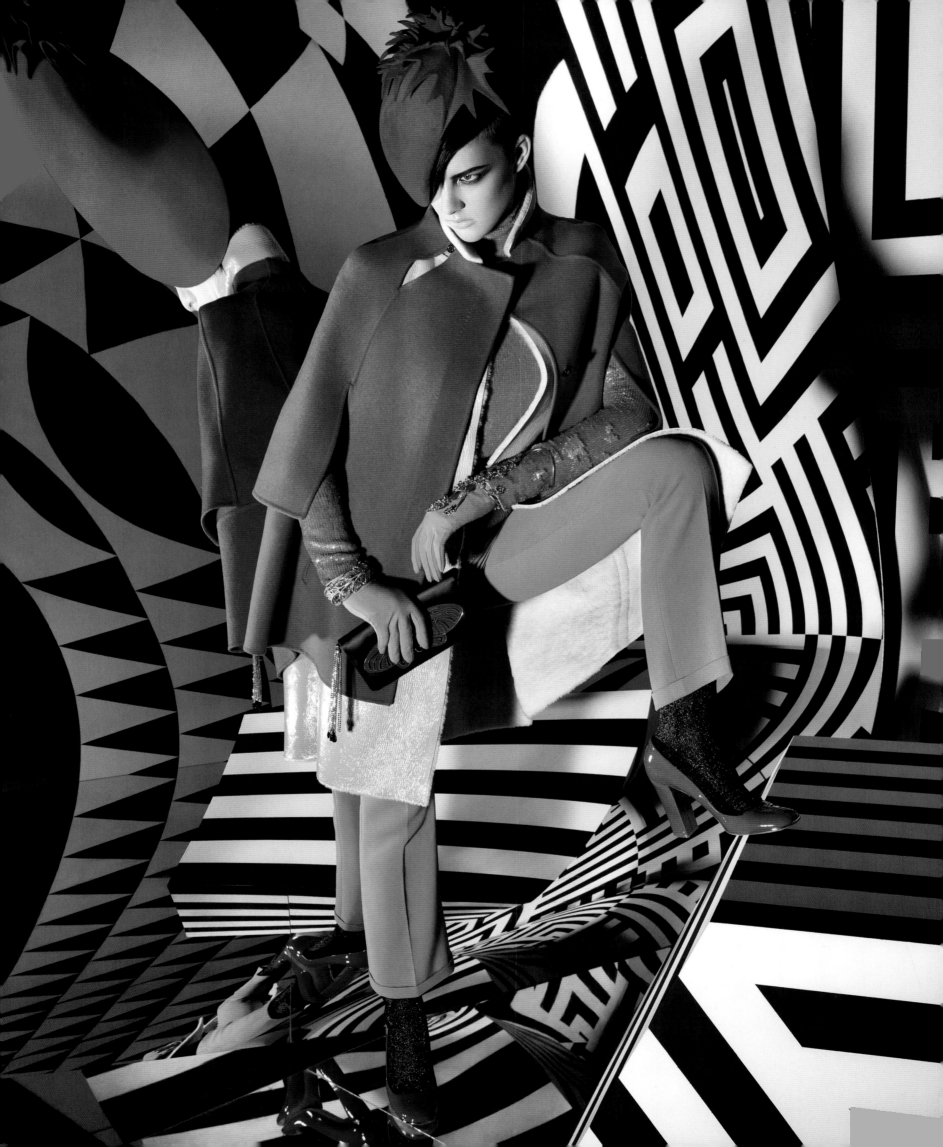

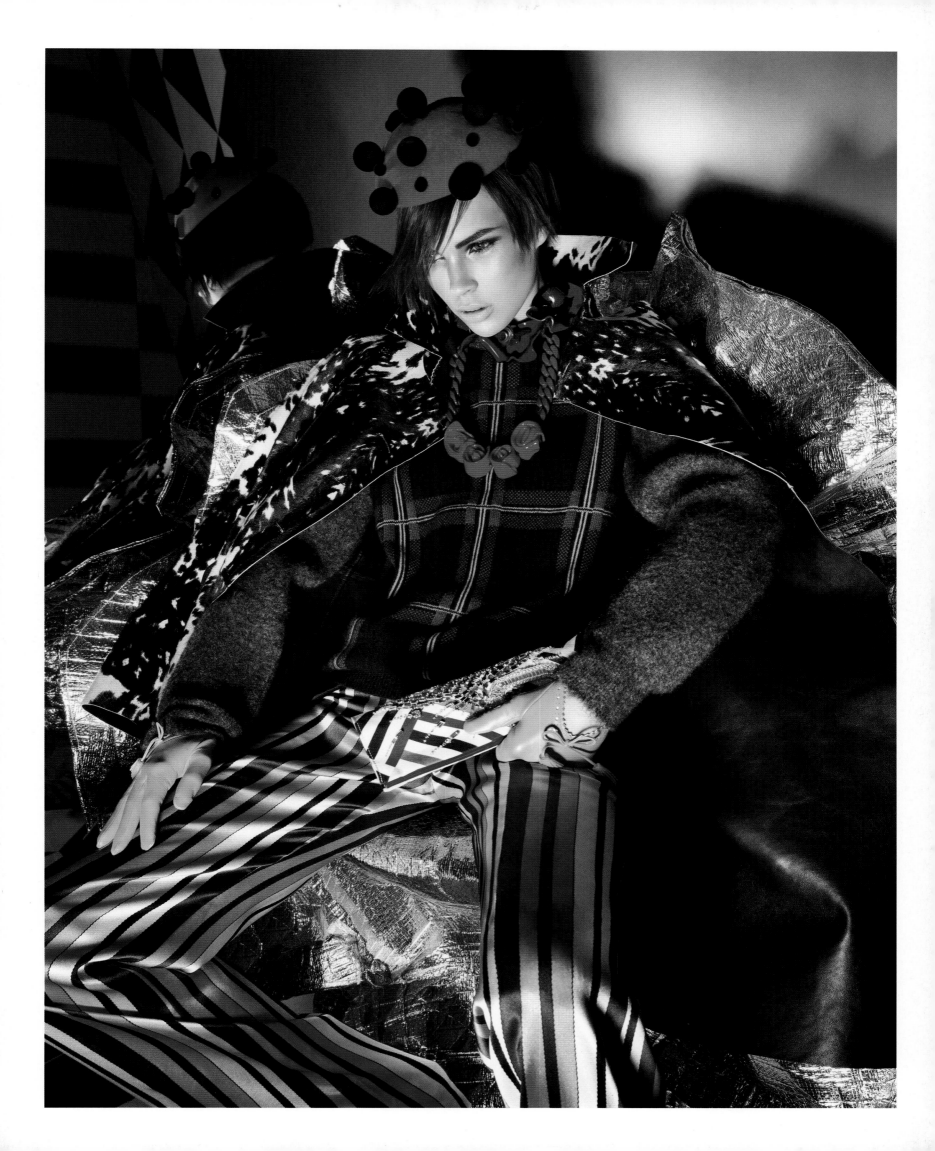

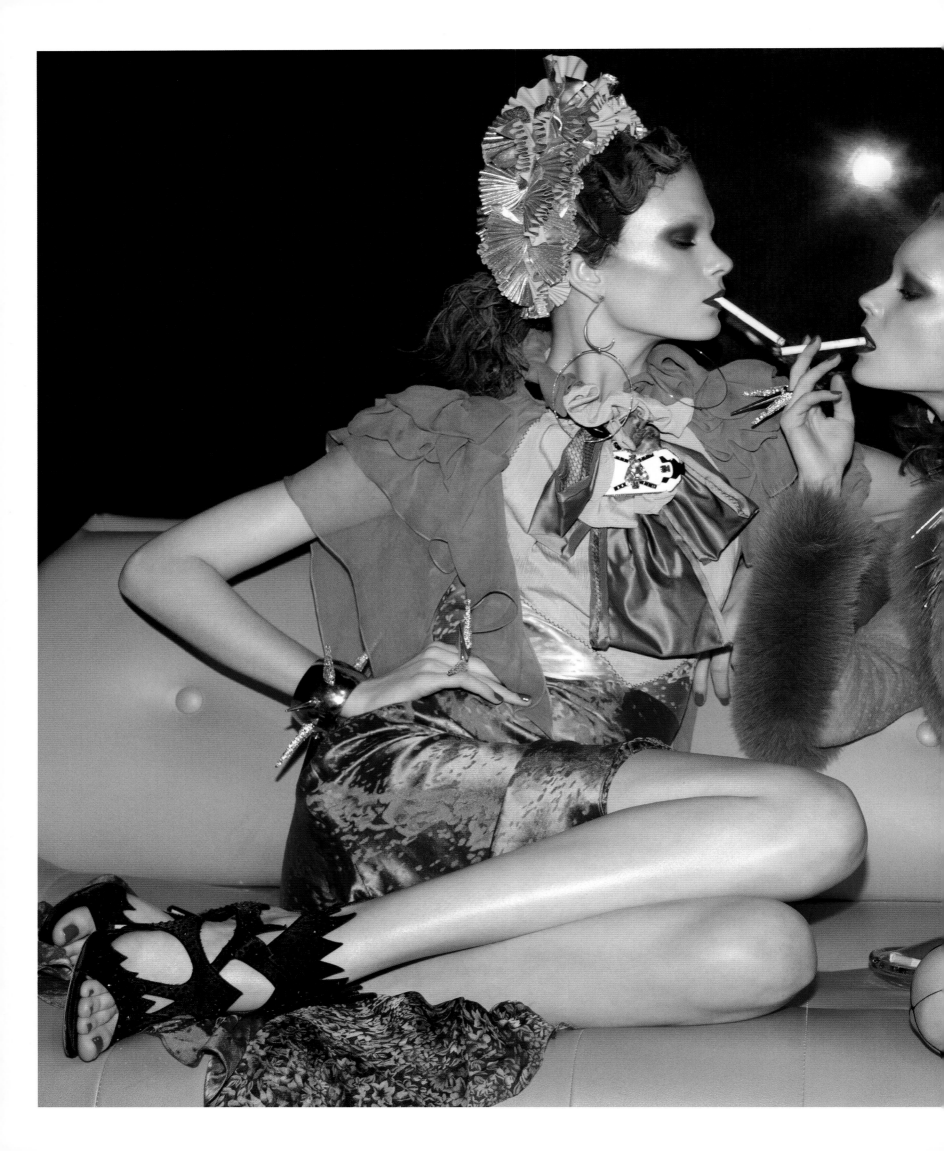

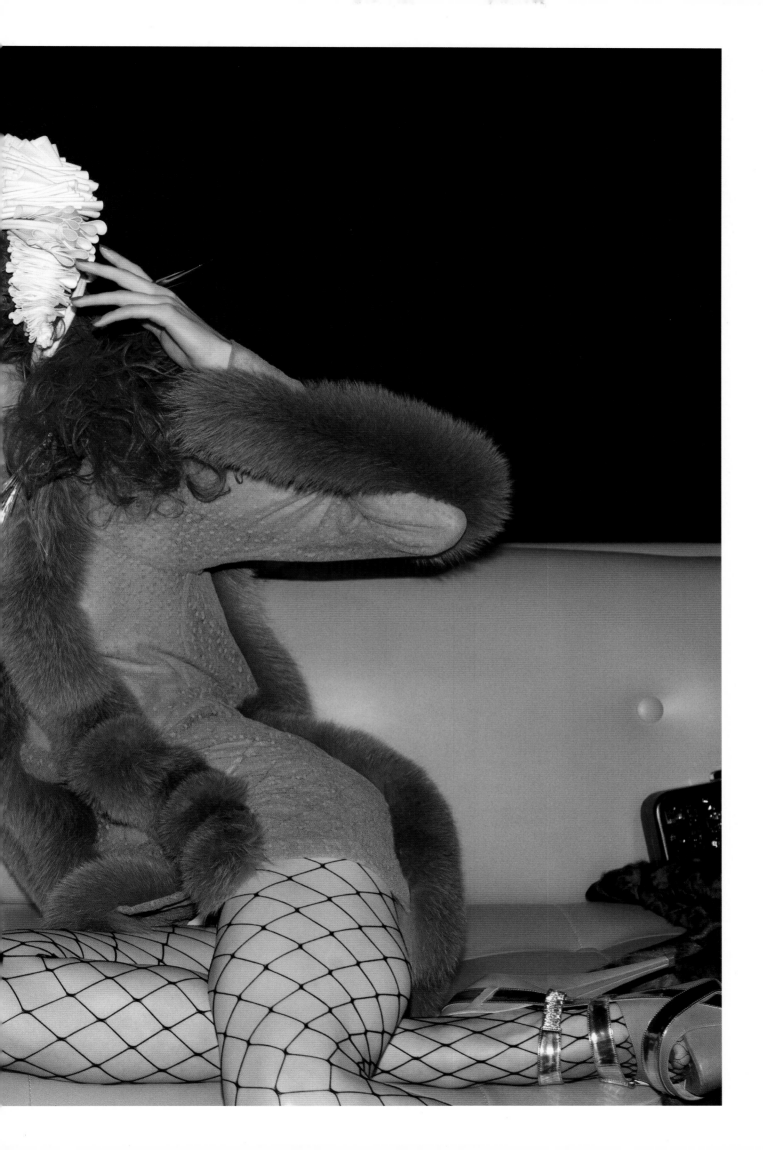

MY WORK COMES FIRST, REASONS FOR IT FOLLOW.

———

ANDY GOLDSWORTHY, from "Residency on Earth," by Lynn Macritchie, 1995

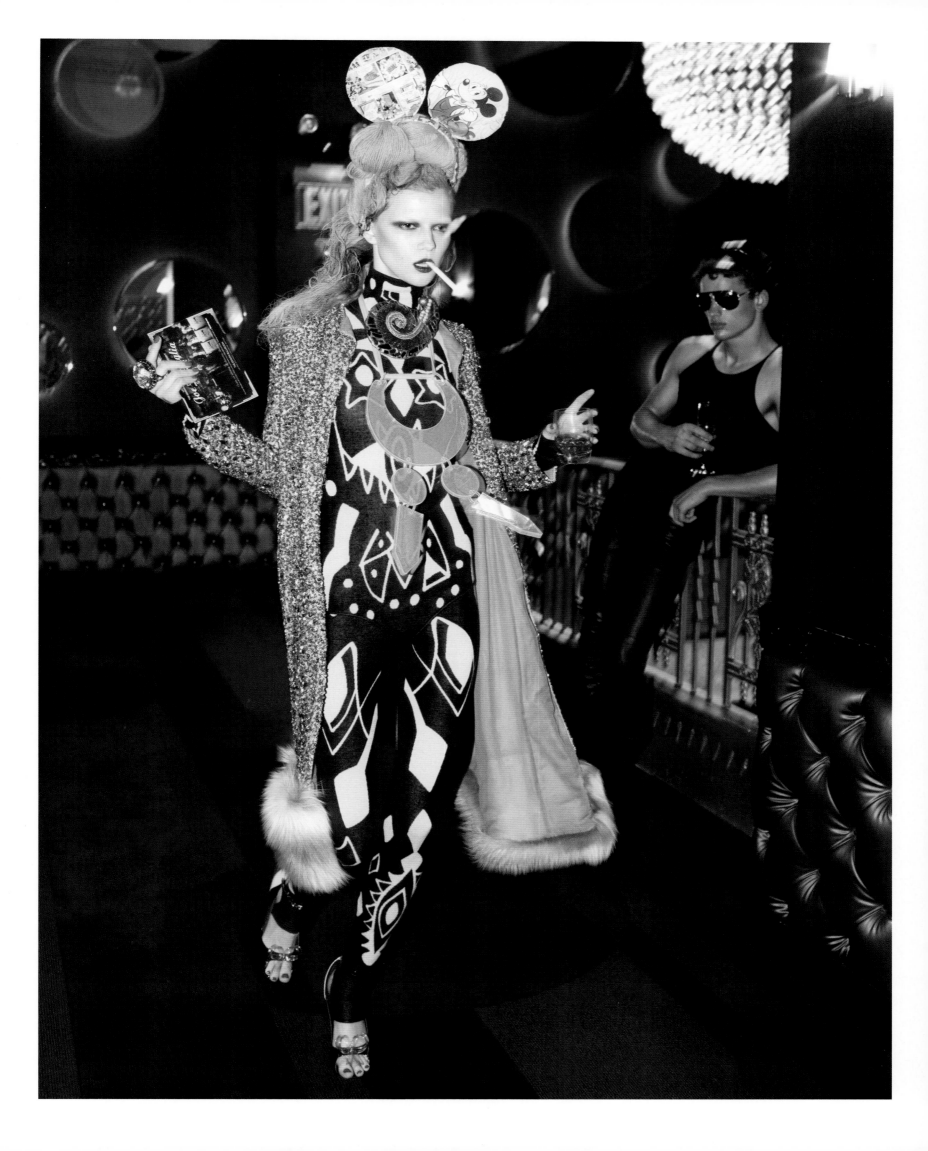

A SIMPLE BOX IS REALLY A COMPLICATED THING.

DONALD JUDD, from "Box of Delights," by Richard Cork, 1996

On a shoot, you never know what is going to inspire genius. For this Italian *Vogue* editorial, set designer Marla Weinhoff turned an old gymnasium into an extraordinary sequence of rooms so that each picture would have a unique setting. Orlando Pita was the hairstylist on the shoot, and when I saw the row of models sitting there in pin curls, I said to him, "That looks amazing—don't take them out!" And so we went with the hair just like that for the story.

The clothes I had brought were simply everything I loved at the time. I pulled from my favorite avant-garde designers, and I sourced a lot of clothes from young talents who were just starting out. New talent is incredible because they haven't learned to follow the rules yet, and that makes their clothes all the more exciting to wear and style.

The challenge was to take all of the inspiration and turn it into one cohesive story; a whole composed of parts; a full-length drama composed of impactful, stand-alone scenes. In the final shots, it was clear that we had succeeded, for each set had become its own vignette, a fashion story within a story.

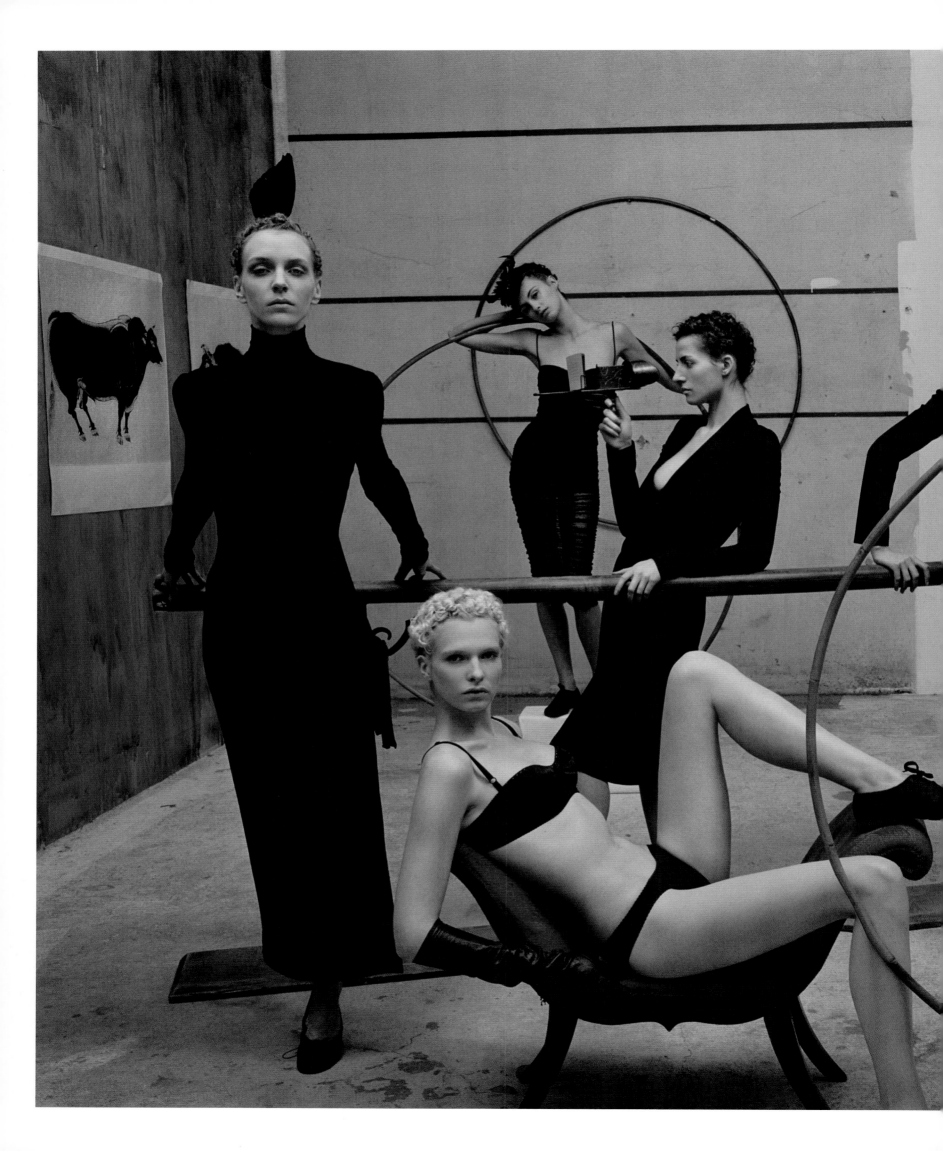

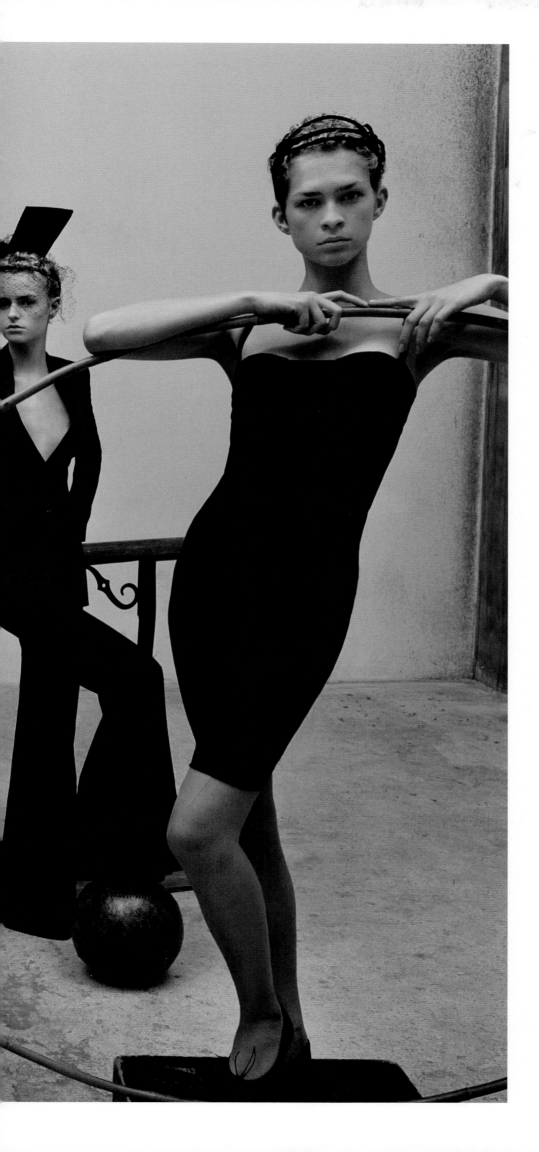

pages 144 – 147
Steven Meisel, Italian *Vogue*, March 2001

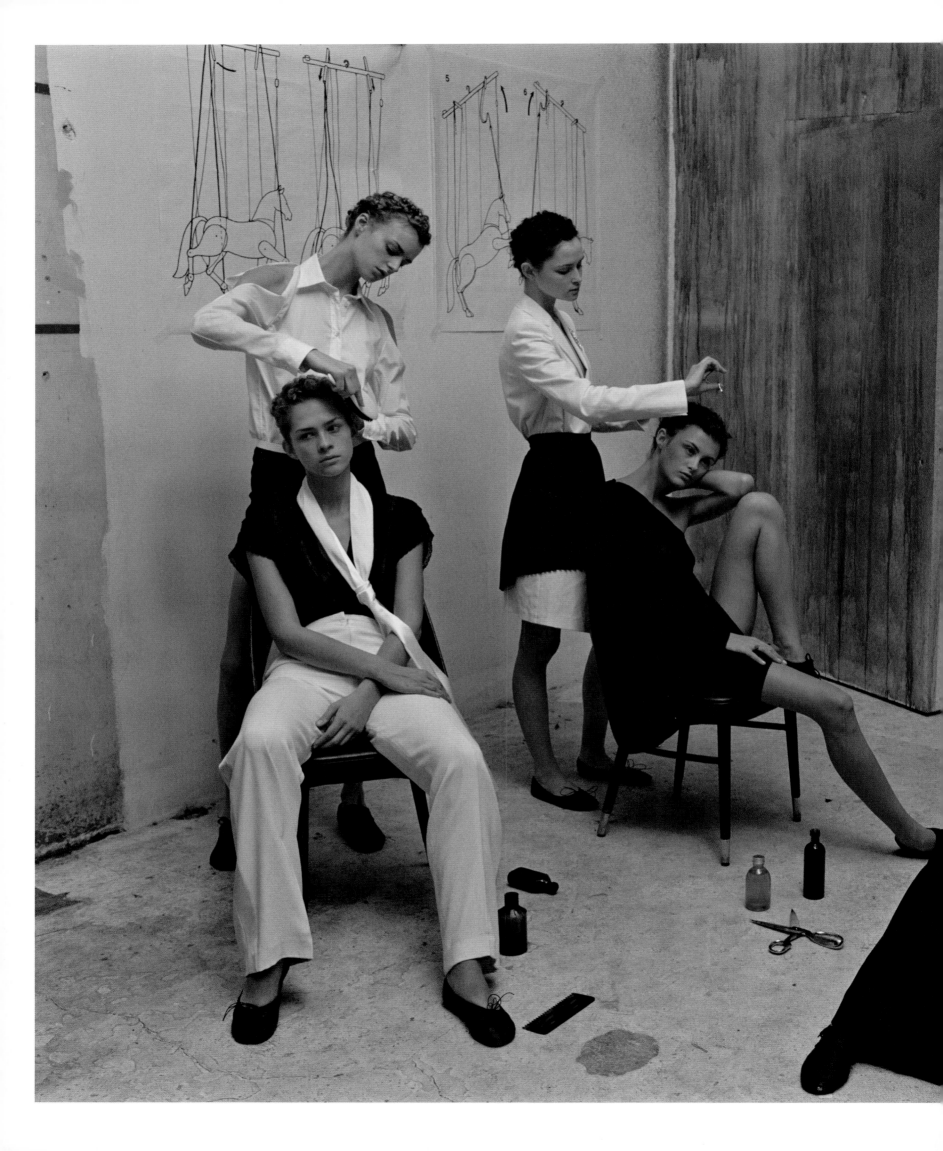

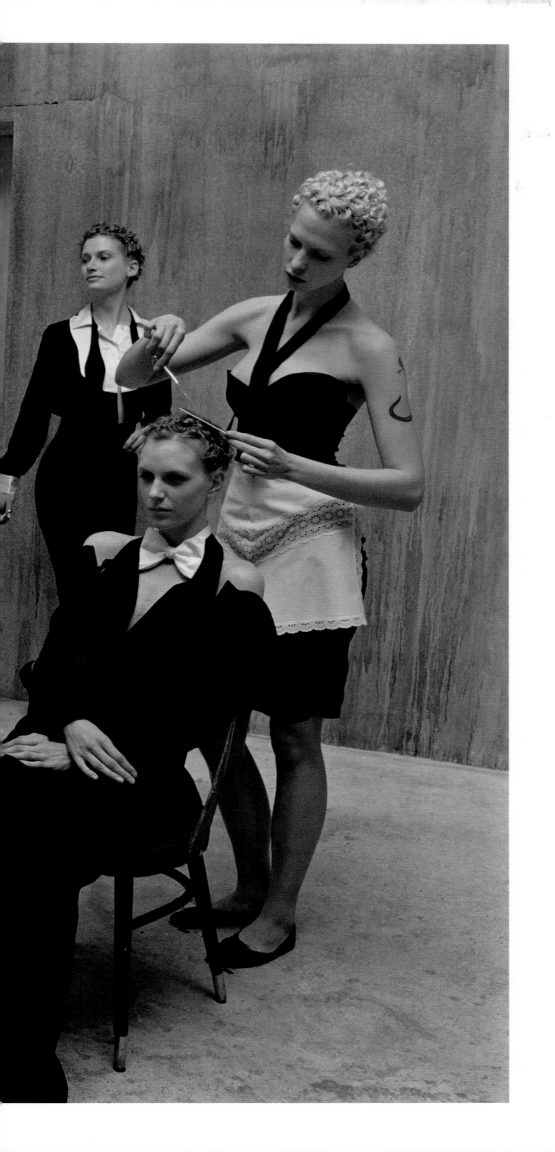

opposite
Hedi Slimane, *Los Angeles Times Magazine*, November 2008

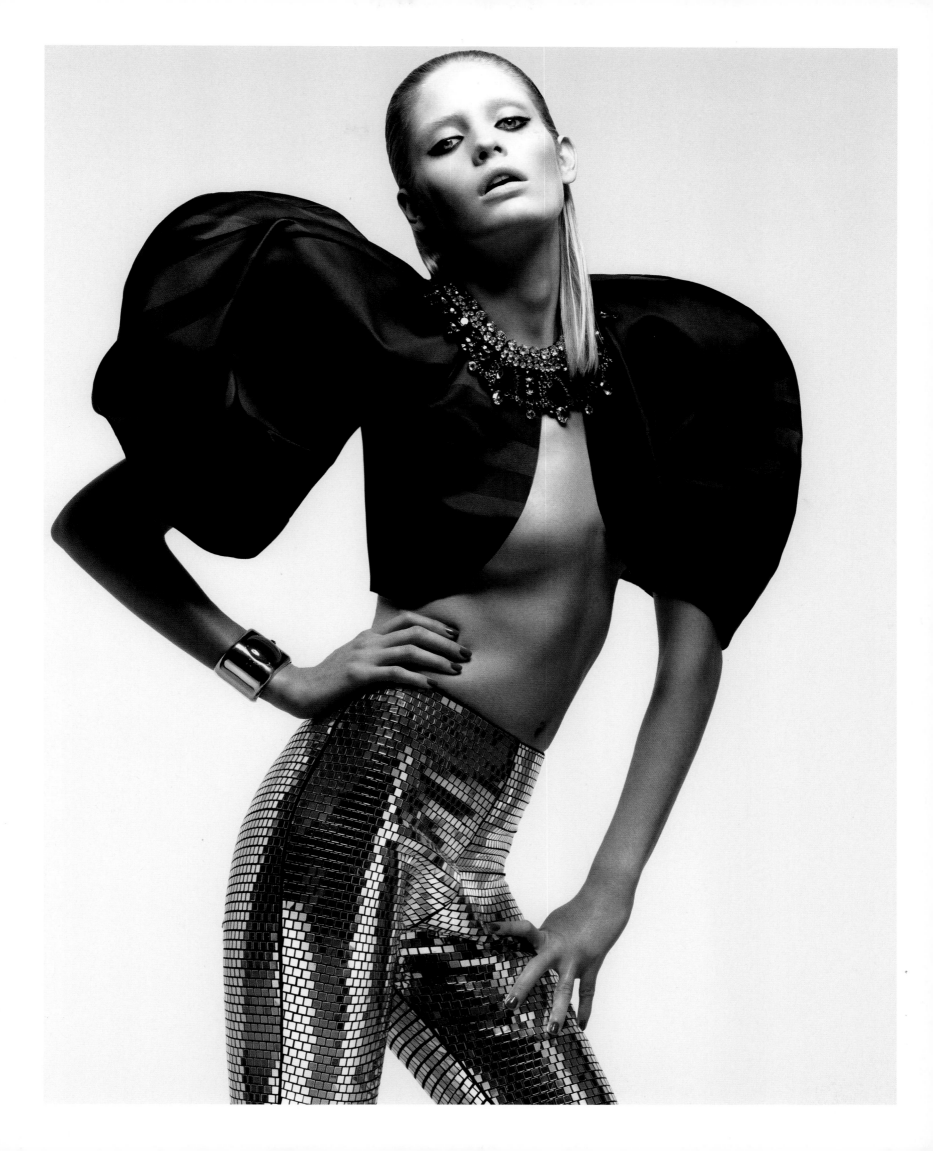

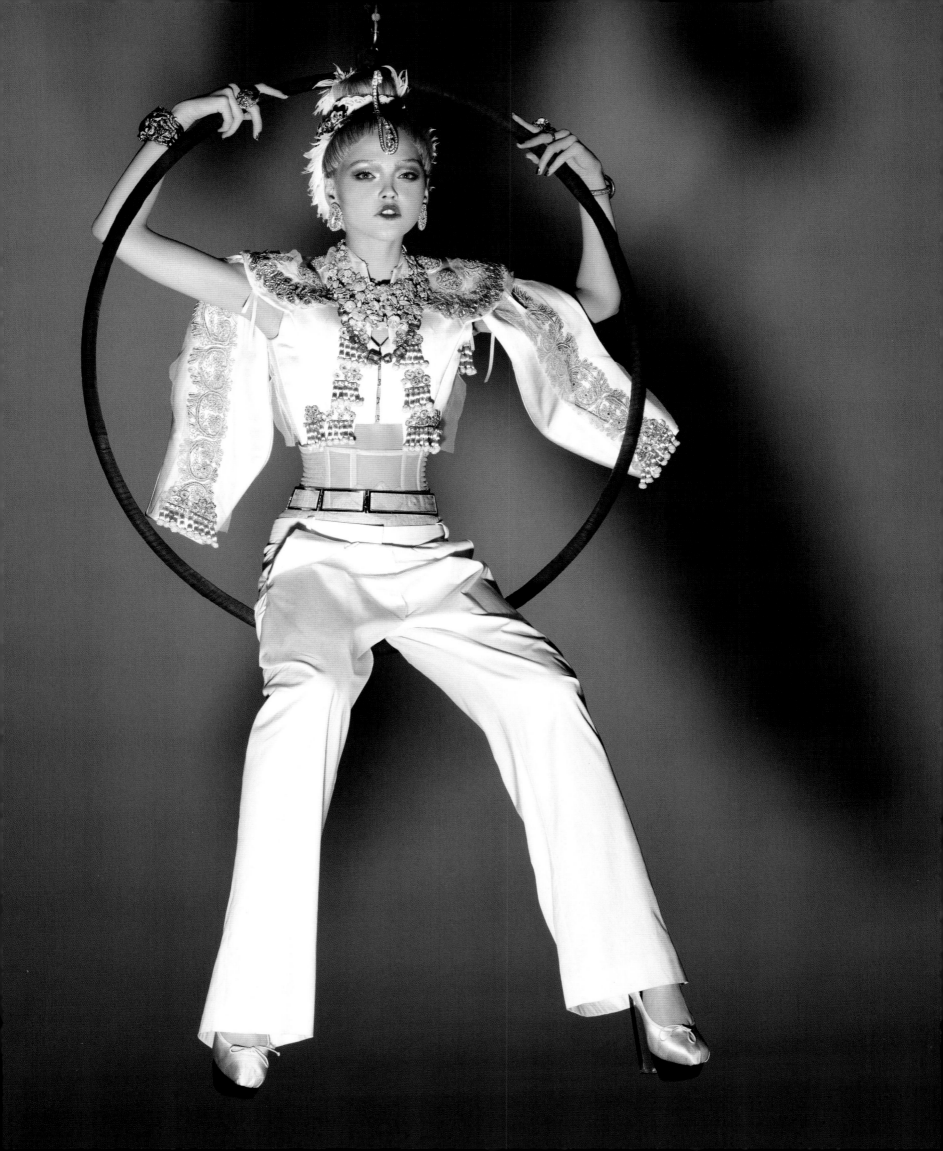

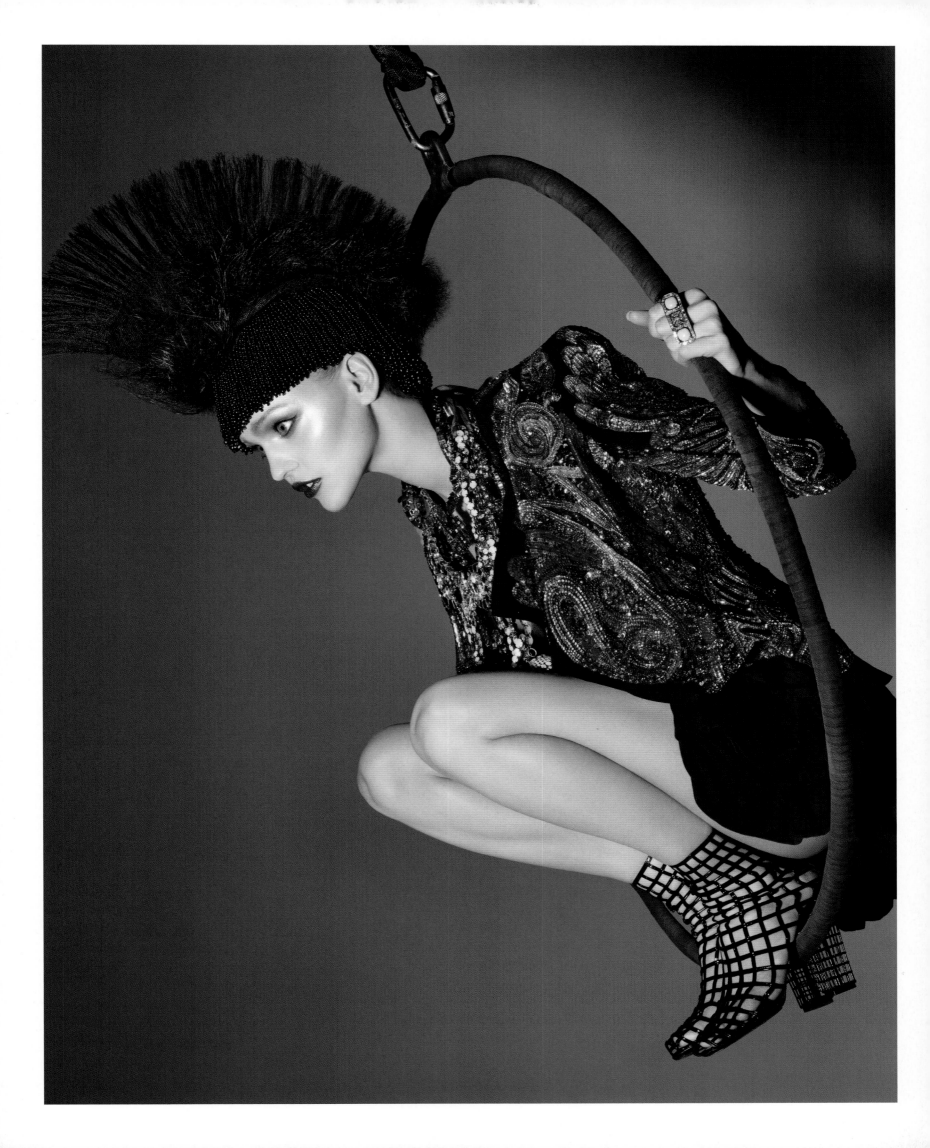

pages 150 – 151, 153
Sølve Sundsbø, *Los Angeles Times Magazine*, March 2009

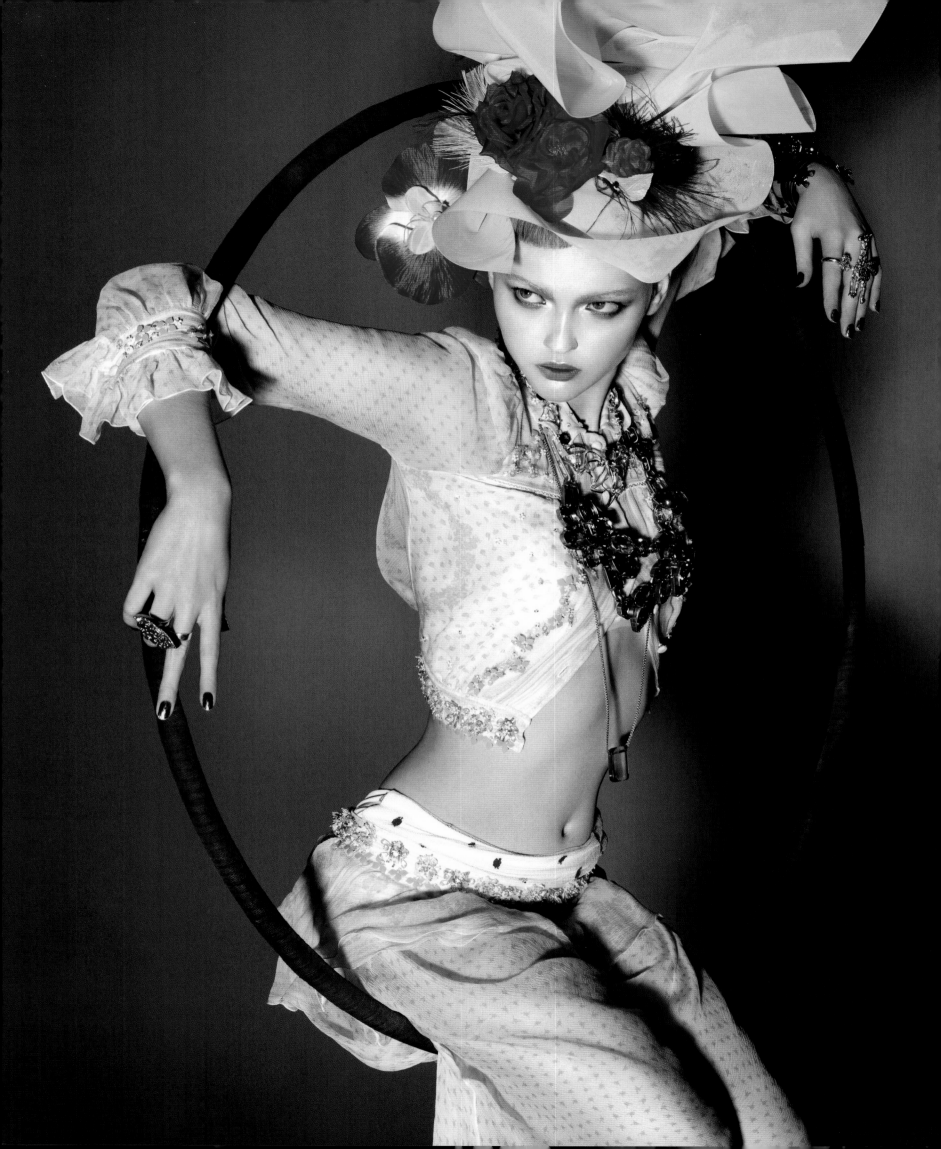

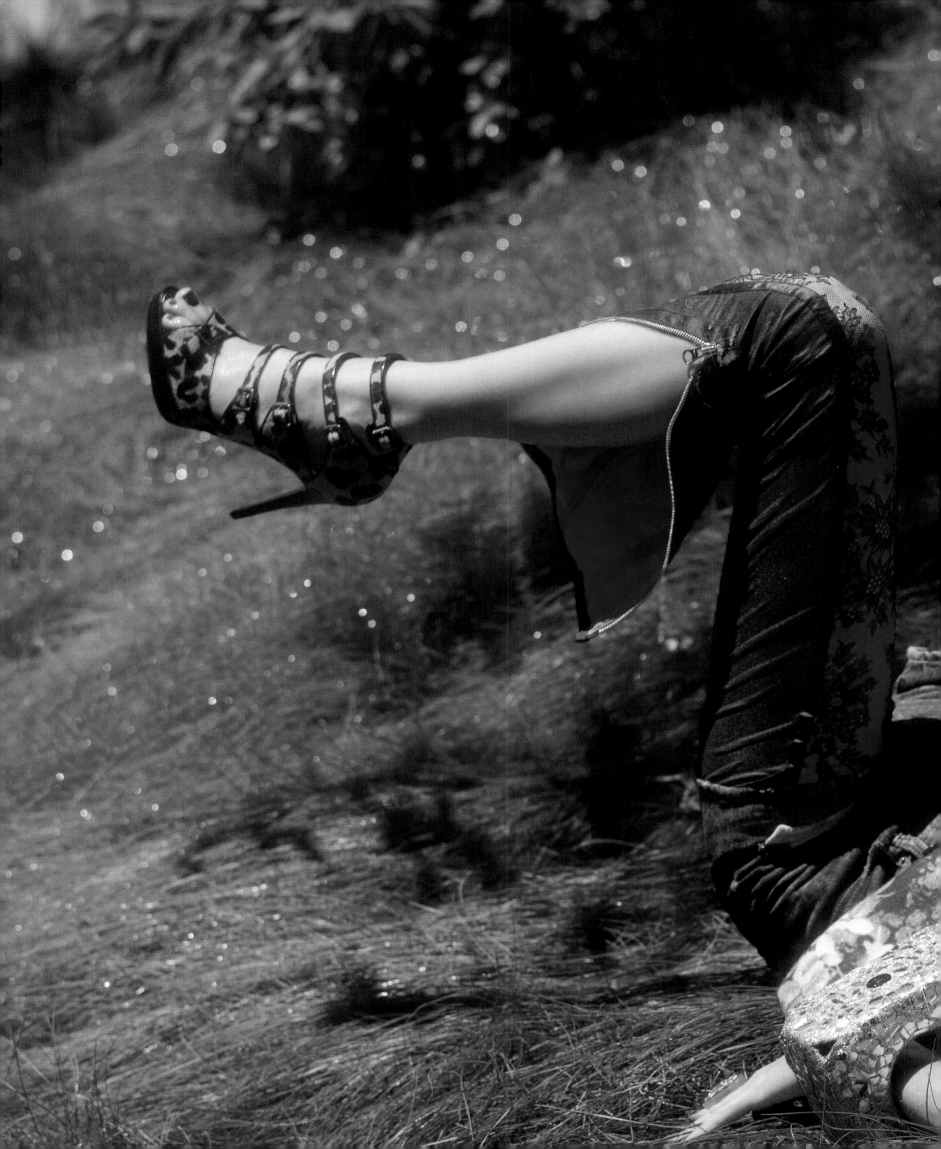

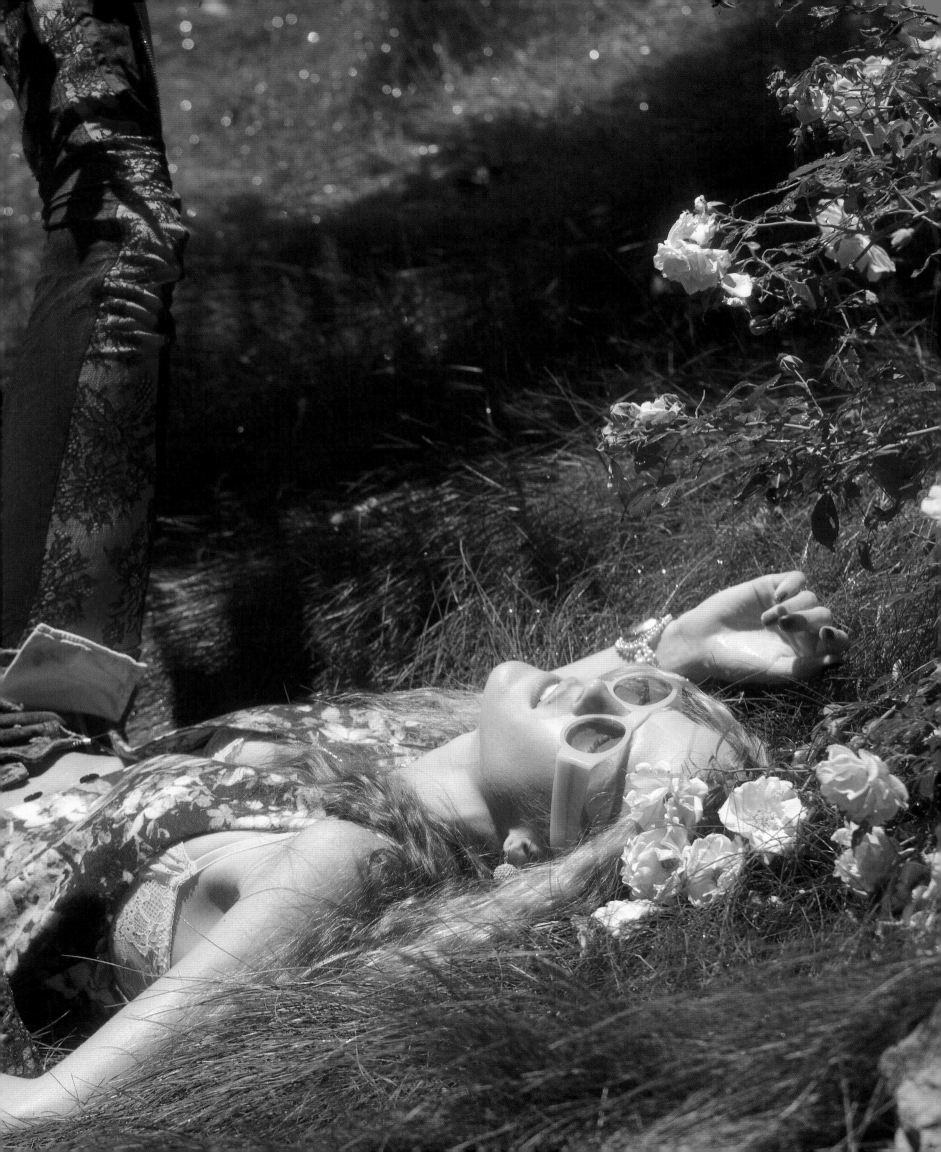

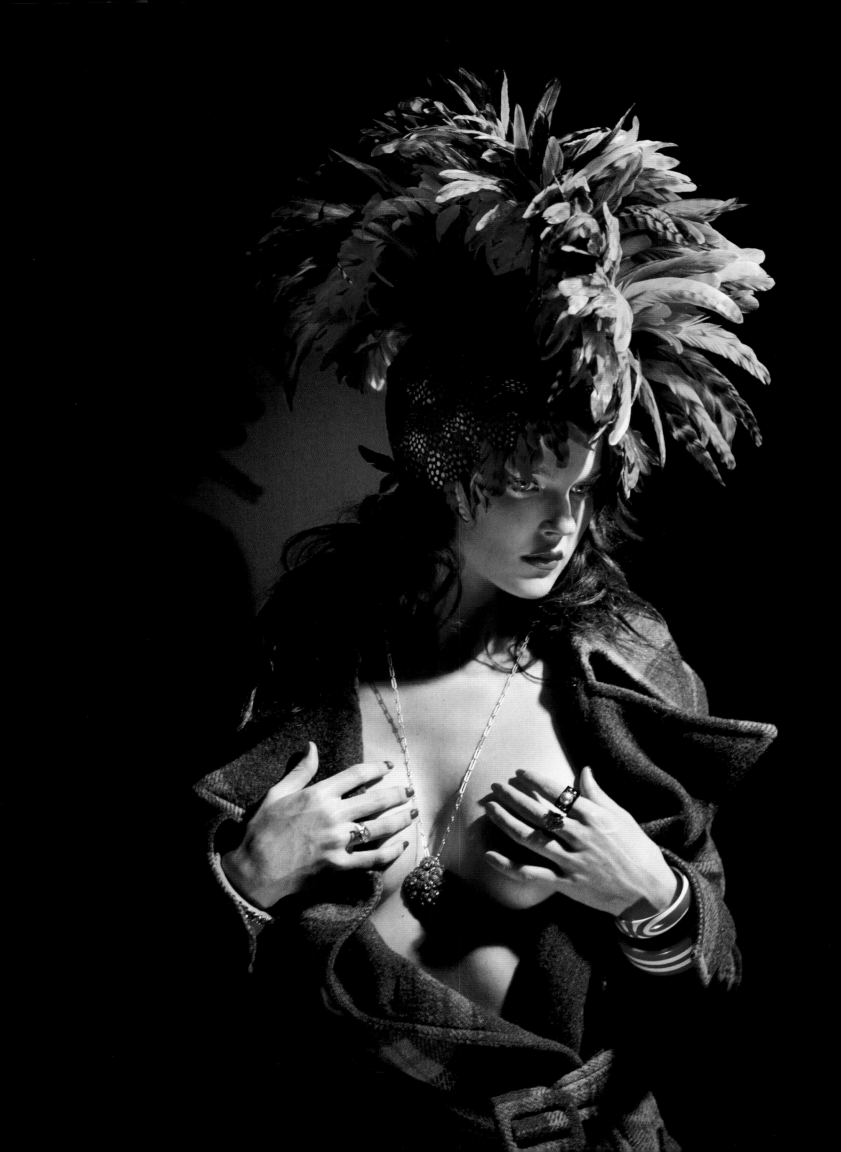

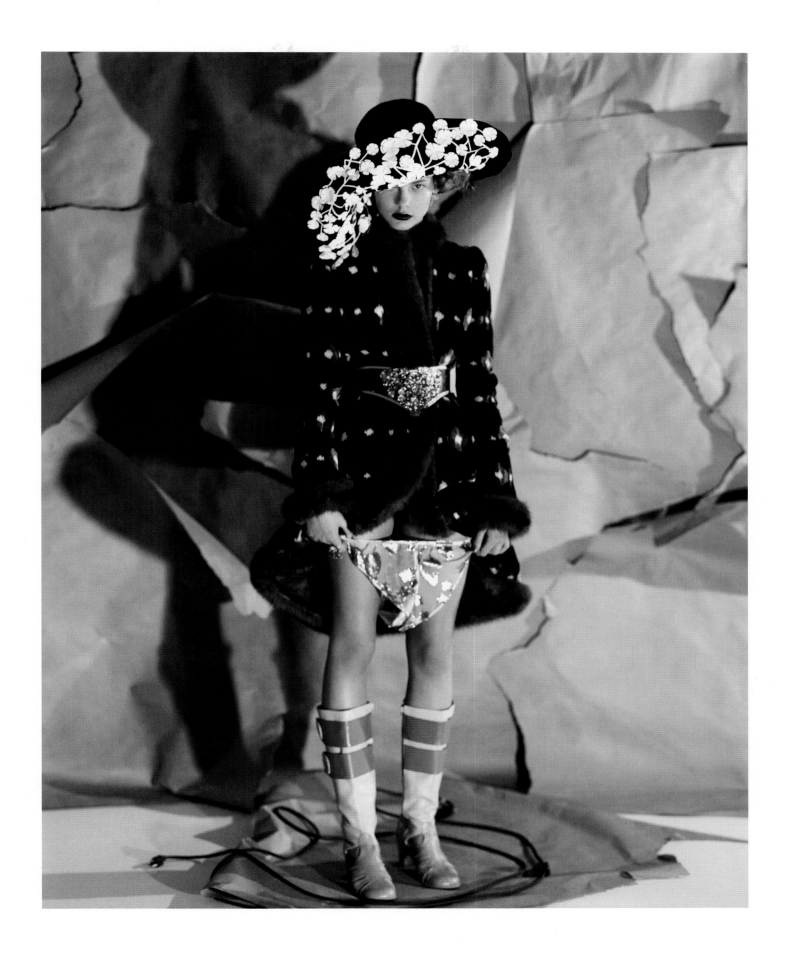

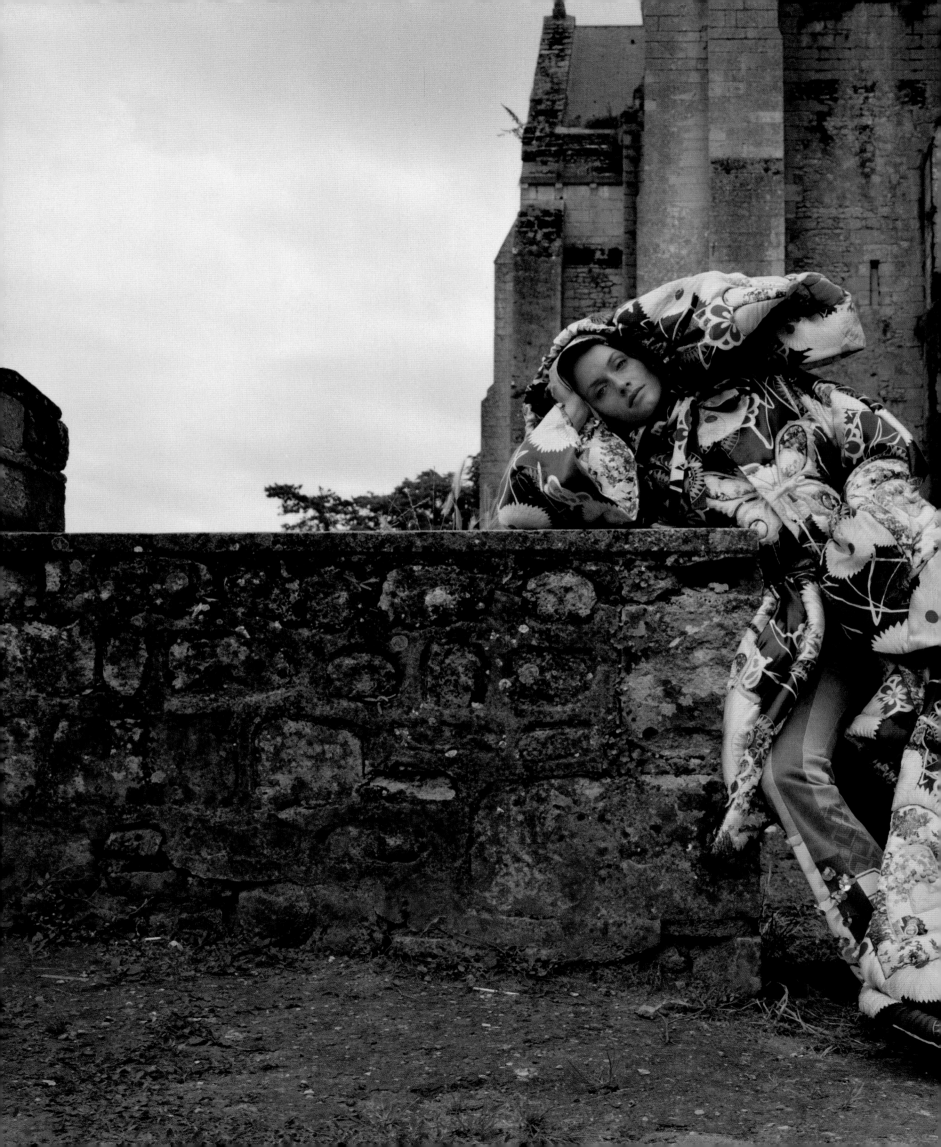

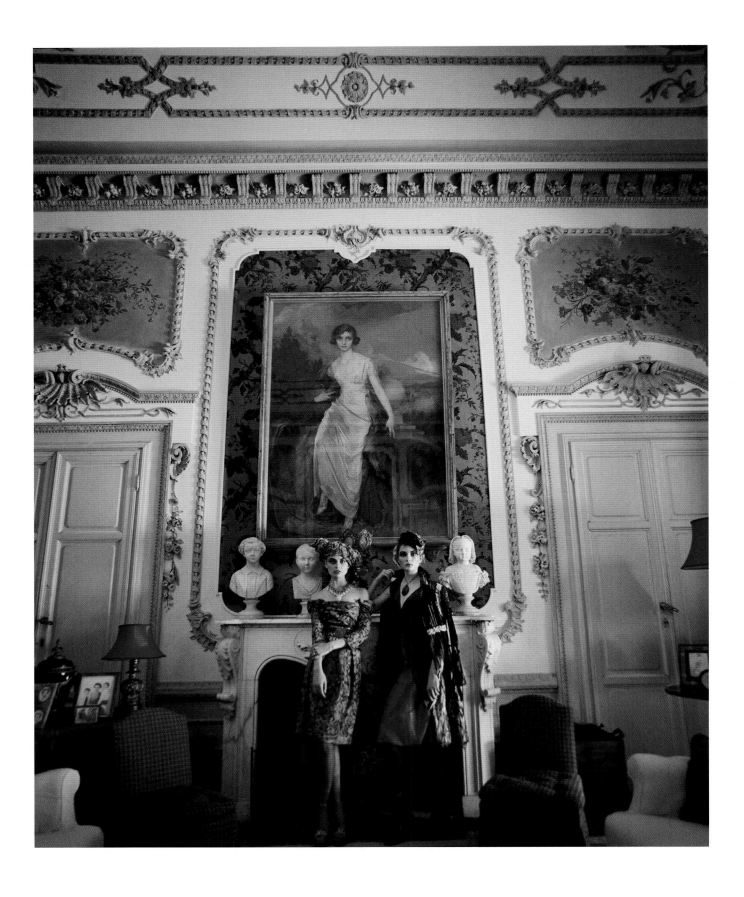

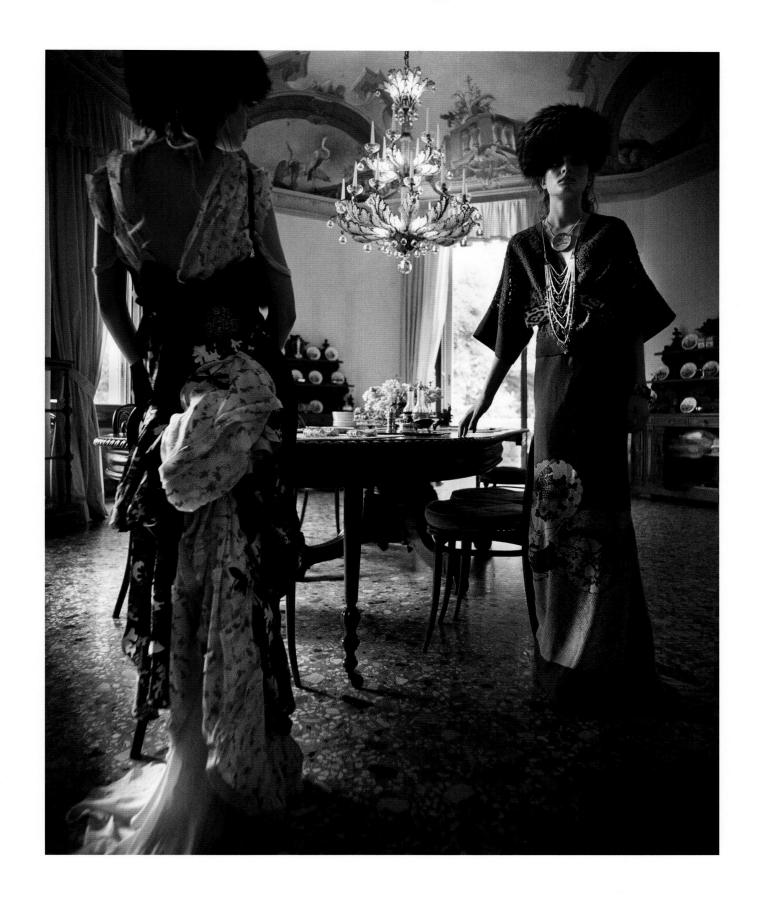

pages 158–159
Steven Meisel, Italian *Vogue*, September 2001

pages 160 – 161
Michael Thompson, *W*, September 2005

161

STYLES, LIKE EVERYTHING ELSE, CHANGES. STYLE DOESN'T.

—

LINDA ELLERBEE, *Move On*, 1991

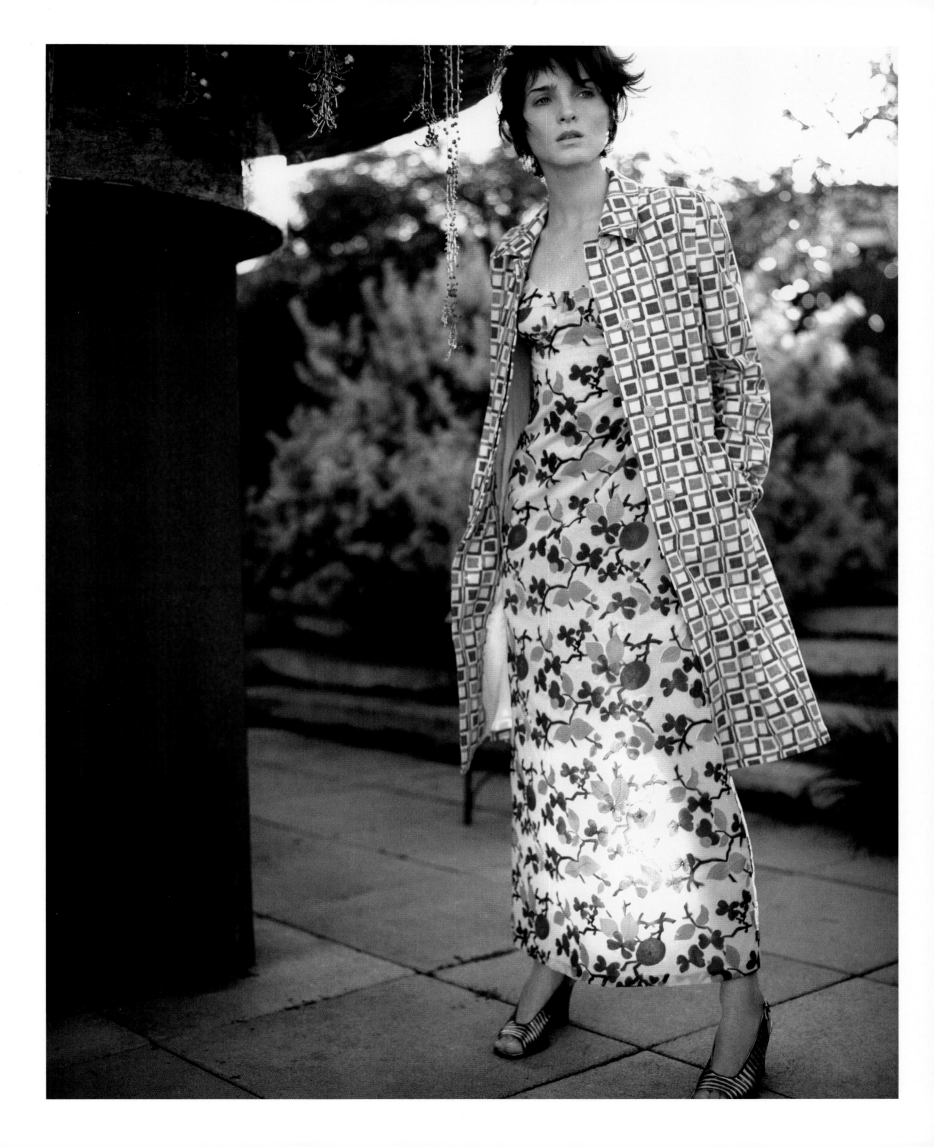

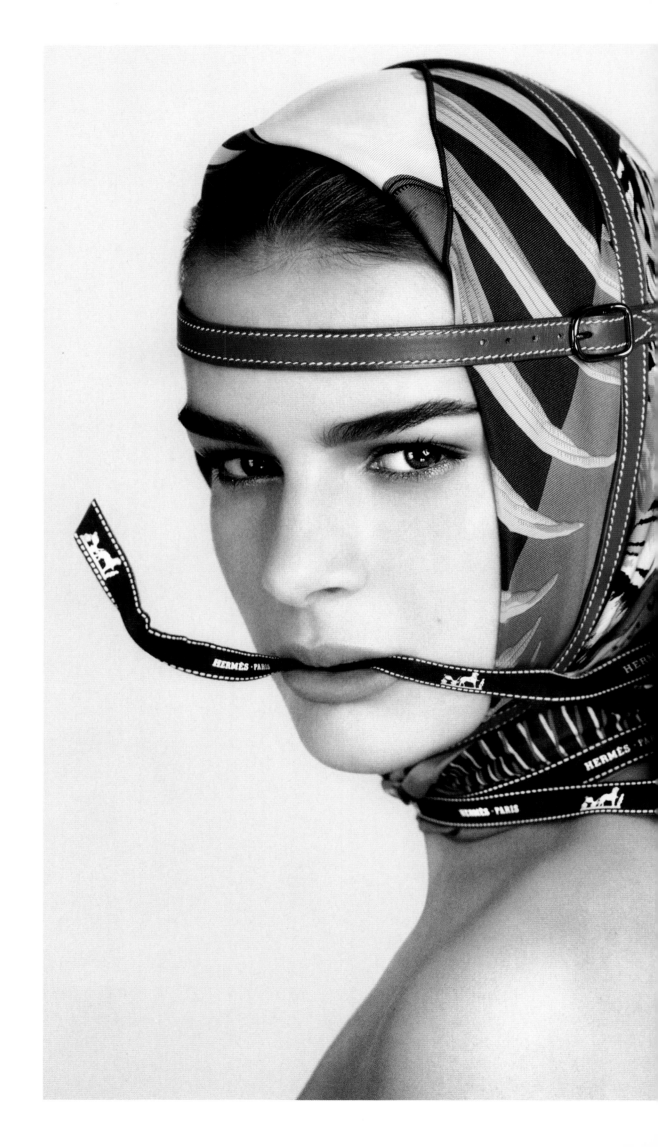

Richard Avedon, Hermès, Fall 2004

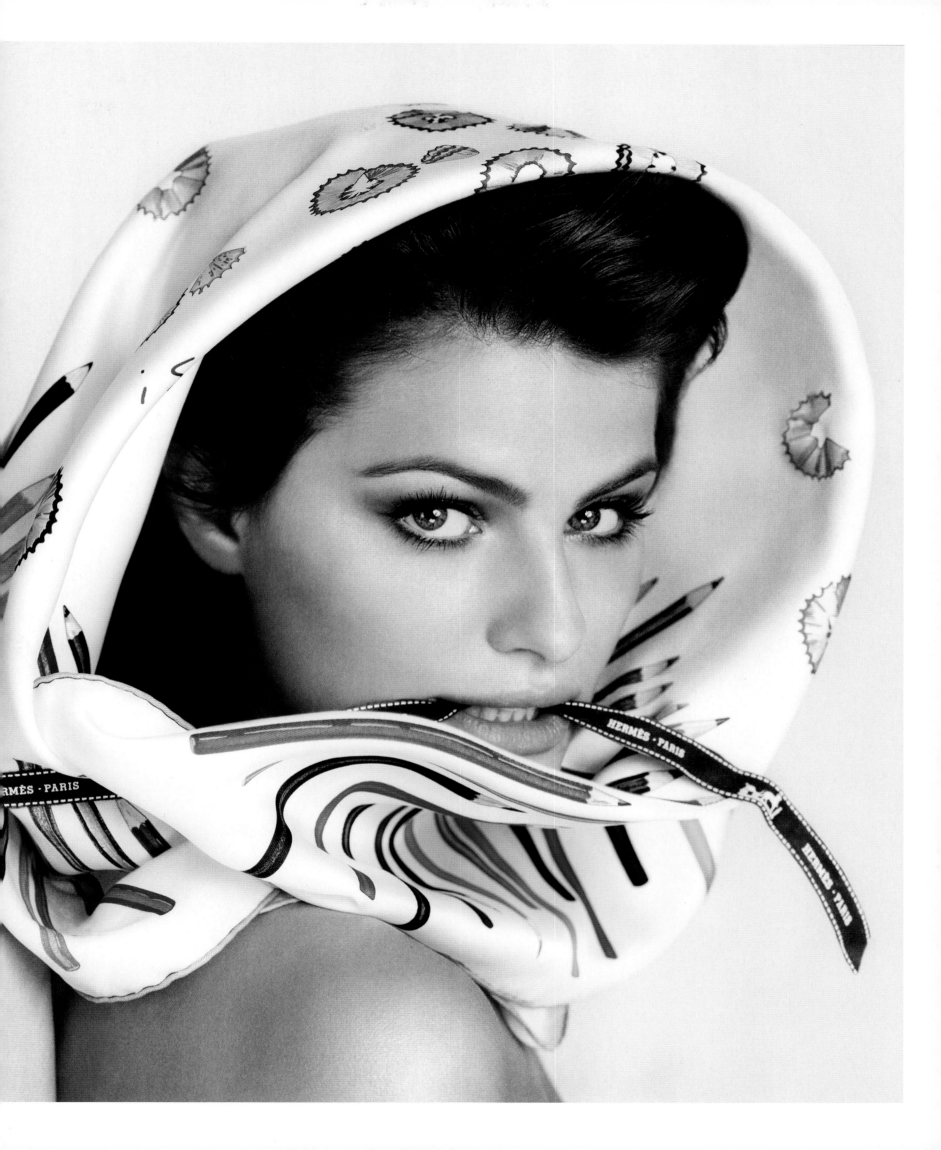

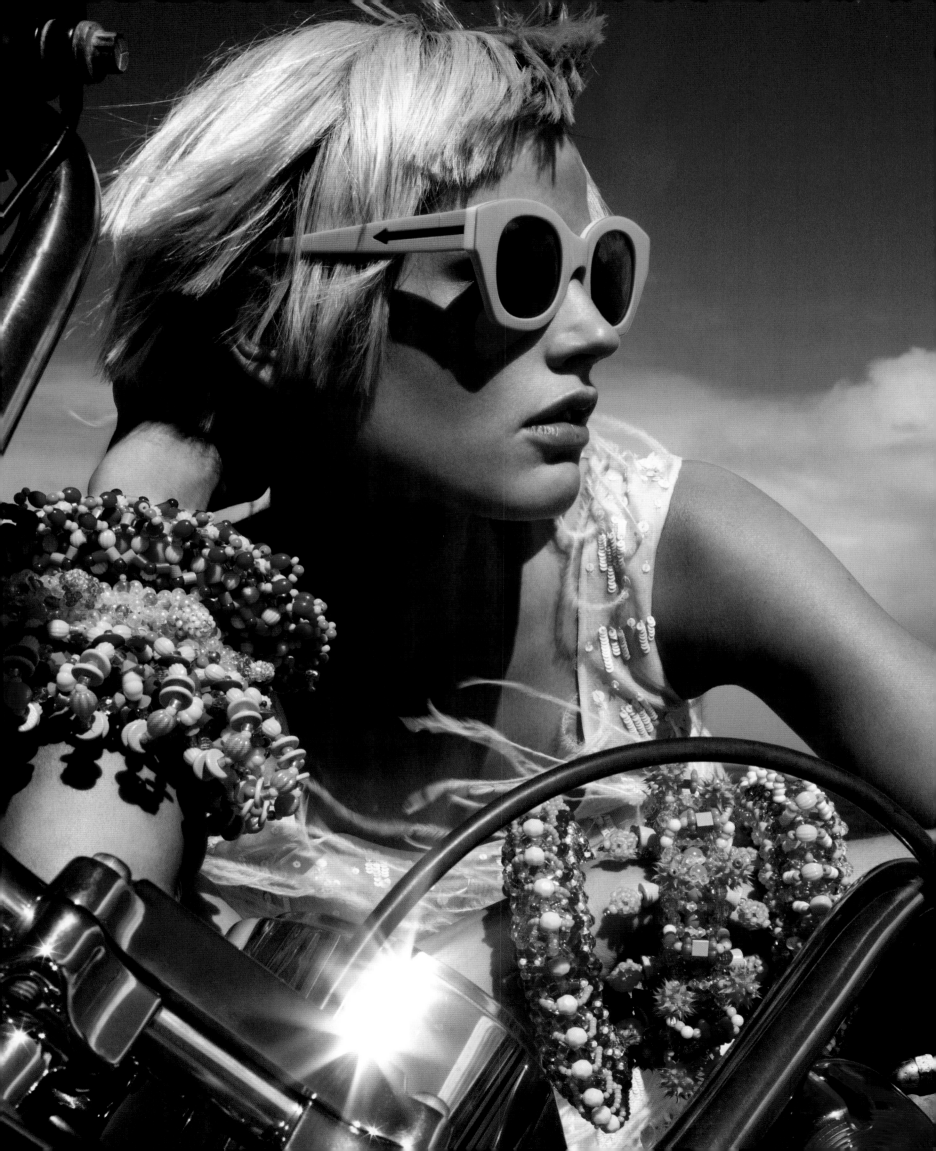

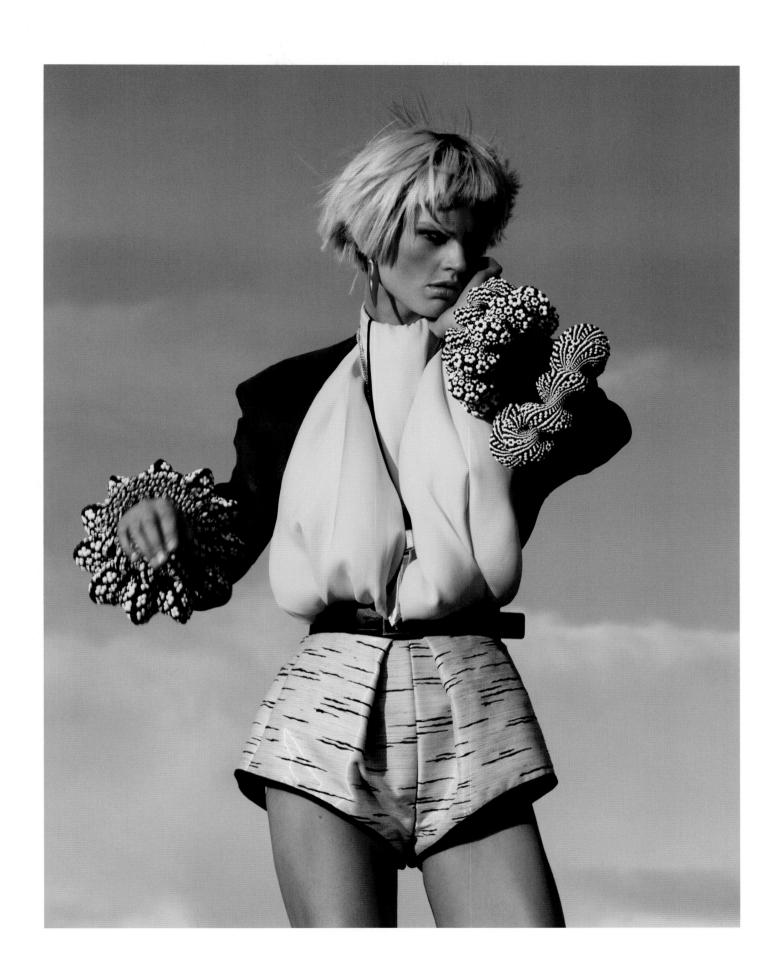

opposite
Mario Testino, *Allure*, January 1994

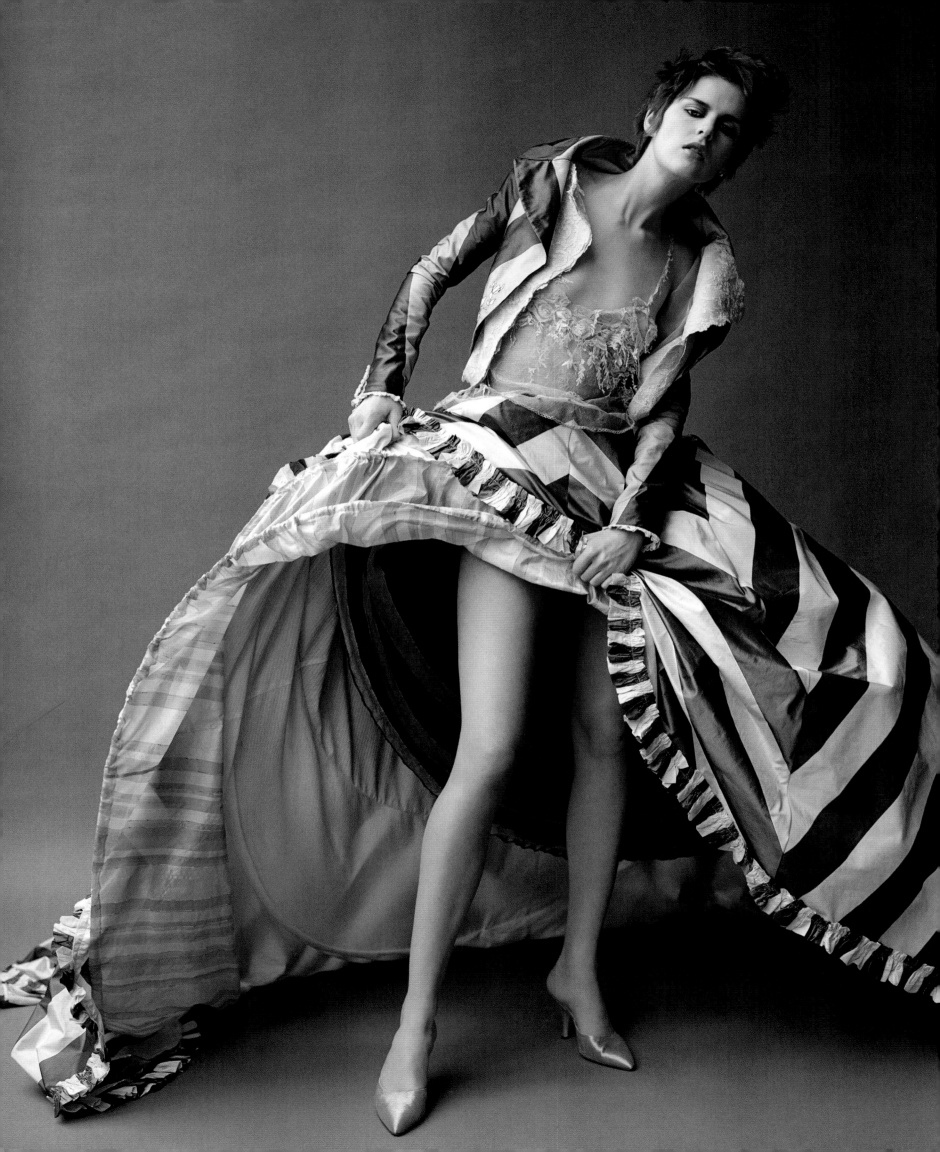

POP IMAGERY

is a mirror of our time, reflecting where we are as a global culture. These pictures reveal our collective dreams and ambitions, and remind us of who we were as individuals when we first encountered them.

I feel a special connection with the images in this chapter because they bring me back to the time when I helped create them. So much has to come together when shooting—who the subject is, what we're making the pictures for, the location, the time of day, the clothes, the movement—to get a sense of immediacy, the bang of capturing the final shot. Not surprisingly, this is more challenging with people who live their lives in the public eye.

The true job of a stylist is to understand the context in which the clothing is being worn and in which the star is being portrayed to communicate a range of feelings, a sensibility, a mood. Part of the work is knowing how to push a subject who is holding back, no matter how famous they are. You have to smooth over the "I can'ts," get the publicist out of the room, and start working your magic. I love encouraging people to leap out of their comfort zones. The second a "no" is in the air, the challenge is on. Turning the no into the yes is how memorable photographs are made.

These images are pop culture. They are transformation. You see the faces, you know them, and then you look again. Someone familiar has become someone new, somone imagined, someone extraordinary. Whether a subject is playing a role or playing him- or herself, so many things come together in these pictures: presence and individuality; timeliness and timelessness; a world of dreams; a world of desire. Each is a universe all its own, fixed in an image.

opposite
Herb Ritts, *Vanity Fair*, April 1997, Madonna

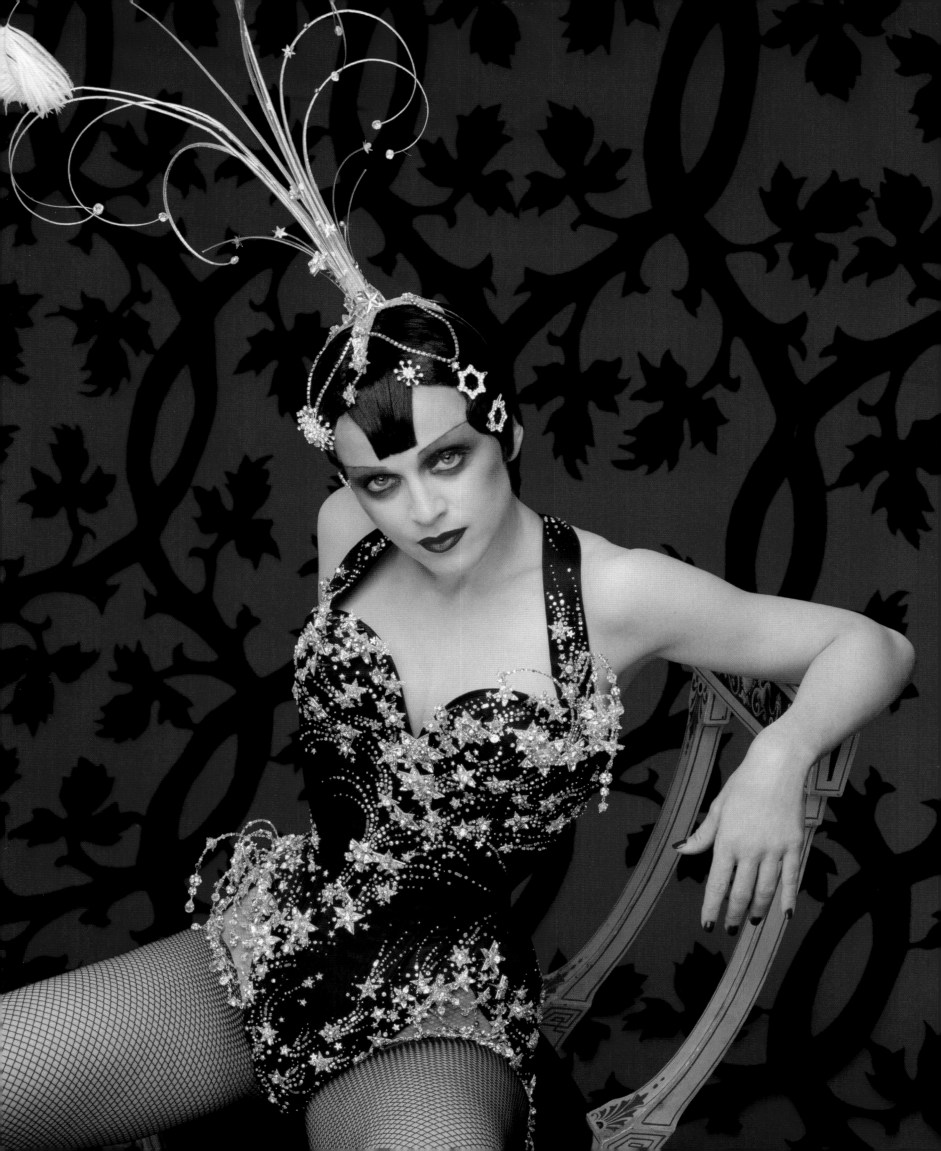

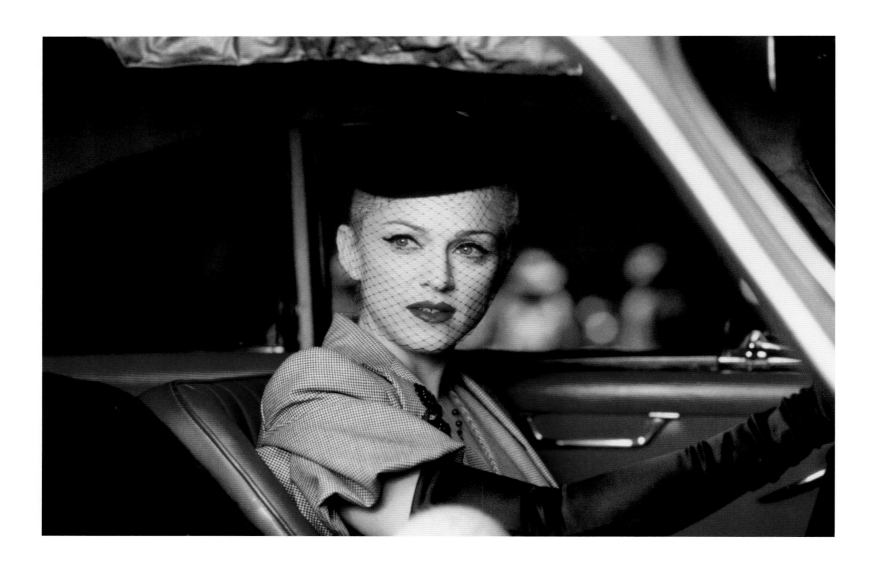

The first time I met Madonna was during fashion week in Paris in fall 1994, just before we were going to go to Spain to shoot the video for her song, "Take a Bow." We went to John Galliano's show at Dior together. The collection was full of these extremely feminine, 1940s-inspired dresses that were body-conscious and sexy, yet very elegant. Madonna and I knew they were perfect for the character we were creating for her—sophisticated and radiating Old World glamour. We were given access to the entire collection, and went through rack upon rack, pulling clothes. Except for the lingerie by Sabbia Rosa and the hats by Tracy Watts, everything Madonna wore in the video was Galliano.

"Take a Bow" turned out tremendously. It has a beautiful film quality. Madonna's character is so gorgeous; that look marked a real turning point in her image: suddenly, everybody perceived her as glamorous, ladylike, womanly. The video was a defining moment for me, too, because I had never really worked on a project of that scale and visibility. In just five minutes and twenty seconds, I had helped create a totally new image for one of the world's biggest pop stars.

VH1 gave me the Fashion and Music award for best stylist for a music video for my work in "Take a Bow." That was the first time I had ever spoken in public to a large audience. All I said was "Thank you very much." I don't think the microphone was even on for half of my acceptance speech.

opposite
Michael Haussman (director), "Take a Bow" music video, 1994, Madonna

TALENT IS LIKE ELECTRICITY. WE DON'T UNDERSTAND ELECTRICITY. WE USE IT.

———

MAYA ANGELOU, from *Black Women Writers at Work,* by Claudia Tate, 1984

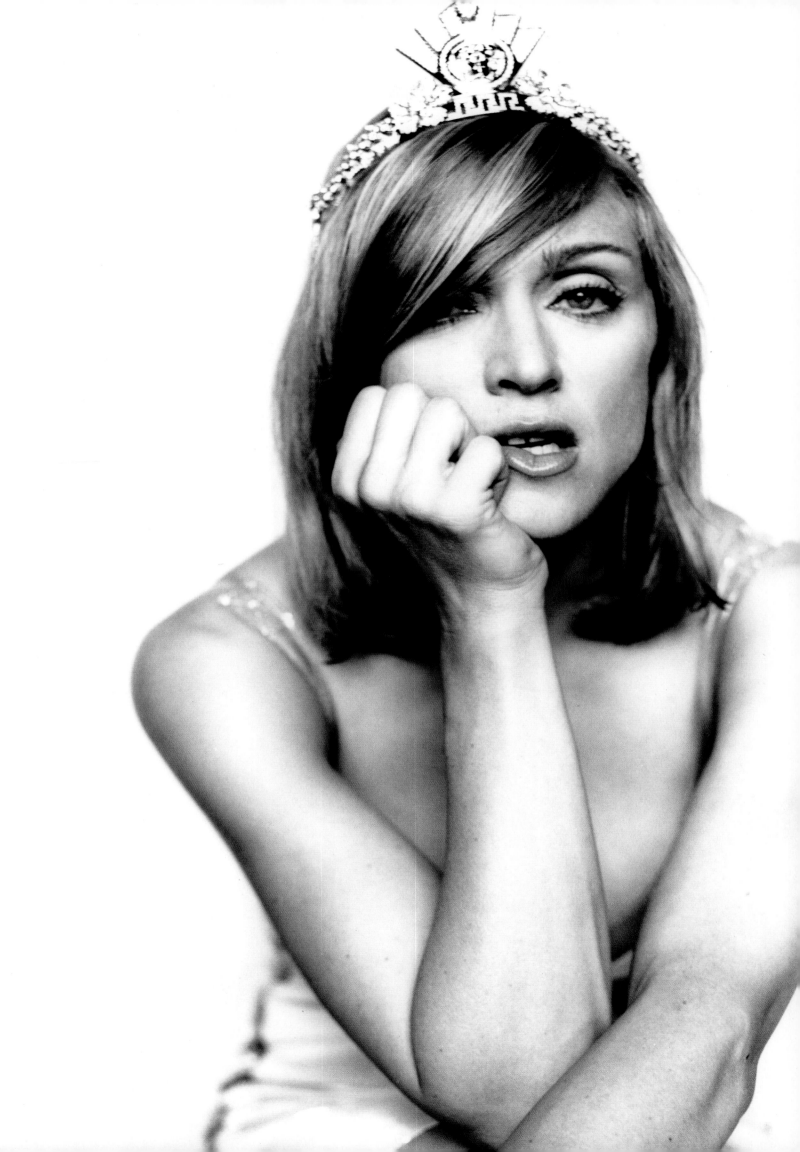

opposite
Mario Testino, *Vanity Fair,* November 1996, Madonna

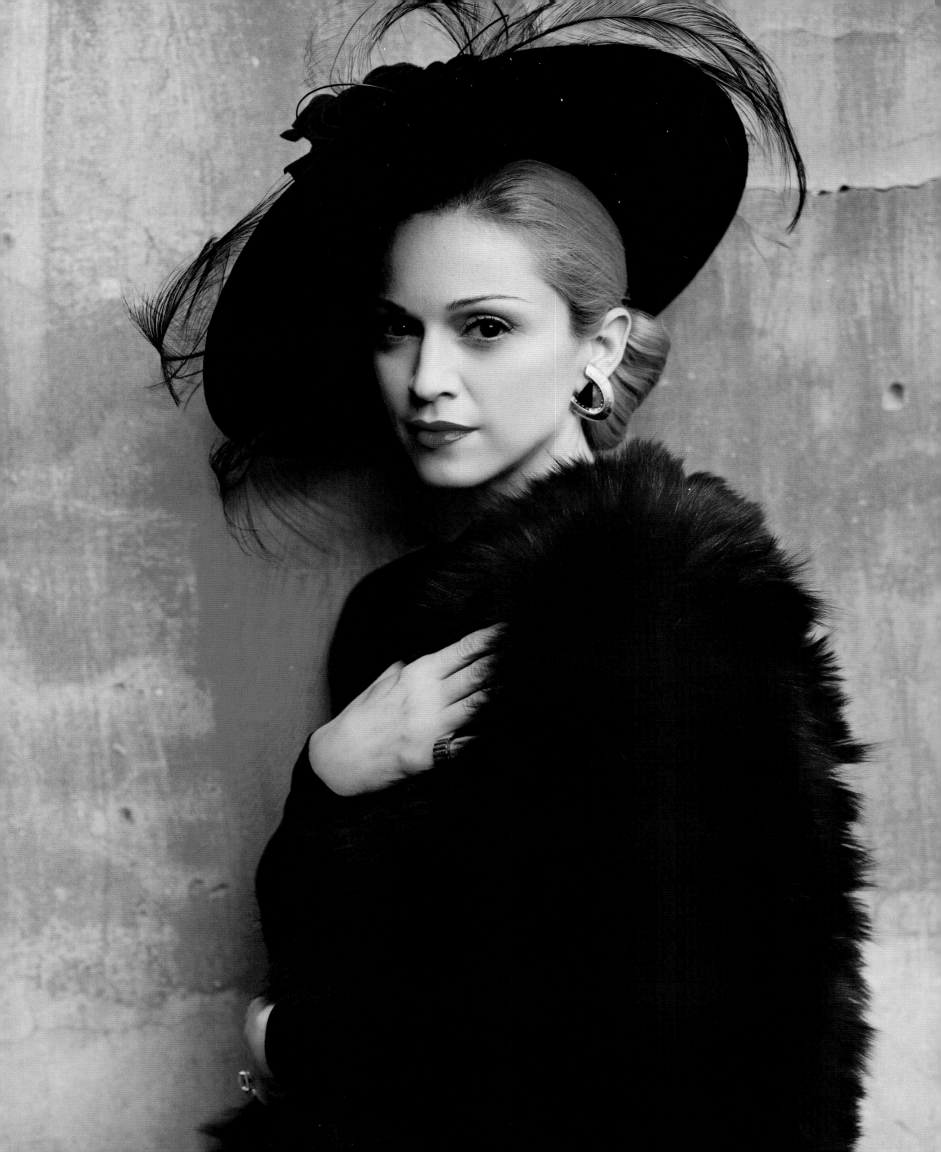

ADVERTISERS ARE THE INTERPRETERS OF OUR DREAMS.

—

E.B. WHITE, *Writings from* The New Yorker, *1927–1976,* 2006

This Gap print campaign launched in 1989, marking the beginning of how and when the world of mass marketing began to take its hold on fashion. The Gap had established itself as the wardrobe choice at the time, so adding to its own iconography with the allure of celebrity was the natural next step. This campaign was the first to use famous people embracing a huge brand on a massive scale. Before the Gap series ran, celebrities and artists didn't want to do endorsements that were so blatant, so it was a real challenge to get the right people—recognizable, cool, yet nonchalant—to agree to participate in advertising campaigns.

One reason the Gap series worked so well was the photographer herself: Annie Leibovitz took the portraits. Through the styling, I sought to bring these famous faces into an everyday reality. I worked with Annie to create a convincing intimacy between the talent and the clothes that would expand the Gap's "every person" sensibility into something seemingly more enticing, more covetable. I styled all the clothes so they would appear casual, as if they had been worn by ordinary people. In fact, I remember being at the laundromat at 2:00 AM, washing the T-shirts repeatedly so that they would look lived in. I used everything that was available at the Gap, too, including the children's clothes. The idea was to style everything with a sense of individuality—and to send the message that the clothes were something everyone could make their own. This was, I think, the Gap's intention: to be the great equalizer.

When I look back at these images, they are so much more than a fashion advertising campaign—they're a portrait of a cultural aesthetic of an era.

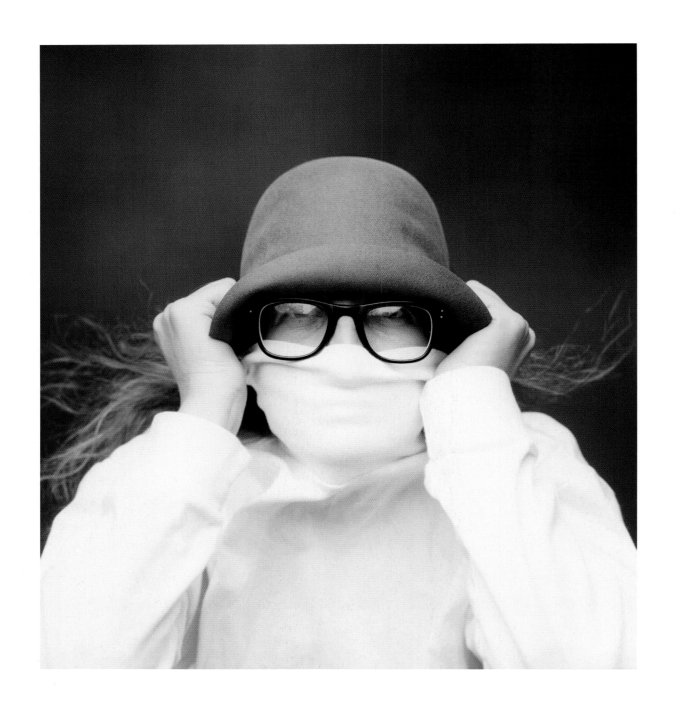

above
Annie Leibovitz, Gap campaign, 1990, self-portrait

opposite
Annie Leibovitz, Gap campaign, 1990, Steven Meisel

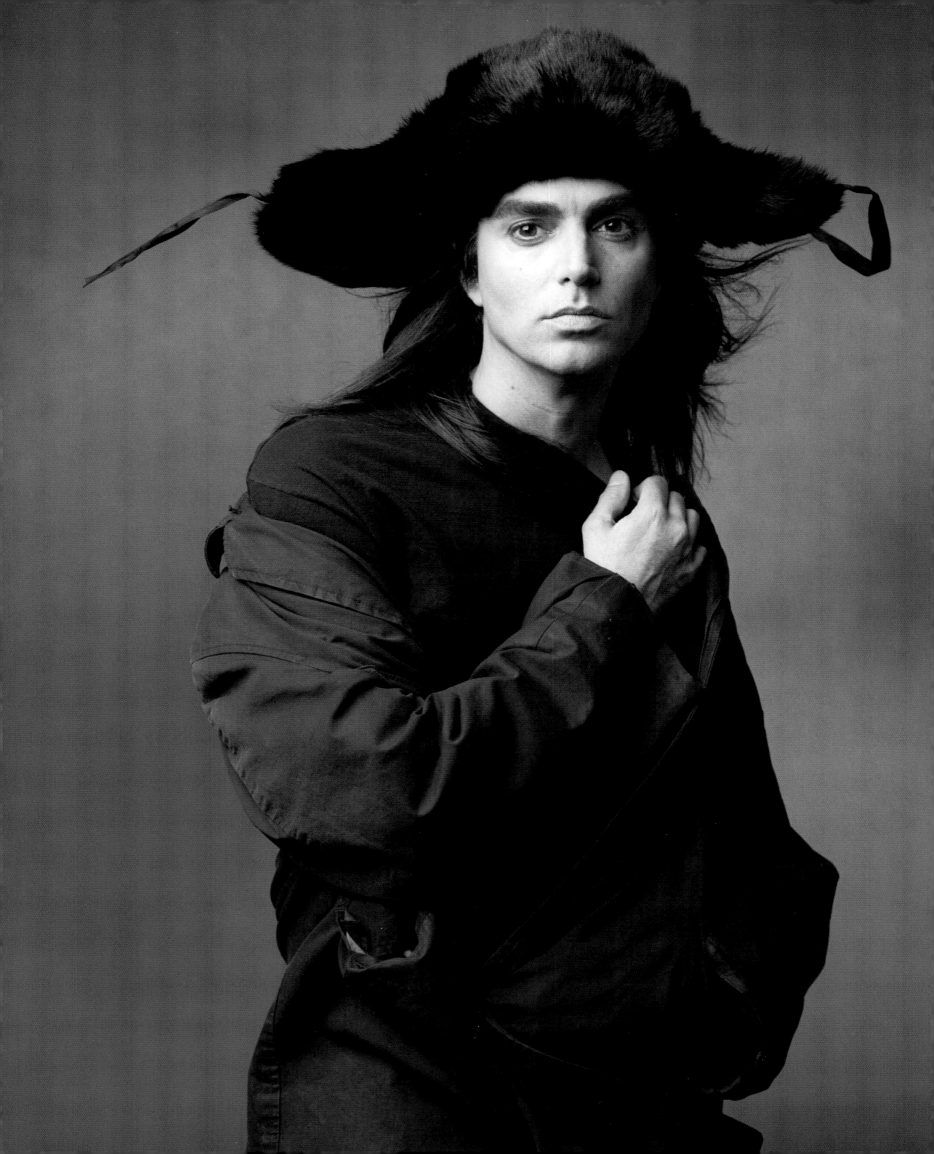

IN A GENTLE WAY YOU CAN SHAKE THE WORLD.

MAHATMA GANDHI, from *Seasons of Flowers*, by Wilbur Thornton, 2009

We shot Octavia Spencer for *W* right before she won the Academy Award for Best Supporting Actress in *The Help*. Before we met Octavia, her publicist sent numerous notes in which she listed all the things the actress might not be comfortable wearing for the shoot.

I always answered the publicist by reassuring her that I would never ask anyone to do anything he or she didn't want to do. And I would have a million things for Octavia to try.

What people often don't understand is that I always gather and prepare a selection of clothes for them. I never just show up with one dress and say, "This is what you have to wear." Image making is a collaboration, and every idea can easily evolve into another.

Octavia loved the look we created for her. She loved it so much, she really owned it—and you can see that in the pictures. At the end of the shoot, she cried and said, "I've never felt so beautiful in my life." I was thrilled that she was so happy. At times like that, I really feel like I've done my job.

Mario Sorrenti, *W*, February 2012, Octavia Spencer

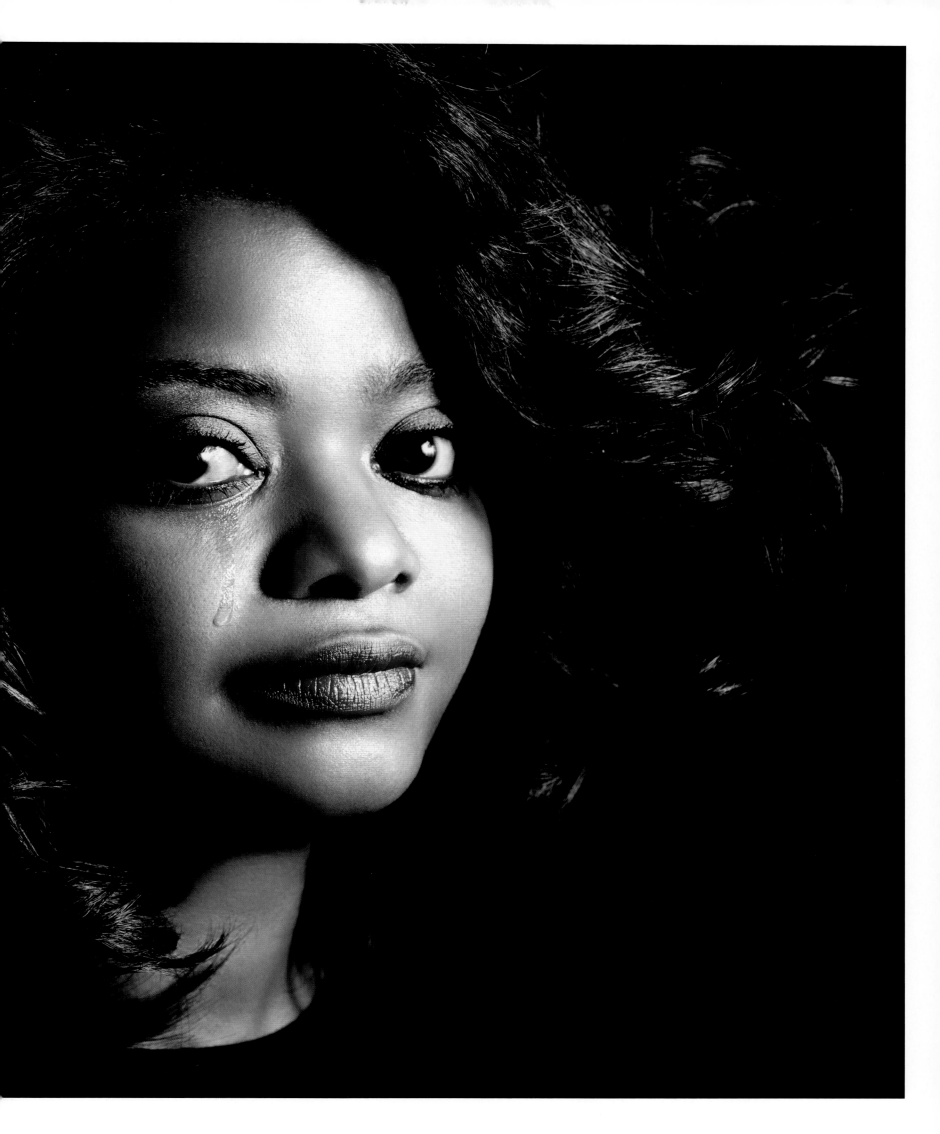

CULTURE IS WORTH A LITTLE RISK.

———

NORMAN MAILER, from *The Poetic License to Kill,* by Lance Morrow, 1982

A portrait is less about styling, more about transformation. Every element I add or take away is a layer that shows you what is really there, letting the character emerge fully formed.

I had this image in my mind before we shot it. I could see it framed perfectly while we were coming up with the concept; I wanted Elizabeth Olsen to look as if she had slipped into someone else's skin, not like an actress wearing a silk slip. This was the second time I had worked with Lizzie, and I knew that she could take risks that would intimidate a lot of other young actresses. She dives in. And she isn't afraid to have her photograph taken.

When she came to the set, and Mario and I explained to her what we were thinking about doing, I could see her begin to consider the nuances that would help her become that character. And she did a tremendous job. She just became Liz Taylor playing Maggie from *Cat on a Hot Tin Roof*.

opposite
Mario Sorrenti, *W*, February 2012, Elizabeth Olsen

pages 194 – 195
Mario Sorrenti, *Los Angeles Times Magazine,* February 2009, Anne Hathaway

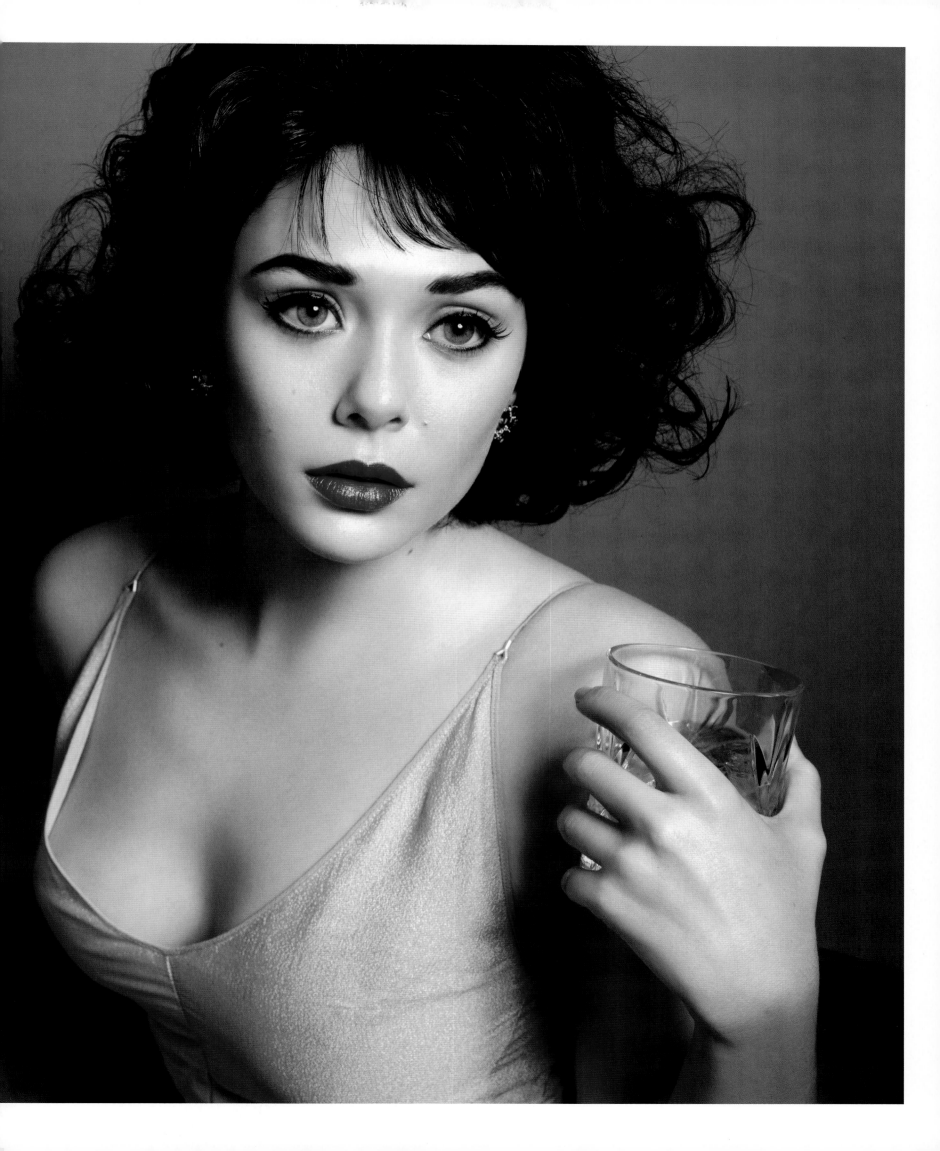

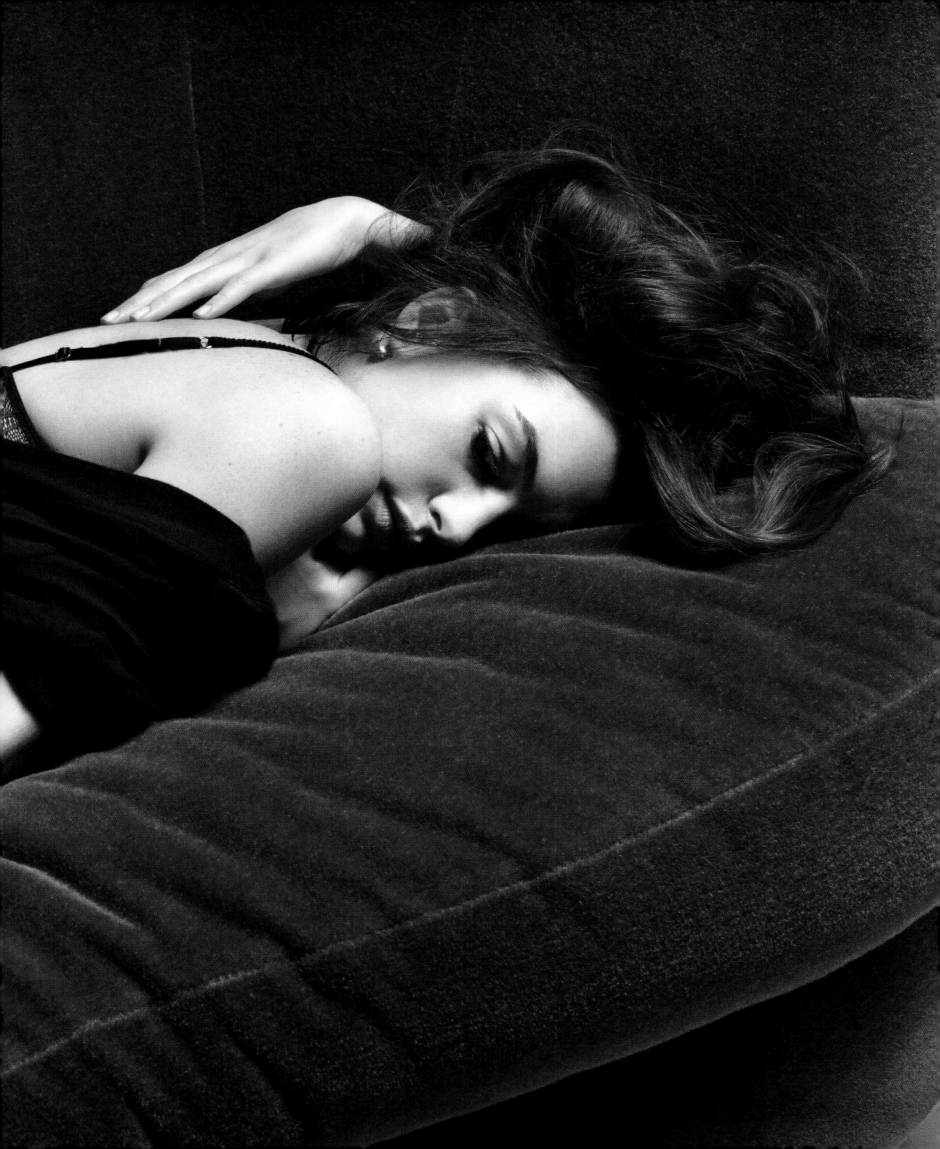

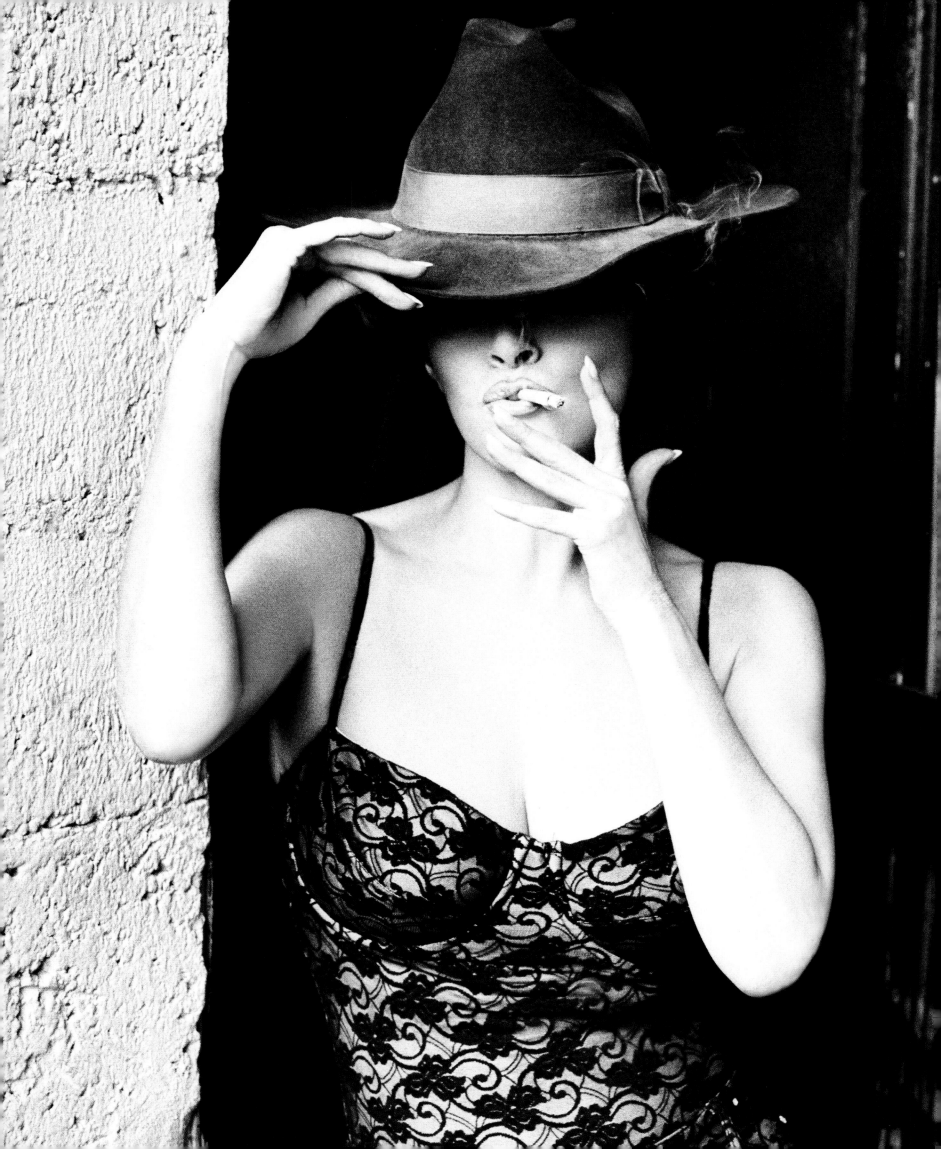

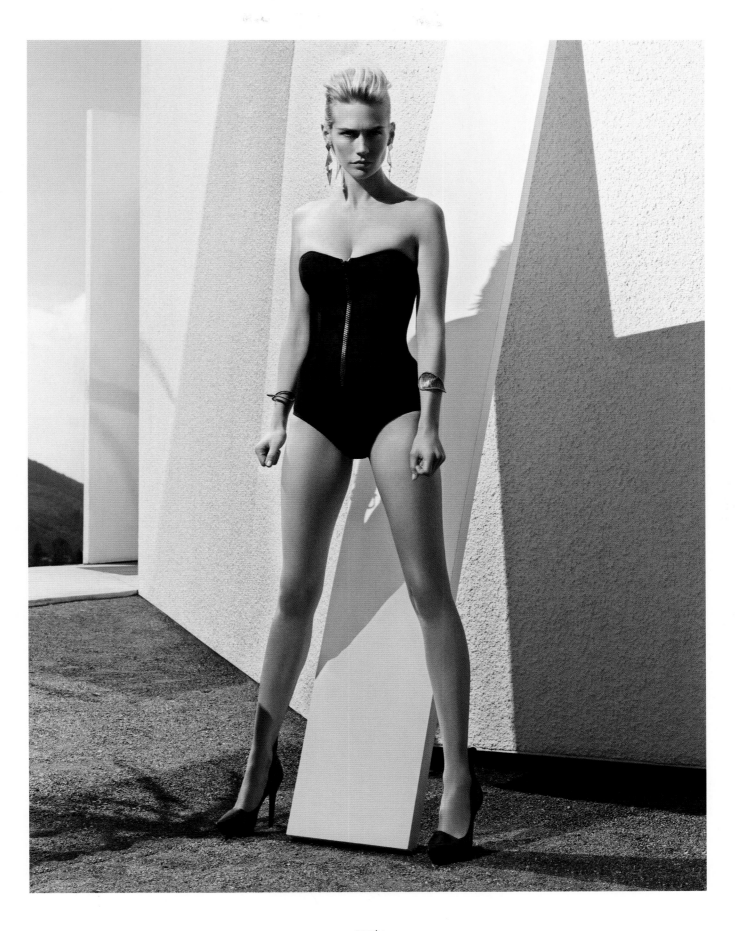

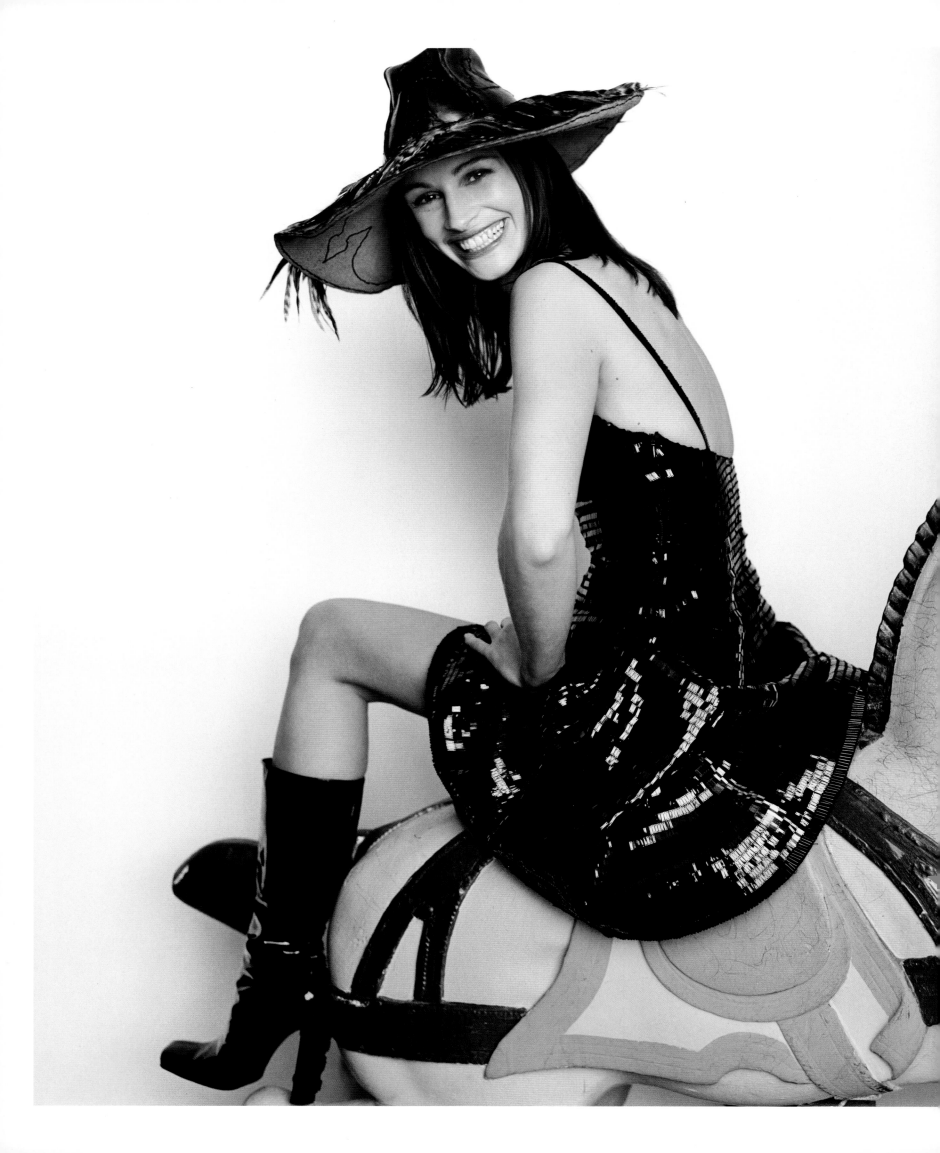

Mario Testino, *Vanity Fair,* June 1999, Julia Roberts

The portraits in this story for *W* magazine pay homage to the First Ladies of the United States, to those women whose role requires the careful bridging of their political and personal lives.

In September 2004, as the presidential race between John Kerry and George W. Bush was in full swing, conceptual artist and photographer Jean-Pierre Khazem wanted to showcase several First Ladies in recent American history in a series of vignettes that juxtapose history and current events—as fashion typically does. Of course, these portraits are fantasy. The women wearing Khazem's masks were cast solely for their size and height, then transformed into "first wives" through a combination of clothing, makeup, and wigs, an effect enhanced by the sets in which they appeared.

This story represents what I love about my work: the potential to create an image that is artful, that reflects a point of view on current events, that is about fashion and sells it by getting the work of important designers on the page. That's a lot to achieve—but that's exactly why I love this series: it incorporates all of these things. Interpreting art with fashion, and melding what was happening in politics and culture with the idea of presenting the First Ladies as fashion plates—all of this was part of my inspiration.

I had a yellow silk suit custom-made for "Lady Bird." "Barbara Bush"'s dress was vintage Geoffrey Beene, and we had her wear her signature three strands of pearls. All the other women are dressed in contemporary fashion, wearing designer clothes that made them perfect for fashion editorial and that had to showcase the clothes of the season: Bill Blass for "Pat Nixon" and "Nancy Reagan"; St. John for "Betty Ford"; and Escada for Laura Bush. We set "Rosalynn Carter" in her living room shaded in darkness—wearing Marc Jacobs in full, which was really exciting for me, as Marc's clothing is always the most contemporary of all of the American designers. Everything in this particular photograph is from his Fall 2004 collection. I loved that we created this brilliant drama with the same Marc Jacobs cardigan that every fashionista would be wearing in a totally different context.

In the end, the clothing is the only real part of these editorial vignettes. The uncannily realistic masks by Jean-Pierre Khazem, the way Orlando Pita fashioned each wig individually, the personal environmental sets constructed by Marla Weinhoff—these elements are all fantasy. Still, I felt a sense of awe when I was working on this series. It was if the First Ladies had all stepped out of time and into the studio. Even with the sets in front of me, I found it hard to remember that what I was looking at wasn't real.

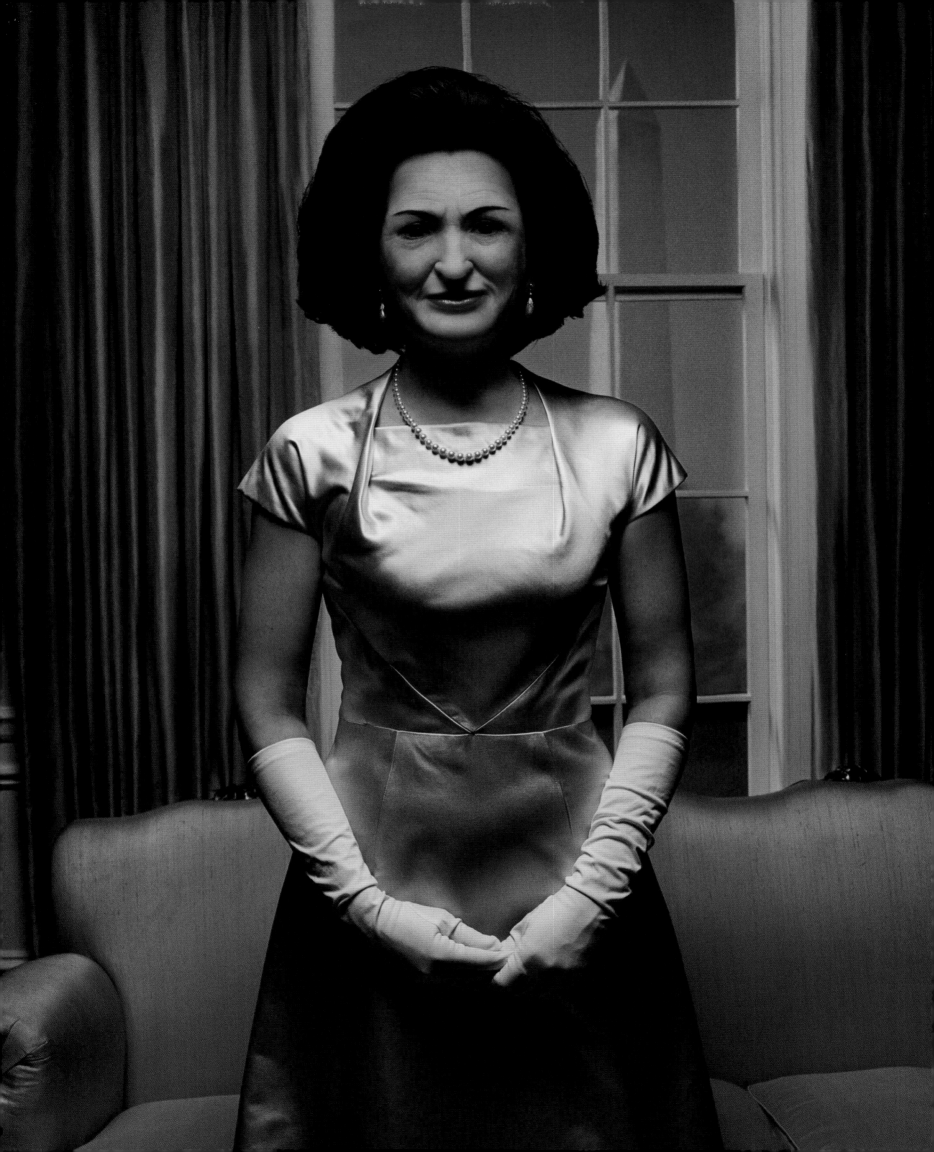

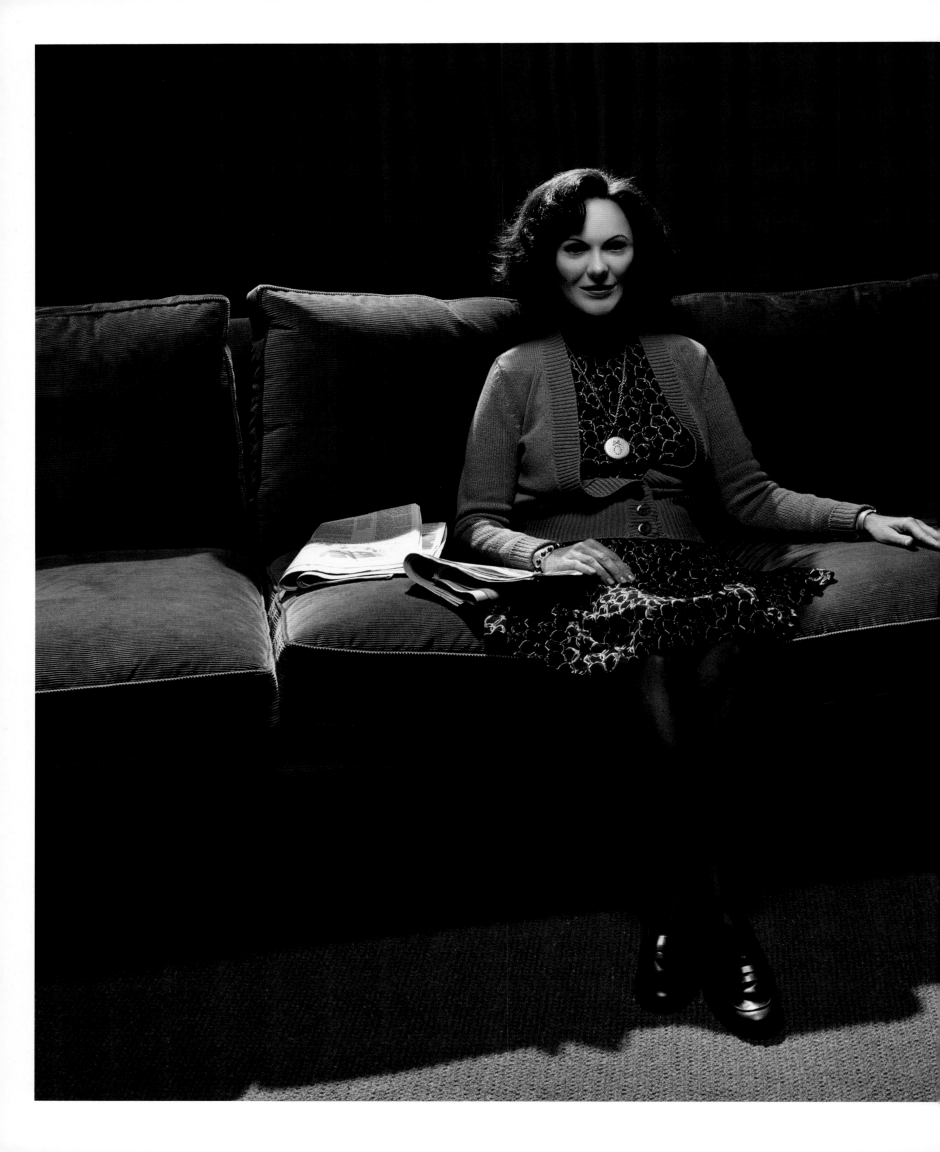

pages 201 – 203
Jean-Pierre Khazem, *W*, November 2004

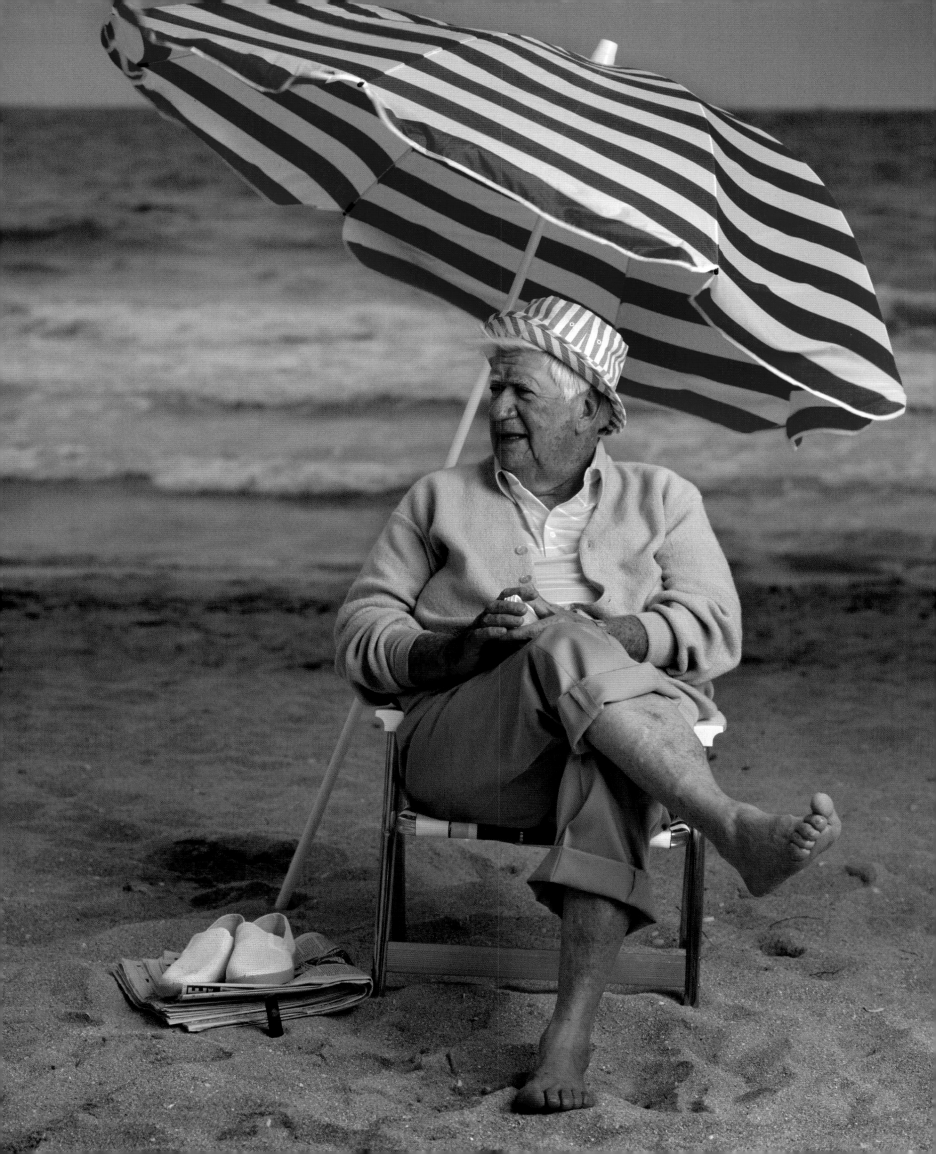

The American Express campaign was a milestone in the advertising world and in my own life. Annie Leibovitz was the photographer, Parry Merkley was the art director, and I was the stylist: beginning in 1987, we spent ten years traveling the world shooting this campaign. In the end, we probably photographed more than fifty luminous personalities such as Karl Lagerfeld, Quincy Jones, James Earl Jones, and Catherine Deneuve. The Portraits Campaign was one of the most successful of its day, winning many awards, culminating with *Advertising Age* naming it "campaign of the decade" in 1990.

The very first portrait that we shot was of Tip O'Neill Jr., the former Speaker of the House of Representatives, in Miami. We arrived at the location at 6:00 AM, and it was still pitch-black. We were four hours early! That's how overzealous we were then. We laughed for years about that.

Each portrait that we did for AmEx was the creation of a world unto itself. What I remember most vividly was that making each picture was like putting on a theatrical production. Before every shoot, the creative team would meet with Annie to discuss the concept for the advertisement and how we wanted to portray each celebrity. On this campaign, my role moved beyond fashion styling to wardrobe, an experience that taught me to look at clothes as a way of communicating character and emotion as well as fashion.

opposite
Annie Leibovitz, American Express Portraits Campaign, Tip O'Neill Jr., 1987

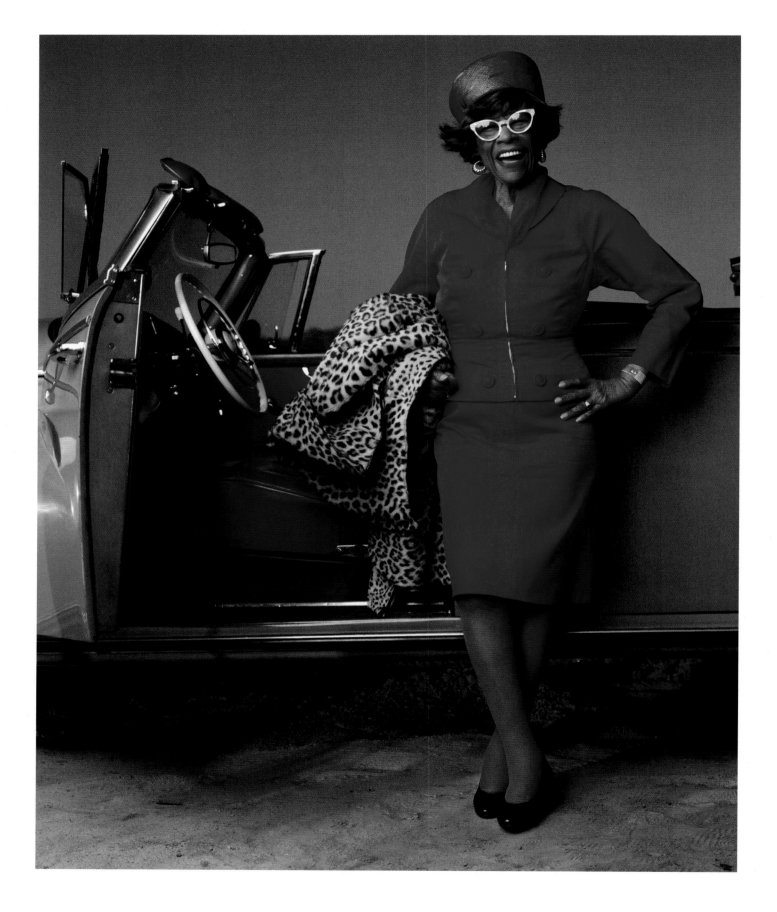

above
Annie Leibovitz, American Express Portraits Campaign, Ella Fitzgerald, 1988

opposite
Annie Leibovitz, American Express Portraits Campaign, Sammy Davis Jr., 1989

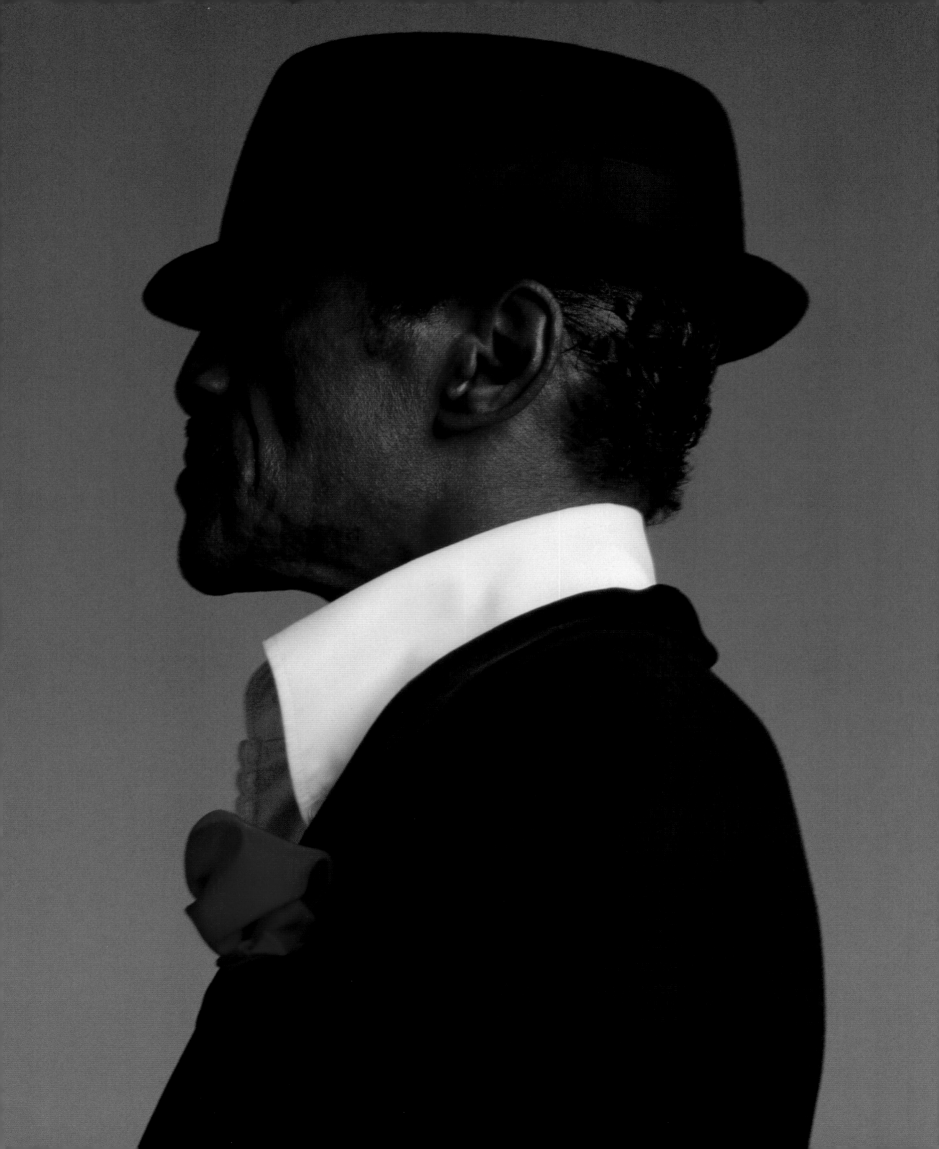

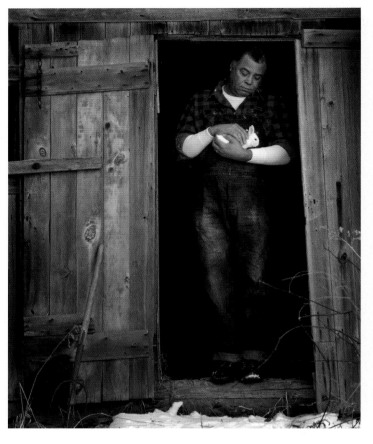
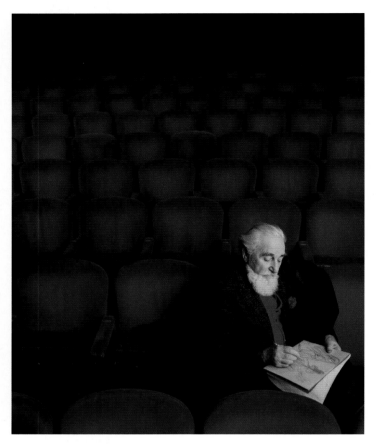
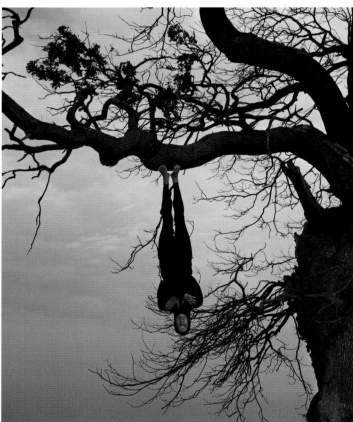
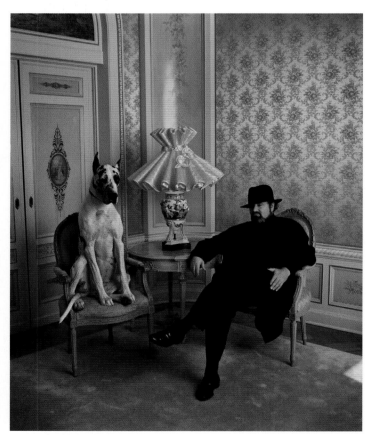

above, clockwise from top left
Annie Leibovitz, American Express Portraits Campaign: James Earl Jones, 1988; Al Hirschfeld, 1988; Rob Reiner, 1990; John Cleese, 1989

opposite
Annie Leibovitz, American Express Portraits Campaign, Hume Cronyn and Jessica Tandy, 1988

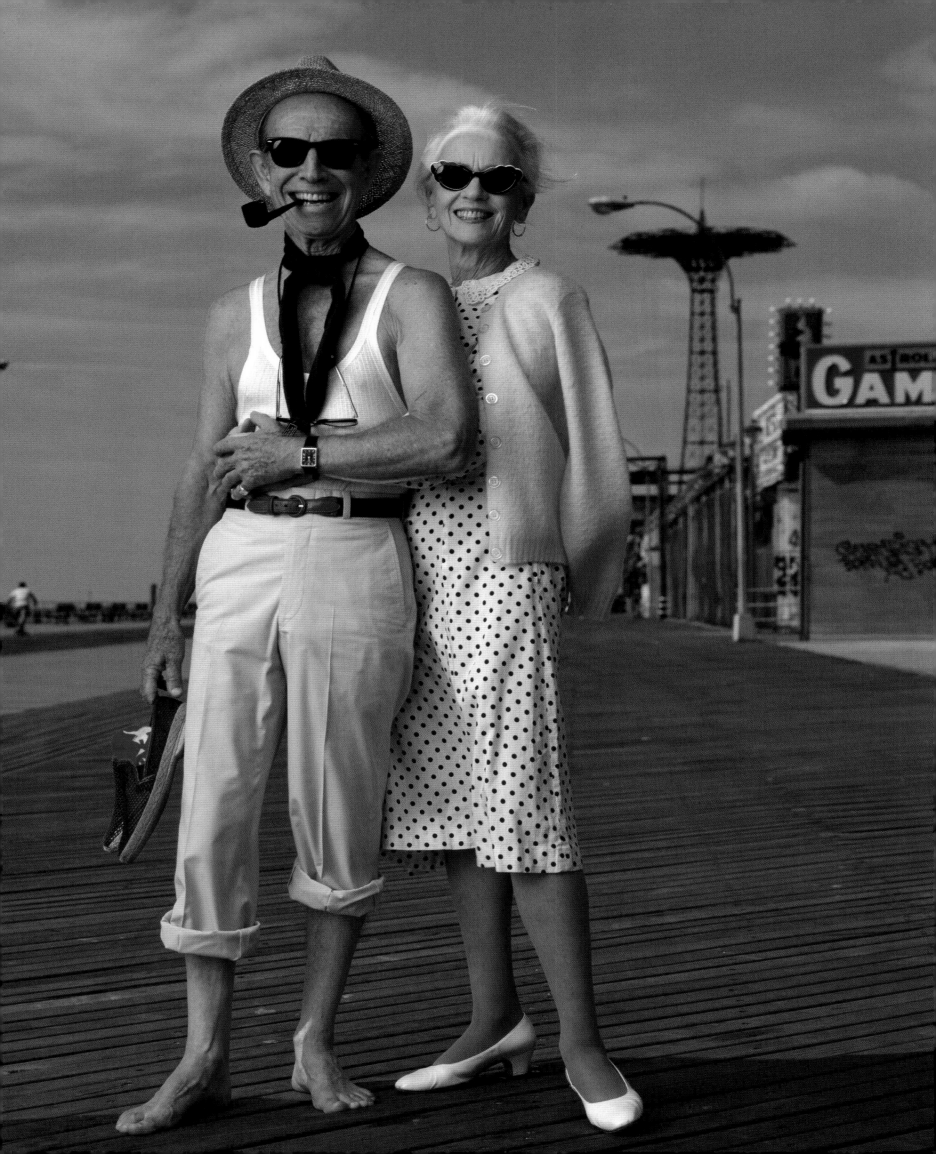

opposite
Annie Leibovitz, American Express Portraits Campaign, Willie Shoemaker and Wilt Chamberlain, 1987

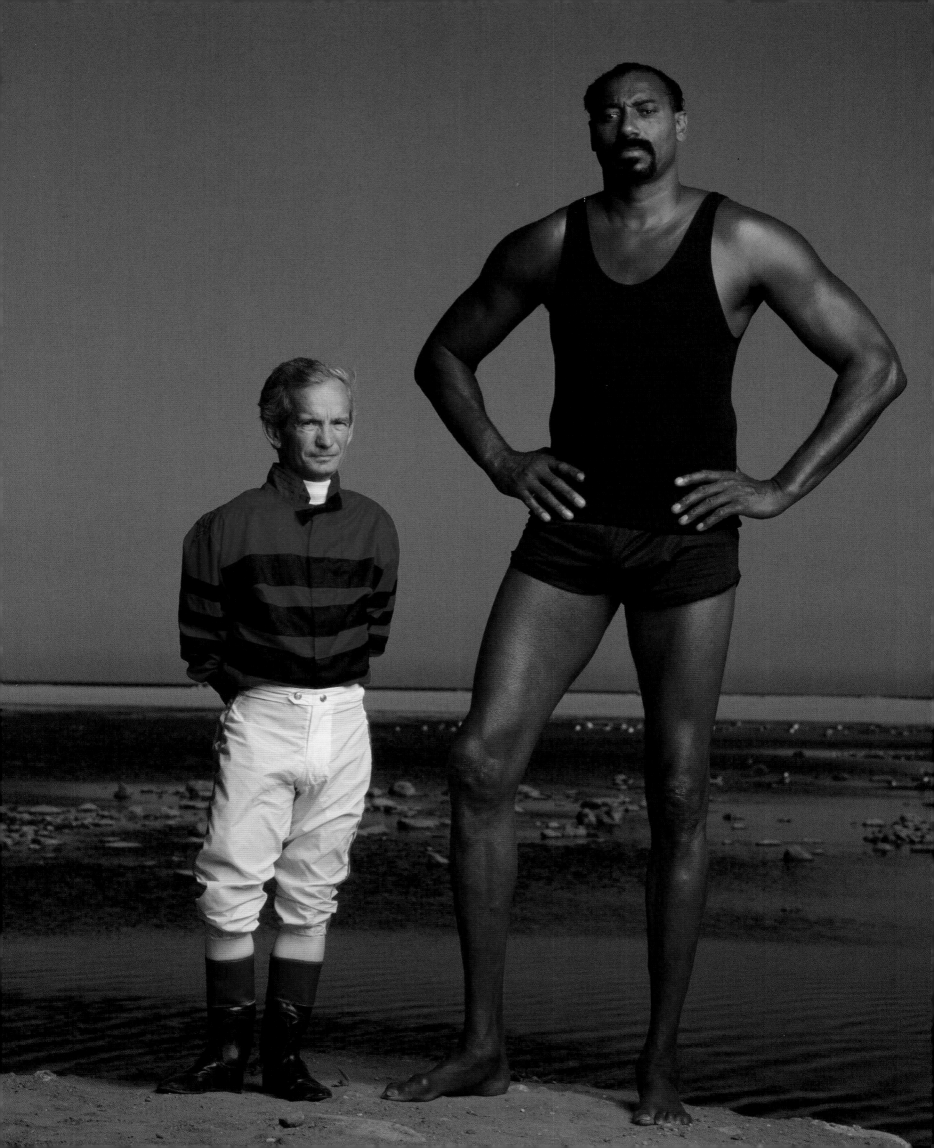

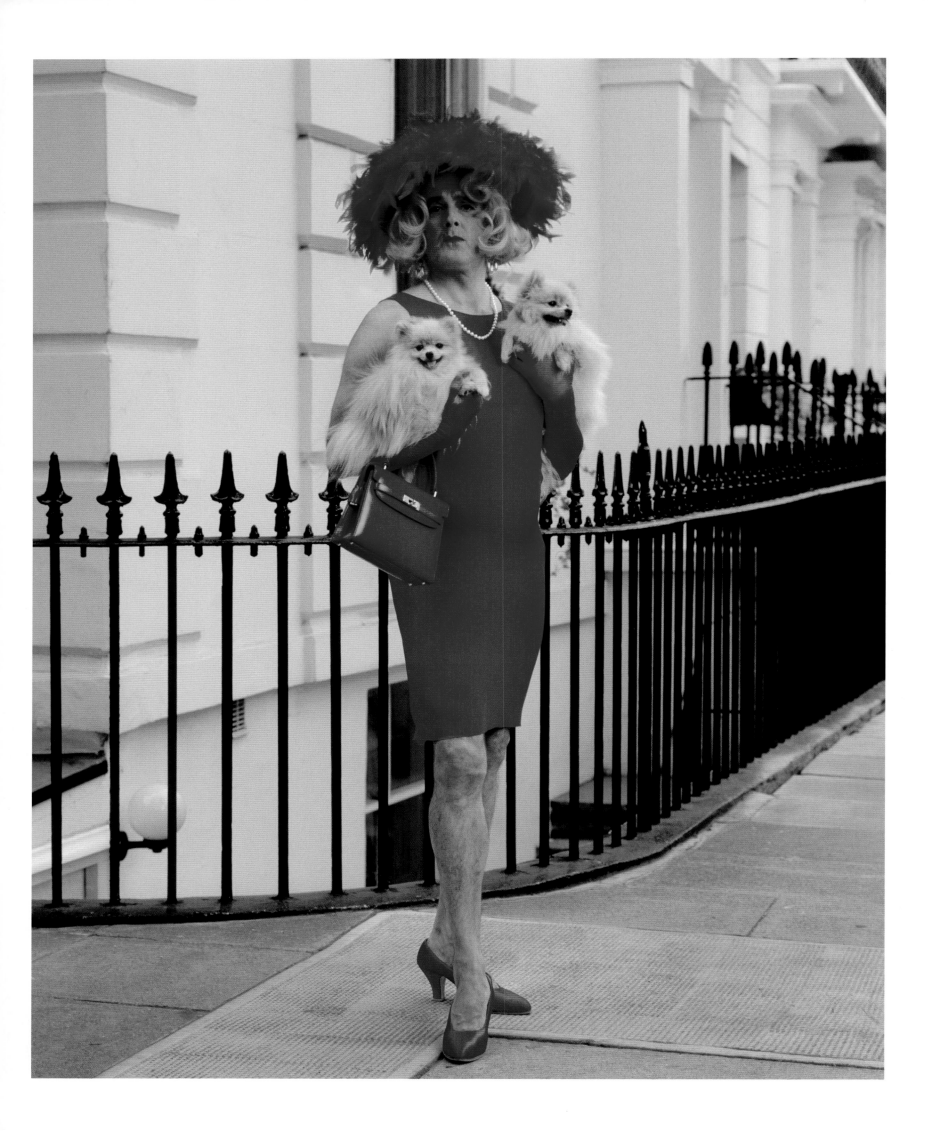

We had arranged to go to outside of London to photograph John Cleese hanging upside down from a tree. That was the original idea. On a Friday night, two days before the shoot, we had a meeting with him. Annie, who always brings more than one concept to a shoot, suggested dressing him as a woman.

John loved the idea. Everyone else was thrilled. I was freaking out. Usually I love when celebrities go along with an idea that's going to take them out of their realm, but I was panicking about how I would find the right clothes and accessories. The stores closed early on Saturday in London and would be closed on Sunday. Our shoot was on Monday! And John Cleese does not wear a normal ladies' dress size—he is six foot five.

It's times like these when you do the backstage work that, in the end, makes Monday morning look easy. Early Saturday morning, I went looking for a dressmaker who could turn out a dress in time for the shoot. Then I went on the hunt for shoes in a big-enough size, and then I found that gorgeous little bag and fabulous hat. In one very short weekend I had a proper lady's ensemble fit for a very tall man!

John Cleese was pure brilliance. Amid the noise of traffic, the stares and comments of curious passersby, he was perfectly poised and confident—a true grande dame.

opposite
Annie Leibovitz, American Express Portraits Campaign, John Cleese, 1990

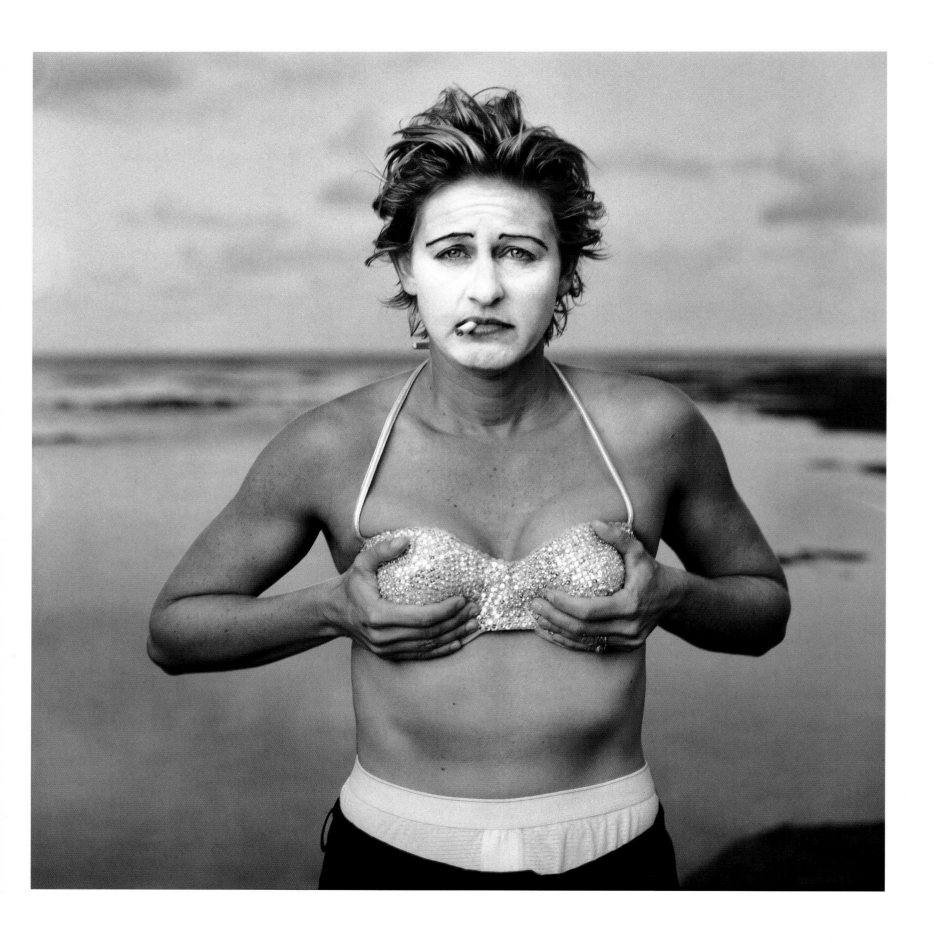

TO "GO TO EXTREMES" IS EVER SYMPTOMATIC OF GENIUS AND GREATNESS.

———

ARTHUR DESMOND, from *Might Is Right*, 1890

This photograph was shot in Hawaii in 1997, when Ellen DeGeneres was becoming a star. We were headed for sexy—and then flipped the switch. This image is all about the makeup and the cigarette and the men's underwear, and there she is—in a bra holding her boobs.

Ellen has her shirt off, but she's not playing coy. She's beautiful, and she's taking a chance. She's playing with society's notion of a seductive woman and turning it on its head. She's not trying to be the ingenue. She's something else entirely.

opposite
Annie Leibovitz, *Vanity Fair*, 1997, Ellen DeGeneres

Annie Leibovitz, *Vanity Fair*, August 1991, Demi Moore

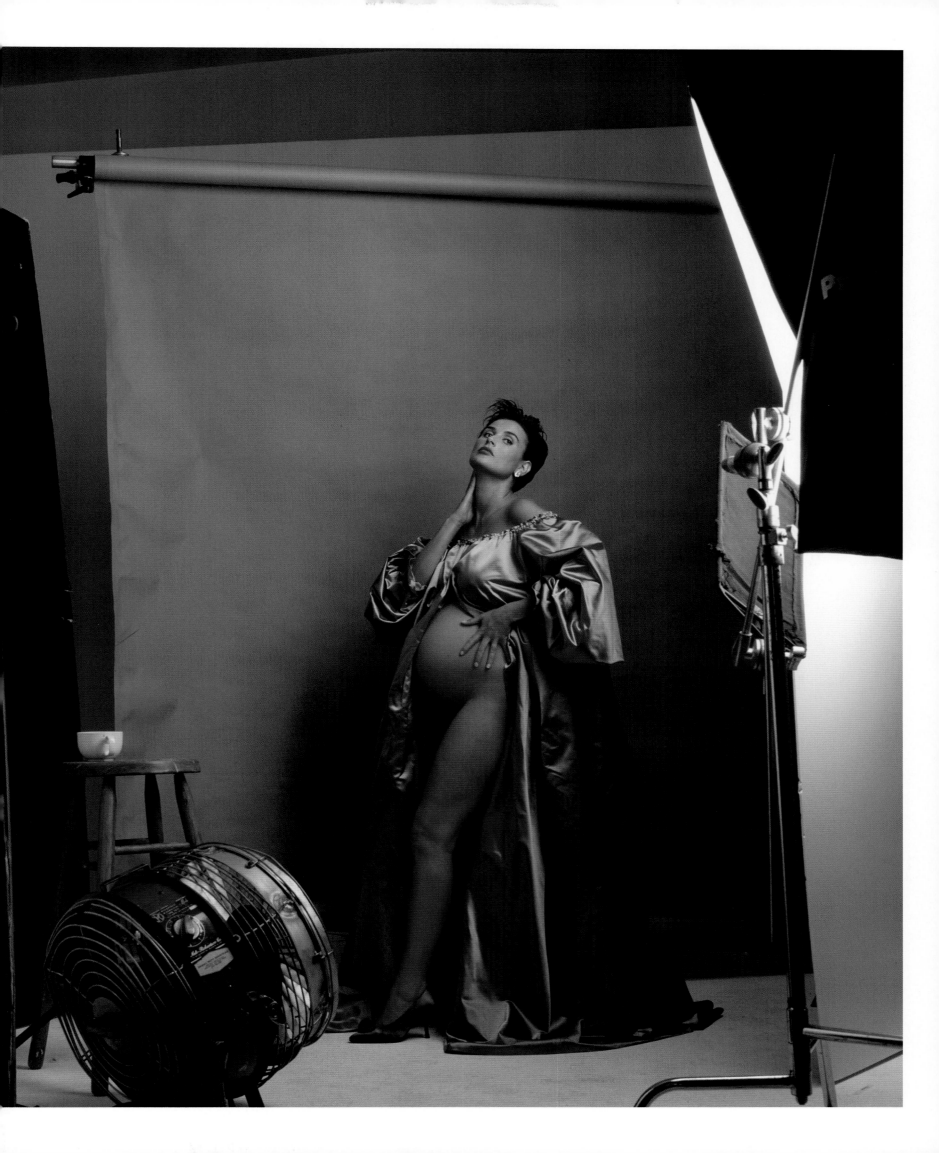

VANITY FAIR

AUGUST 1991/$2.50

More Demi Moore

by Nancy Collins

DARYL GATES
Is L.A.'s Top Cop
to Blame?
by Fredric Dannen

**HOW SADDAM
SURVIVED**
by Gail Sheehy

**SHOWDOWN
AT THE
BARNES COLLECTION**
by John Richardson
and David D'Arcy

VÁCLAV HAVEL
Philosopher King
by Stephen Schiff

**HOLLYWOOD
MAYHEM**
What Is
Joe Eszterhas's
Basic Instinct?
by Lynn Hirschberg

The first time Annie and I shot her for *Vanity Fair*, Demi was well into her pregnancy. We dressed her in Isaac Mizrahi. As Annie began to photograph her, as so often happens in a sitting, layers start to unpeel. First the jacket came off, then the top, then the bra, and there was the purest portrait. Eventually, she was naked, save for a single 40-karat canary yellow diamond ring and a pair of 20-karat white diamond earrings.

We looked at her and considered the image: would it still be beautiful without the ring and earrings? Yes it would, but it would be a completely different picture. It's a huge credit to Tina Brown, then editor of the magazine, that she chose that image as the cover shot. Doing so not only exemplifies her genius but her courage, to present a pregnant major film star that way. I wish more people took such risks today.

That was the shot heard around the world.

opposite
Annie Leibovitz, *Vanity Fair*, August 1991, Demi Moore

One day my agent called and told me that I was going to be styling Michael Jackson for a shoot with Annie Leibovitz.

I was beside myself—and that was an understatement. Michael was, and will probably always be, the biggest pop star in the history of music. Just his image alone has been ingrained in the minds of people all over the globe.

Because Michael was a bigger-than-life talent, Annie and I thought it would be interesting to go the other way—to dress him down, to show him unadorned. Annie had seen images of him onstage in a white T-shirt layered with a white shirt on top—the look was clean and simple—and we took our inspiration from that.

When he arrived on the set in LA, I was completely starstruck. He came with his own crew and brought his own wardrobe. It took some time before he was able to let his guard down, particularly about wearing the clothes I had chosen for him. In the end, though, he trusted Annie, and Annie trusted me.

At one point while we were shooting, the idea to open up his T-shirt came up. I remember taking a pair of scissors and cutting the T-shirt directly on him, right on his chest. And it was that picture that became the magazine cover.

He sang for us that afternoon on a closed set for more than forty-five minutes. It was one of the most memorable shoots of my life. I will never forget it, because Michael was everything.

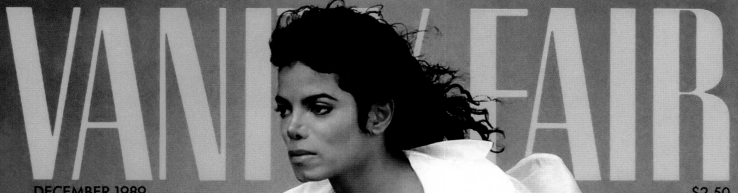

VANITY FAIR

DECEMBER 1989 $2.50

Hall of Fame!

44 Pages of Power Portraits by Annie Leibovitz

PRINCESS DIANA: Serious Stuff by Joan Juliet Buck
DAVID MERRICK: Life's Revenge on the Scrooge of Broadway by Leslie Bennetts
MINDSTORM: A Memoir of Madness by William Styron

pages 222 – 223, 225
Annie Leibovitz, Neiman Marcus, Spring 1995, Jennifer Jason Leigh

WE ARE WHAT WE PRETEND TO BE, SO WE MUST BE CAREFUL ABOUT WHAT WE PRETEND TO BE.

KURT VONNEGUT, *Mother Night*, 1999

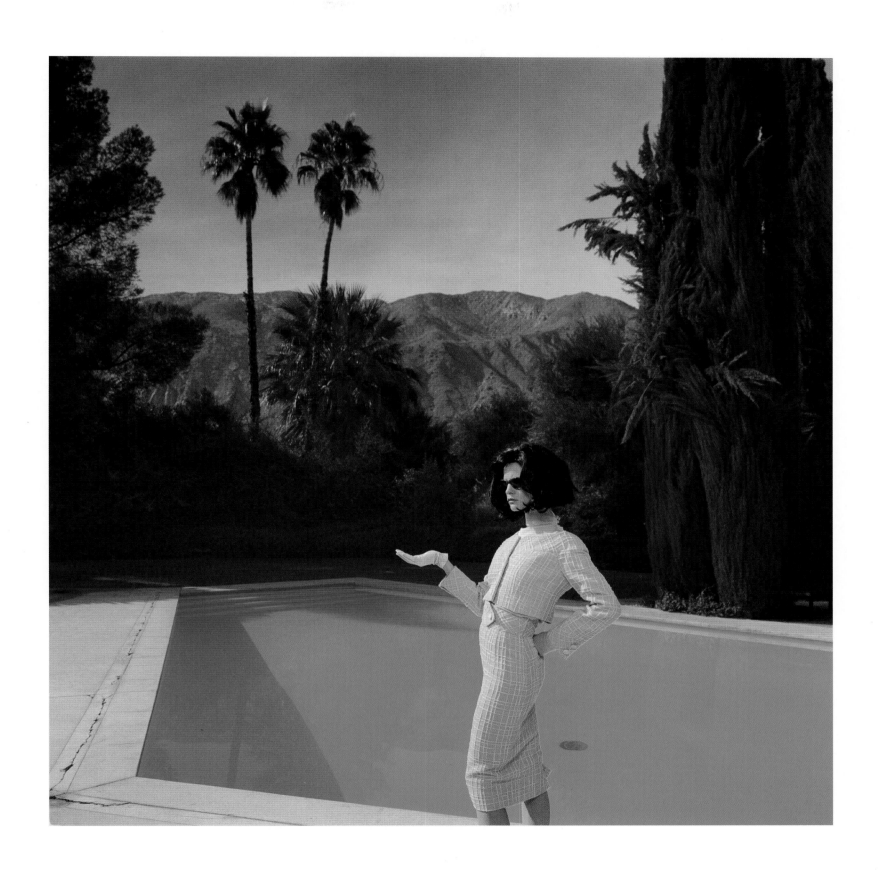

opposite
Annie Leibovitz, *Vanity Fair*, September 1988, Sandra Bernhard

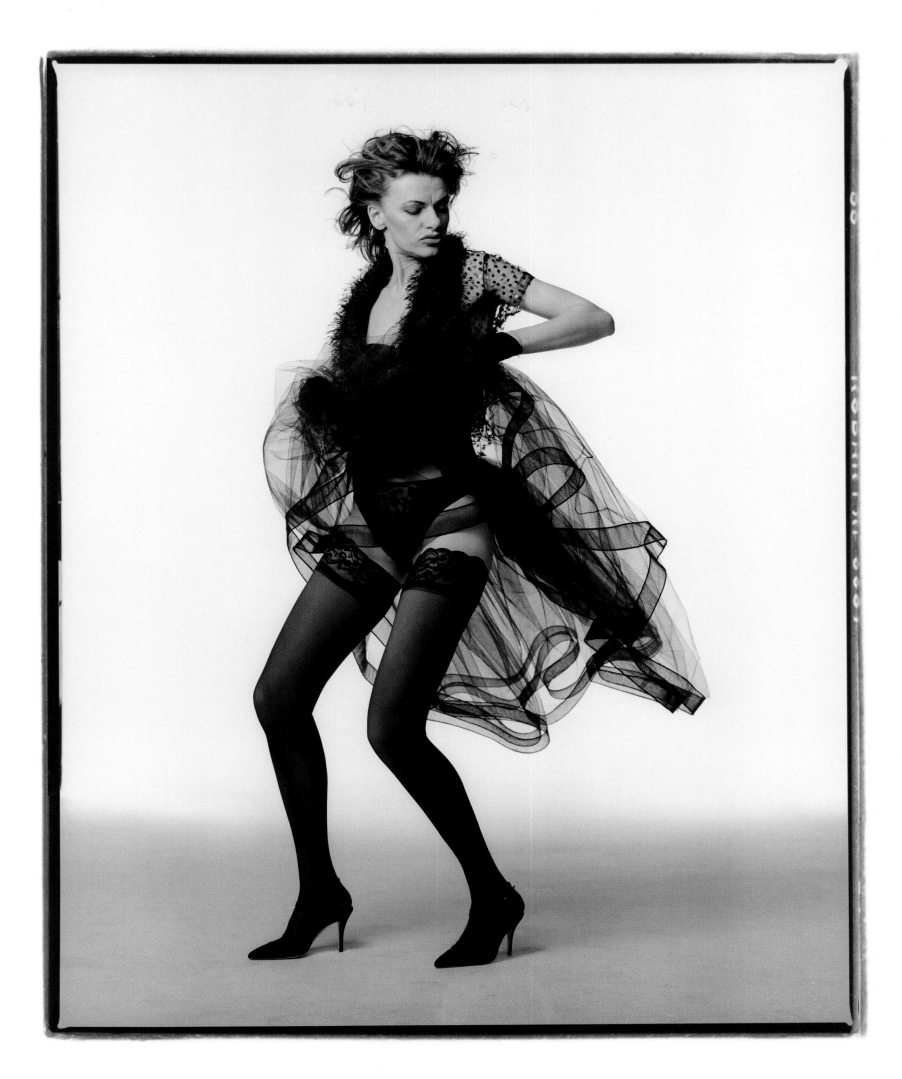

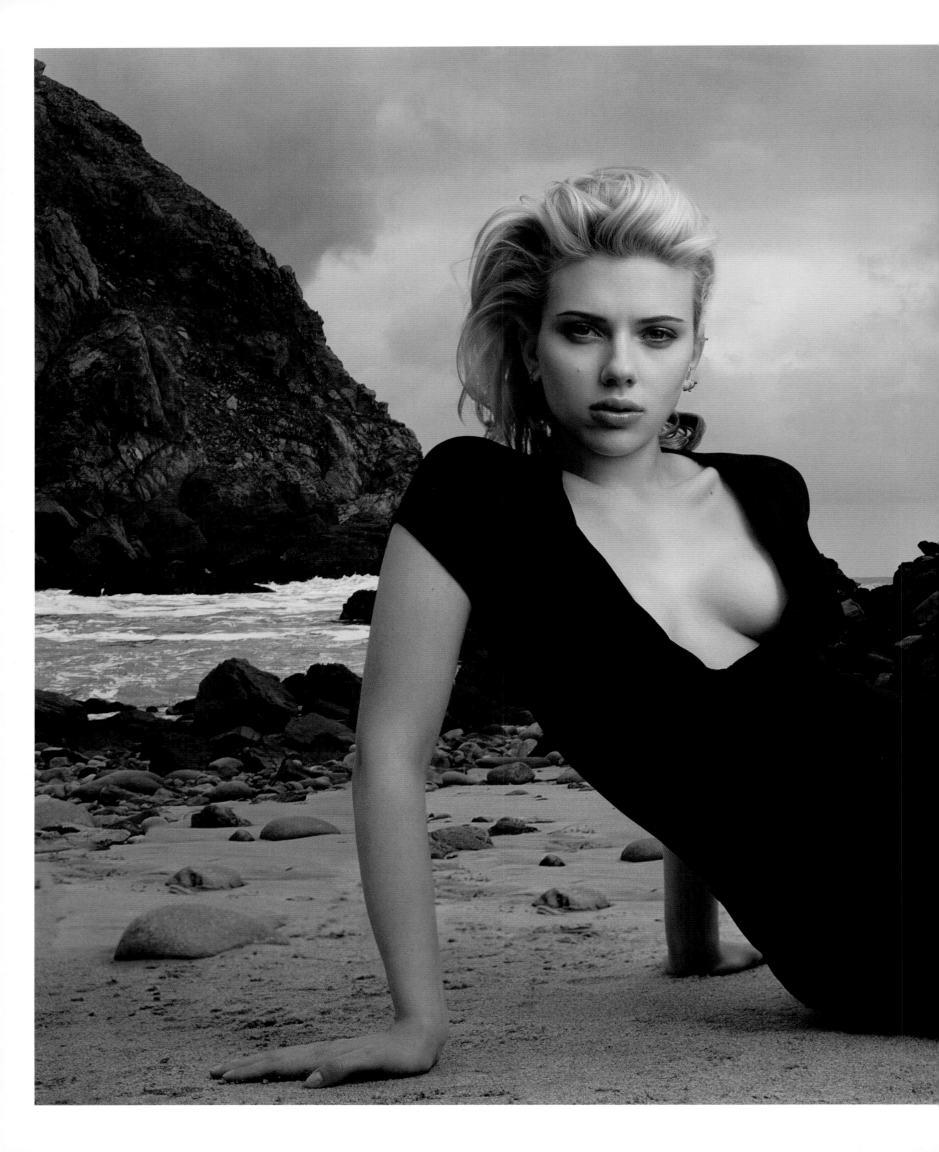

Annie Leibovitz, *Vanity Fair*, August 2005, Scarlett Johansson

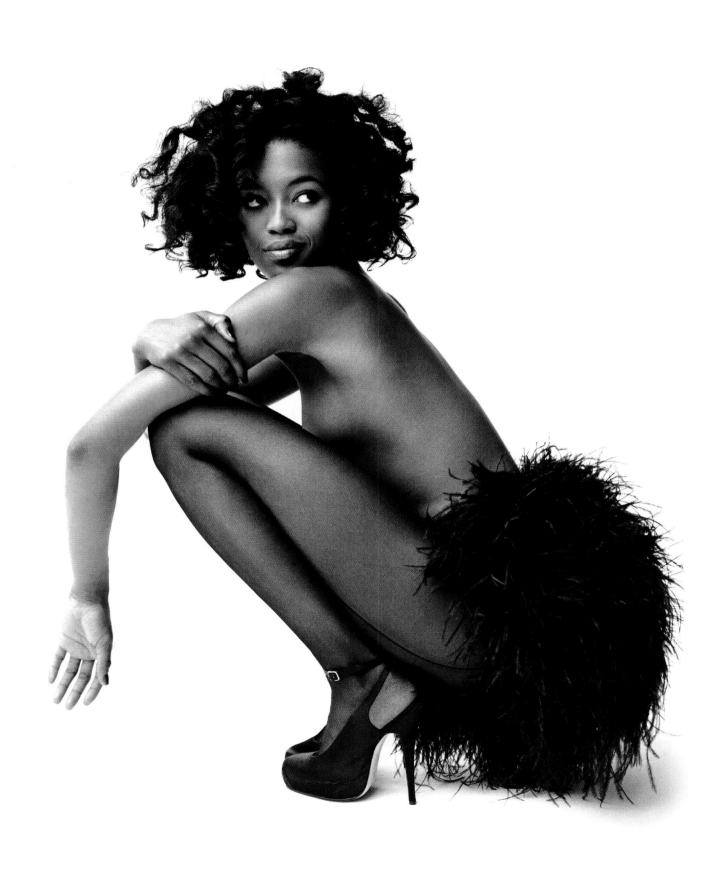

above
Mario Testino, *Allure*, February 1994, Naomi Campbell

opposite
Craig McDean, *W,* June 2010, Cate Blanchett

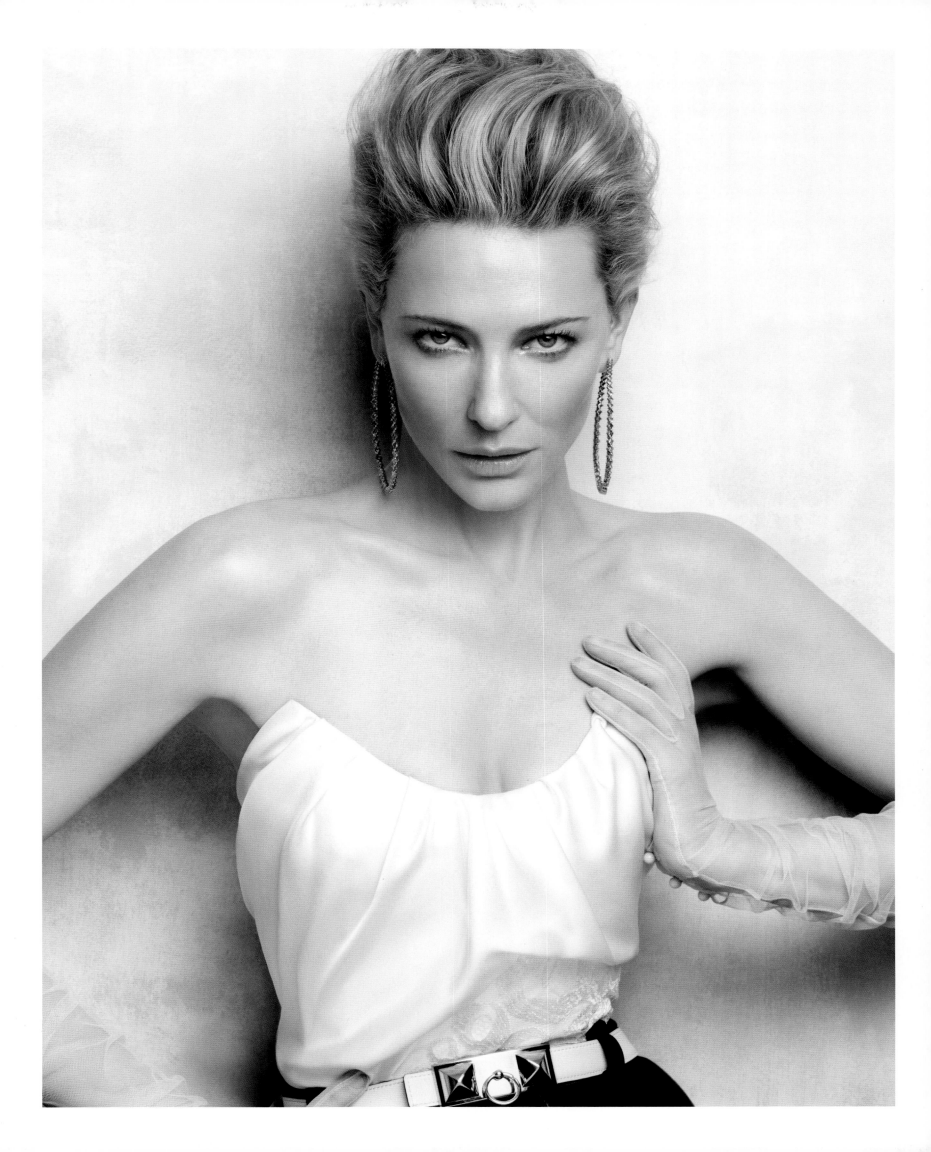

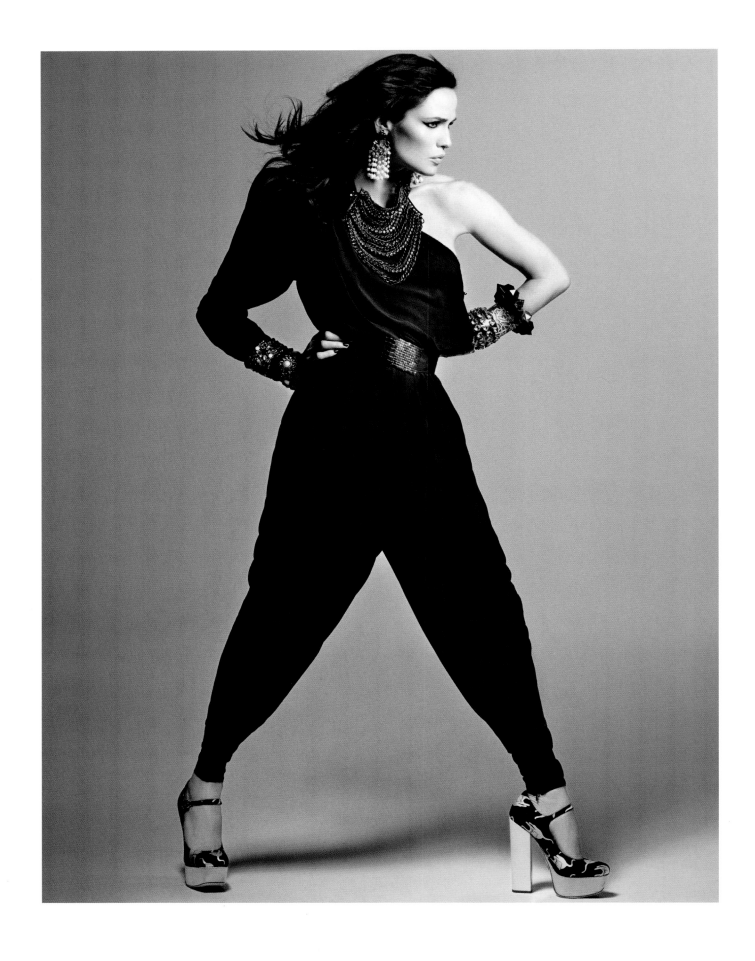

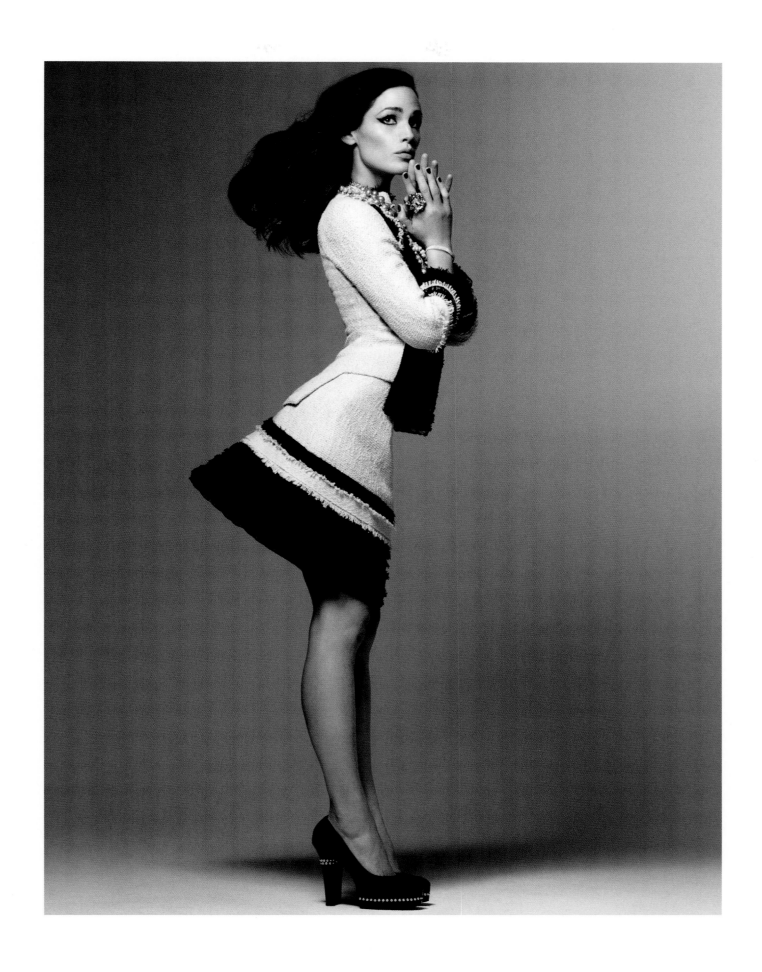

opposite
Sølve Sundsbø, *Council of Fashion Designers of America Awards Journal*, 2010, Sarah Jessica Parker

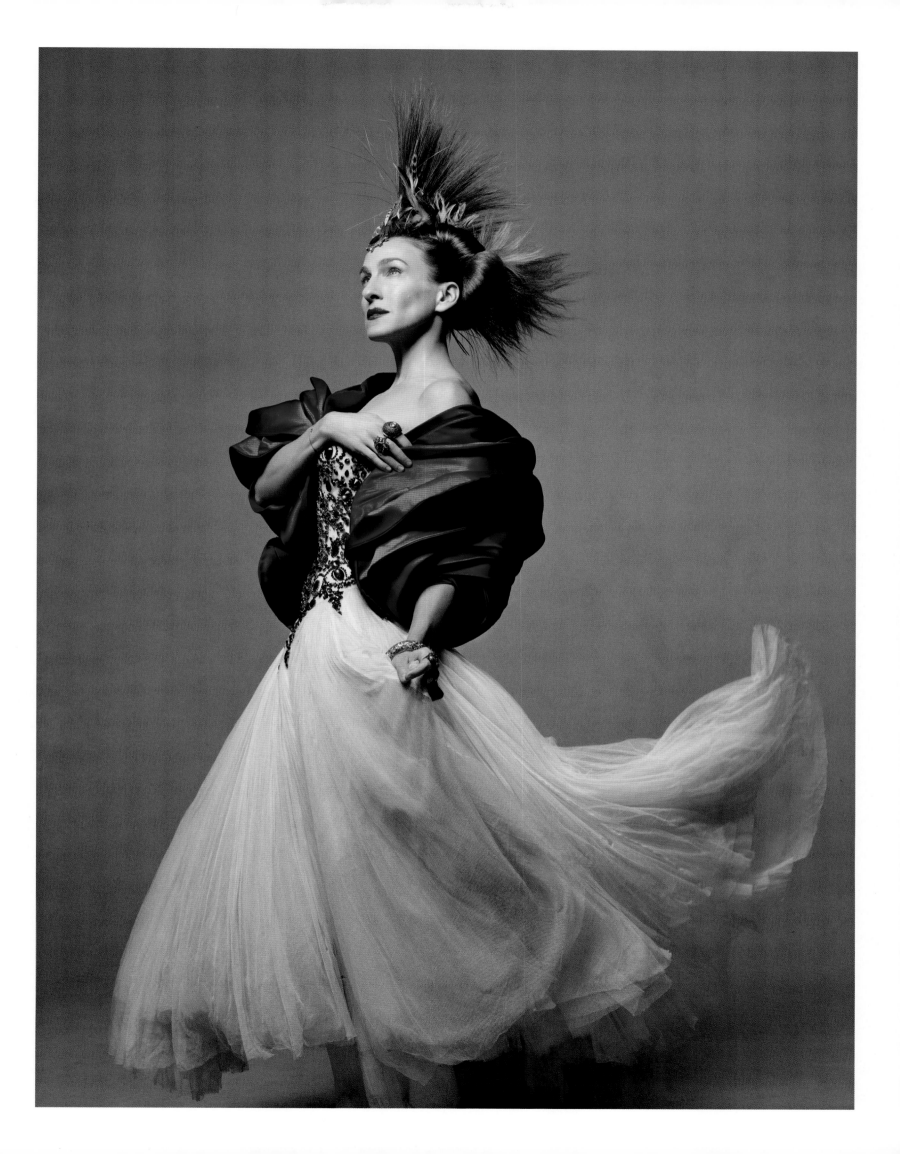

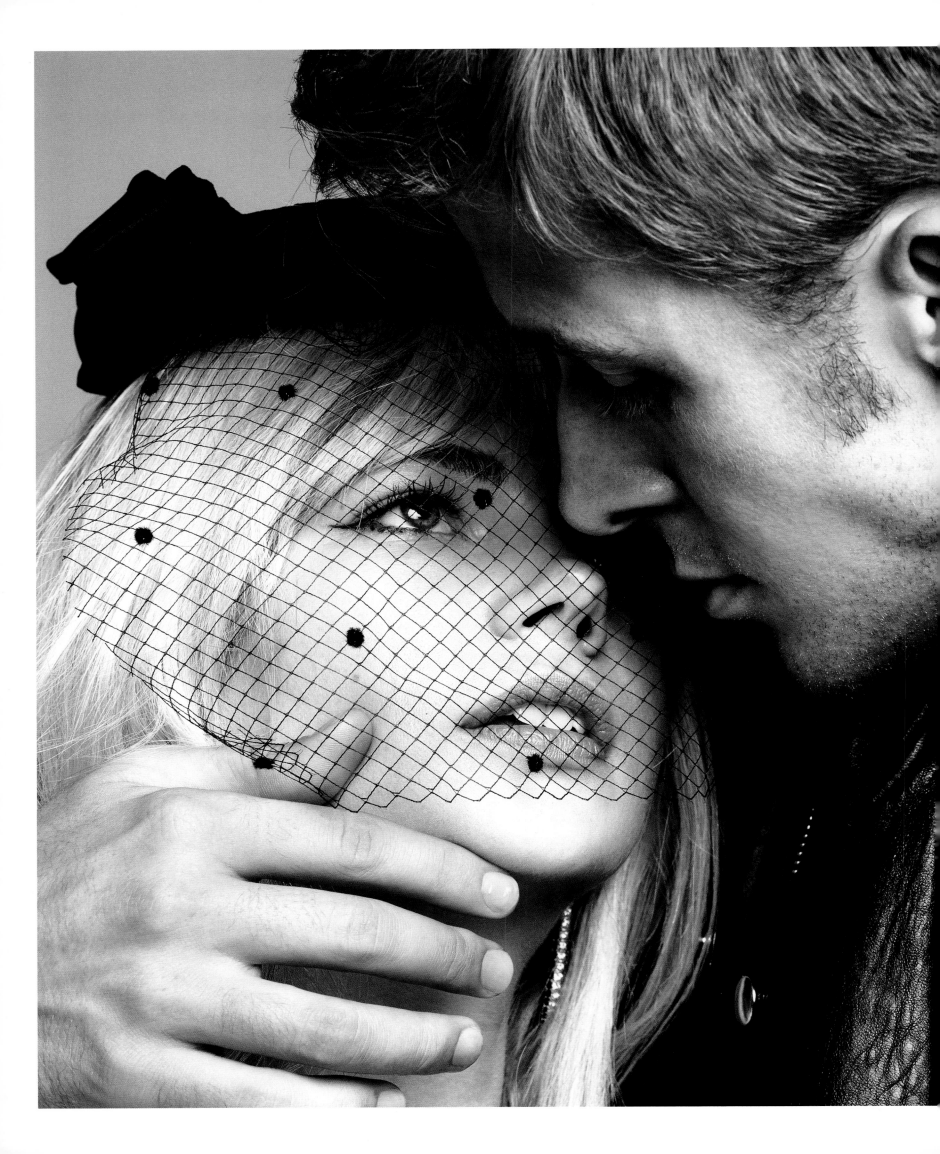

Inez van Lamsweerde and Vinoodh Matadin, *W,* October 2010
Michelle Williams and Ryan Gosling

opposite
Terry Richardson, David Webb, Fall 2012

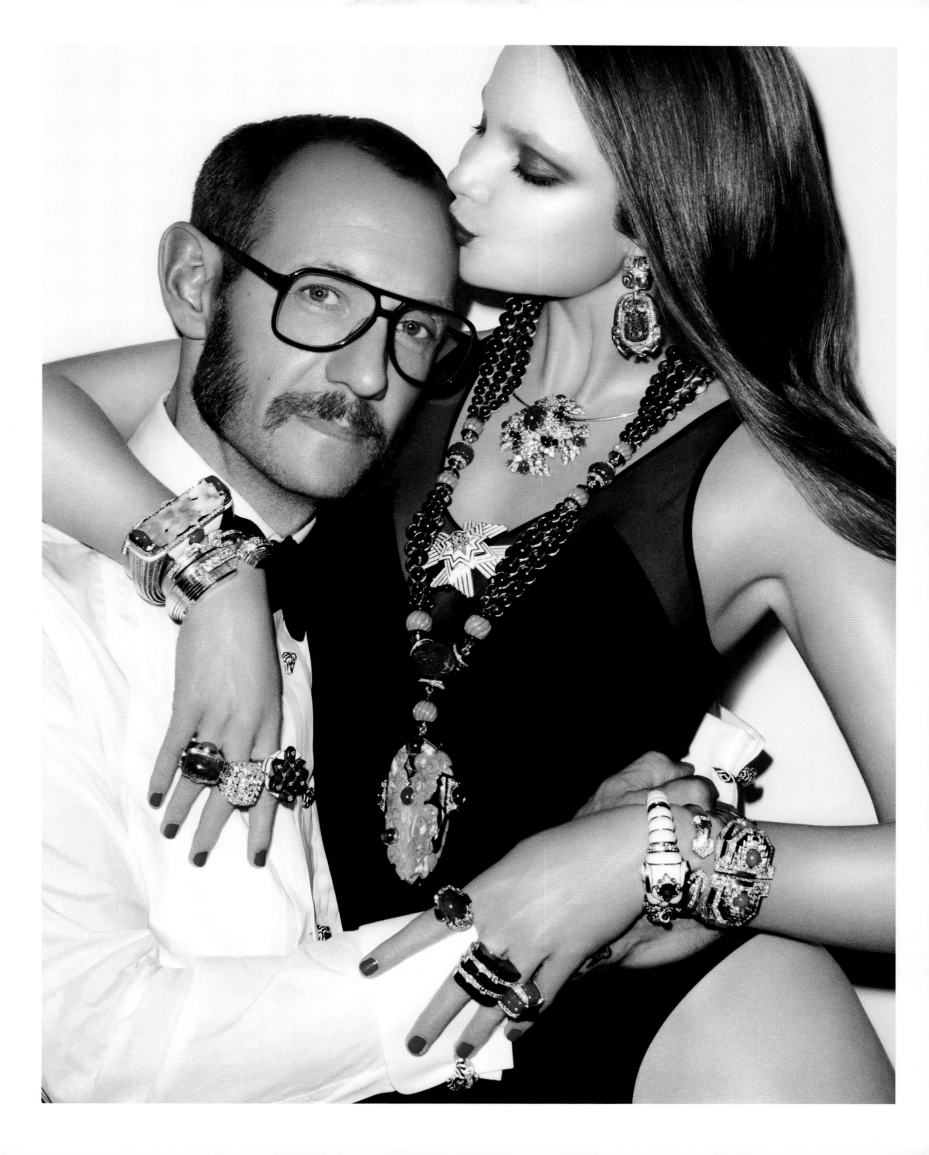

opposite
Craig McDean, *W*, February 2010, Rihanna

pages 242 – 243
Mario Sorrenti, *W*, September 2004, Julianne Moore

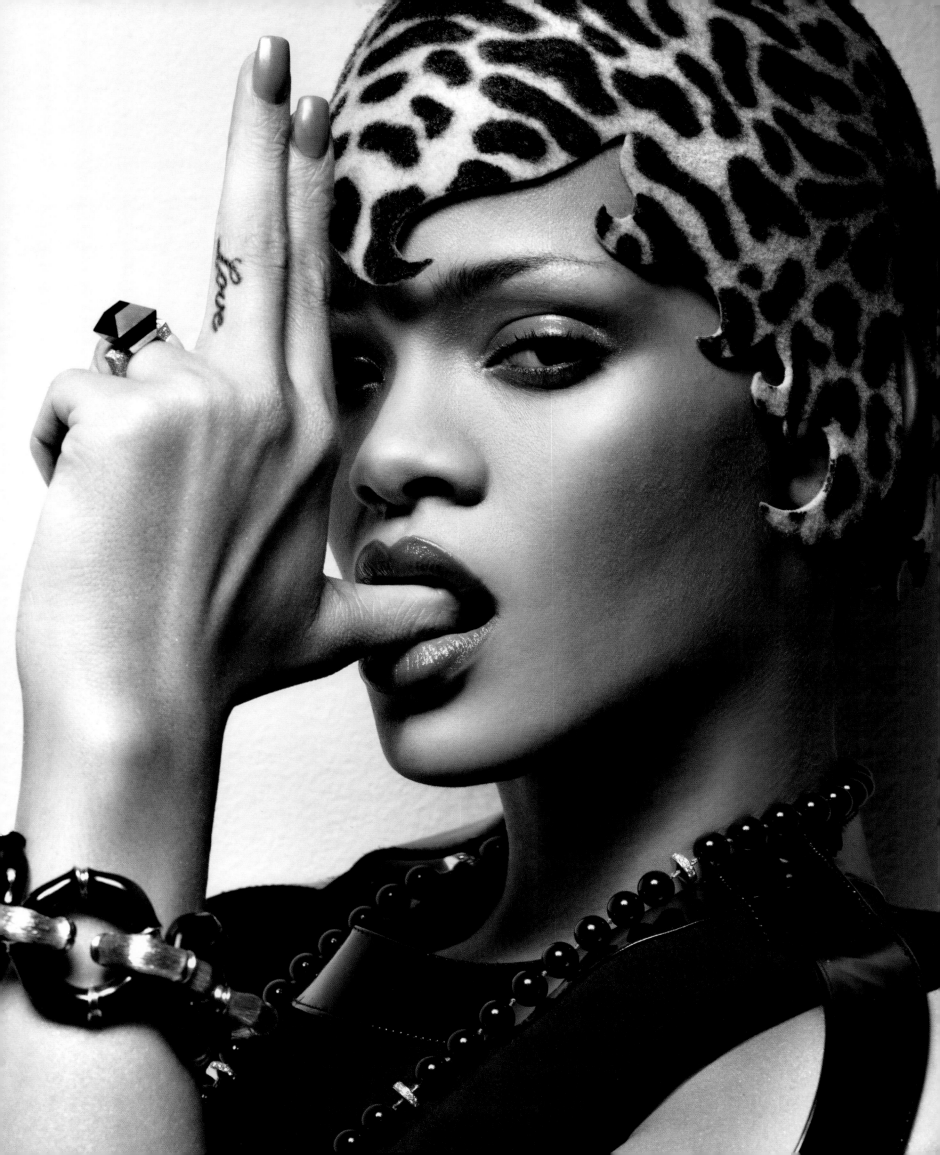

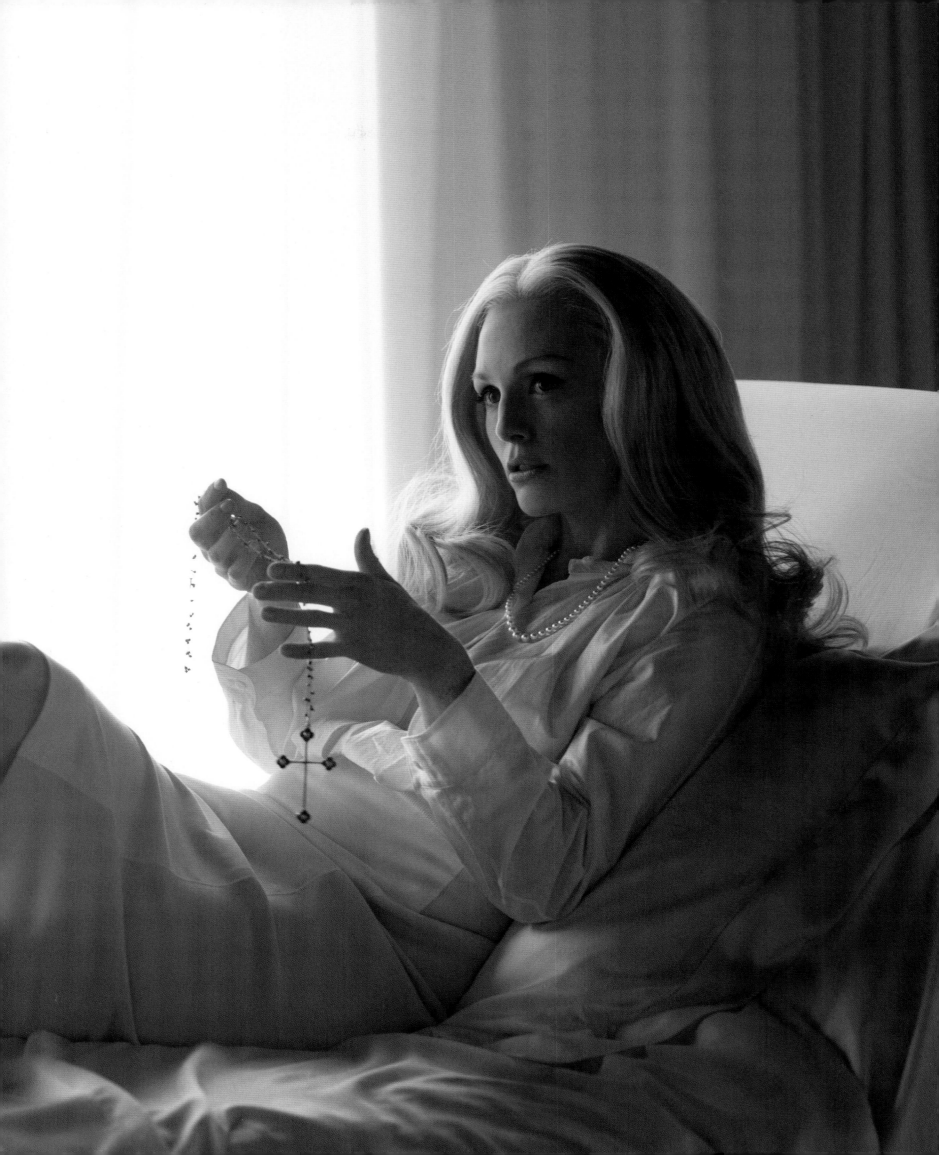

SOURCES

BIBLIOGRAPHY

Burroughs, John. *The Gospel of Nature*. Boston: Houghton Mifflin, 1912.

Chang, Larry. *Wisdom for the Soul: Five Millennia of Prescriptions for Spiritual Healing*.
 Washington, D.C.: Gnosophia Publishers, 2006.

Chesterton, Gilbert K. *The Everlasting Man*. Radford, Va.: Wilder Publications, 2008.

Cocteau, Jean. *Diary of an Unknown*. New York: Marlowe & Co, 1991.

Cork, Richard. "Box of Delights." *New Statesman* (February 23, 2004). Accessed March 1, 2013.
 www.newstatesman.com/node/147350.

Ellerbee, Linda. *Move On*: *Adventures in the Real World*. New York: Perennial, 1991.

Emerson, Ralph Waldo. "Nature." Boston: Self-published, 1836.

Gross, Frederick. *Diane Arbus's 1960s*. Minneapolis, Minn.: University of Minneapolis Press, 2012.

Jung, C.G. *Letters, Vol. 1: 1906-1950*, Gerhard Adler, ed. London: Routledge & Kegan Paul, 1973.

Kipfer, Barbara Ann. *The 1,325 Buddhist Ways to Be Happy*. Berkeley, Calif.: Ulysses Press, 2007.

Macritchie, Lynn. "Residency on Earth." *Art in America*, April 1995, 91–94.

Maugham, W. Somerset. *The Summing Up*. Garden City, N.Y.: Garden City Publishing Company, 1938.

Morrow, Lance. "The Poetic License to Kill." *Time*, February 1, 1982, 90.

Murakami, Haruki. *Dance Dance Dance*. New York: Kodansha International, 1994.

Price, Alison, and David Price. *Introducing Psychology of Success: A Practical Guide*. London: Icon Books, 2011.

Redbeard, Ragnar. *Might Is Right*. Redlands, Calif.: Dil Pickle Press, 2005.

Sheff, David. *All We Are Saying: The Last Major Interview with John Lennon and Yoko Ono*.
 New York: St. Martin's Griffin, 2000.

Sontag, Susan. *Against Interpretation and Other Essays*. New York: Farrar, Straus & Giroux, 1966.

Susann, Jacqueline. *Valley of the Dolls*. New York: Grove Press, 1997.

Tate, Claudia. *Black Women Writers at Work*. London:" Continuum International Publishing Group, 1984.

Thoreau, Henry David. *Walden*. Boston: Ticknor and Fields, 1854.

Thornton, Wilbur. *Gandhi: Seasons of Flowers*. Authorhouse.com, 2009.

Vonnegut, Kurt. *Mother Night*. New York: Dial, 1999.

Waters, John. *Shock Value*: *A Tasteful Book About Bad Taste*. New York: Thunder's Mouth Press, 1995.

White, E.B. *Writings from* The New Yorker *1927-1976*. New York: Harper Perennial, 2006.

Wilde, Oscar. *A Woman of No Importance*. New York: Signet Classics, 1997.

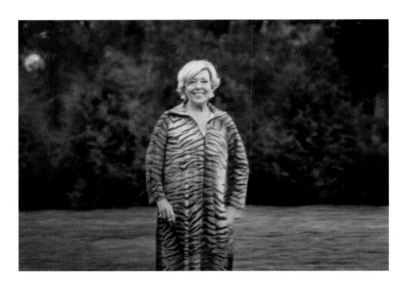

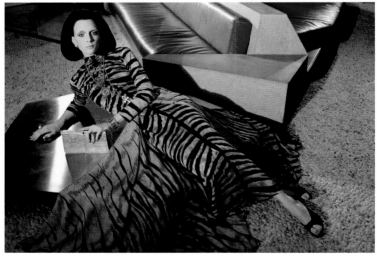

top
GaGa Gladys, Portland, Oregon, 1973

bottom
Steven Meisel, Italian *Vogue*, March 2000

ACKNOWLEDGMENTS

From the bottom of my heart, I would like to thank the many incredible people who helped bring this book to life: Steven and Annie, my teachers and friends. Mario Testino, I couldn't have asked for a better person to start this journey with. I am so grateful for the generosity of every photographer who has contributed to this book. Leslie Sweeney, for being a guiding light. Raul Martinez, for understanding my work and helping me to make sense of it all. Victoria Brynner, Brooke Wall, Ali Bird, and Rebecca Oliver, for their undying support. Elizabeth Viscott Sullivan, for being an amazing editor with the highest of standards. Lynne Yeamans, for translating my vision. Sandra Bark, for helping me find my voice. Laurel St. Romain and Daniel Randell, for being with me every step of the way and without whom I could have never done this. Jeremy Lewis, for always lending a hand. My dear friend Maggie Vitagliano, who always believed in me and who will always and forever be in my heart. My family—Marcia, GaGa Gladys, Howard, my stepfather, Ira, my sisters, my brother, my nieces and nephews—I cherish everything we share. And Lucille, Louise, and Elvis, my true loves.

I would also like to thank each and every hair stylist, makeup artist, manicurist, model, and talent that I've had the privilege of working with—our collaborations are everything!

PHOTOGRAPHY CREDITS

Pages 3, 5, 250 top: courtesy of Lori Goldstein

FOREWORD
Page 10: © Steven Meisel

THE SICKNESS
Pages 20, 22–23, 31, 42–43, 45, 48, 56–59, 62–63: © Steven Meisel

Pages 24–25: © Mario Sorrenti

Page 29: © Mario Testino/Art Partner

Pages 32, 34–35: © Bruce Weber

Pages 36, 38–39: © Billy Sullivan

Pages 46–47: © Catherine Servel

Pages 51–53: © Michael Thompson

THE DIVINE
Pages 68, 70–73: © Paolo Roversi

Pages 74, 92–93, 103: © Yelena Yemchuk

Pages 76–77, 104, 107: © Steven Meisel

Pages 78–79: © Jean-Baptiste Mondino

Pages 80–83: © Mario Sorrenti

Pages 84–85: © John Akehurst

Pages 86–87: © Jeff Burton

Pages 90–91: © Annie Leibovitz

Pages 94–95, 100–101: © Michael Thompson

Pages 96–97: © Patrick Demarchelier

Page 98: © Herb Ritts/Trunk Archive

Page 109: © Bruce Weber

HARMONIOUS DISCORD

Pages 115–117: © Nathaniel Goldberg

Pages 118–119, 124–126, 128–129, 138–139, 141, 144–147, 158–159: © Steven Meisel

Pages 120–121, 154–155: © Jeff Burton

Pages 131–133: © Yelena Yemchuk

Pages 135–137, 150–151, 153: © Sølve Sundsbø/Art + Commerce

Page 149: © Hedi Slimane/Trunk Archive

Pages 156–157: © Bruce Weber

Pages 160–161: © Michael Thompson

Pages 163, 169: © Mario Testino/Art Partner

Pages 164–165: © The Richard Avedon Foundation

Pages 166–167: © Patrick Demarchelier

POP

Page 175: © Herb Ritts/Trunk Archive

Page 176: © Michael Haussman, 1994

Pages 179, 181, 198–199, 230: © Mario Testino/Art Partner

Pages 184–185, 204, 206–209, 211–212, 214, 216–218, 221–223, 225, 227–229: © Annie Leibovitz

Pages 188–189, 192–195, 242–243: © Mario Sorrenti

Page 196: © Ellen von Unwerth

Pages 197, 231–233, 241: © Craig McDean/Art + Commerce

Pages 201–203: © Jean-Pierre Khazem/Courtesy of Sperone Westwater

Page 235: © Sølve Sundsbø/Art + Commerce

Pages 236–237: © Inez van Lamsweerde and Vinoodh Matadin

Page 239: © Terry Richardson/Art Partner

SOURCES

Page 248, bottom: © Steven Meisel

Pages 252–253: © Patrick Demarchelier

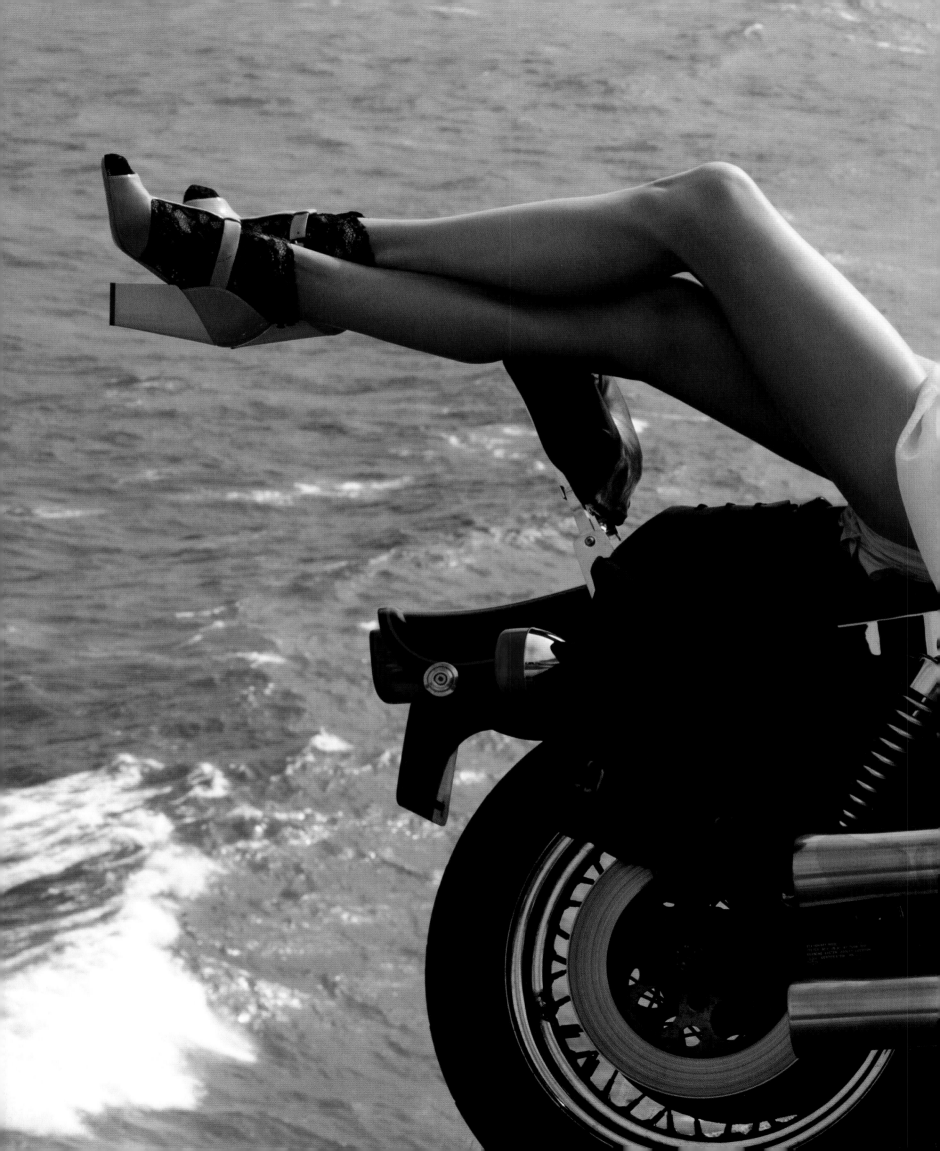

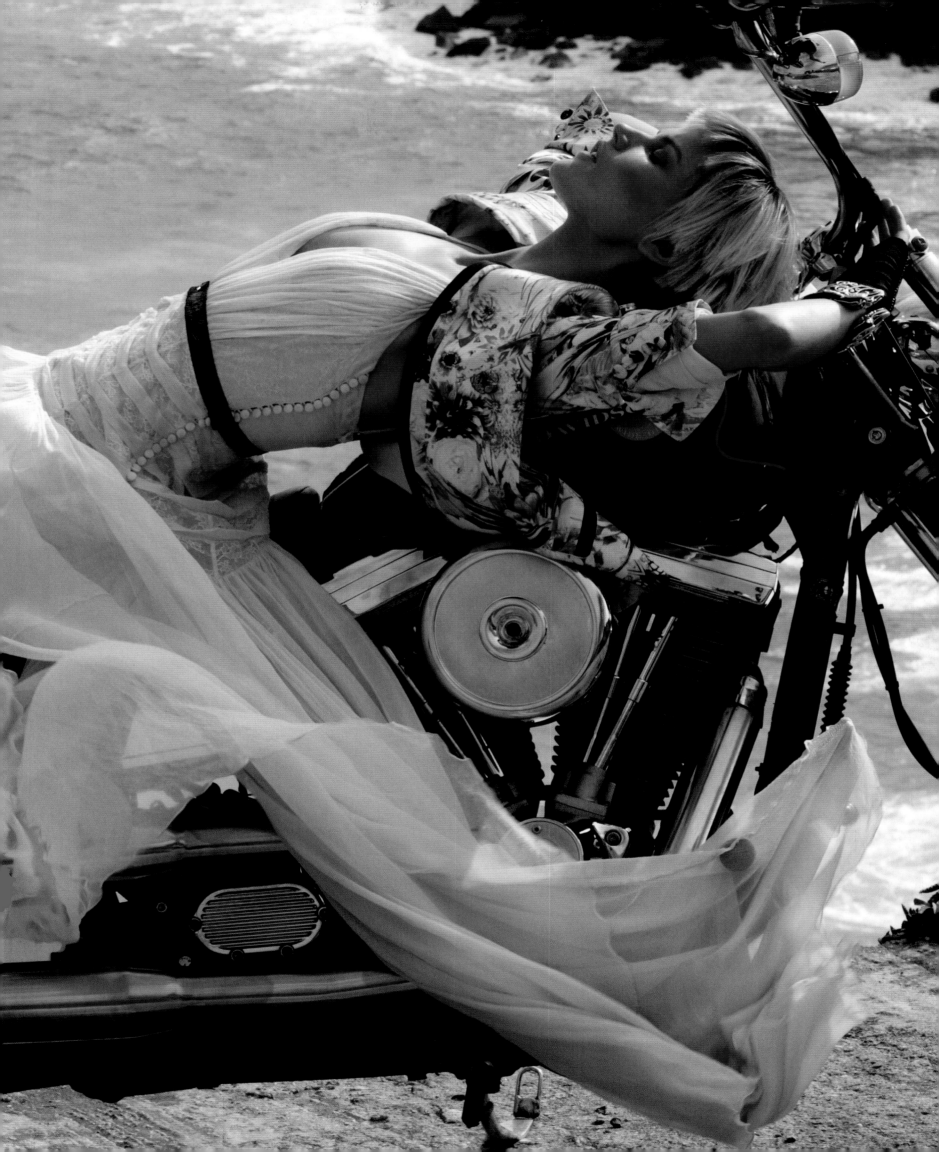

HarperCollins books may be purchased for educational, business, or sales promotional use. For information please e-mail the Special Markets Department at SPsales@harpercollins.com.

First published in 2013 by:
HARPER DESIGN
An Imprint of HarperCollins*Publishers*
10 East 53rd Street,
New York, NY 10022
Tel: (212) 207-7000, Fax: (212) 207-7654
harperdesign@harpercollins.com
www.harpercollins.com

Distributed throughout the world by:
HarperCollins*Publishers*
10 East 53rd Street,
New York, NY 10022
Fax: (212) 207-7654

Library of Congress Control Number: 2011931363

ISBN 978-0-06-211327-6

Book design by Raul Martinez, AR New York
Display typefaces: Curator Grand and Curator Ultra, by Patrick Giasson

Printed in China

ABOUT THE AUTHOR

Lori Goldstein is one of fashion's most well-respected editors and stylists. A contributing fashion editor to many magazines over the years, including Italian and Japanese *Vogue*, *Harper's Bazaar*, and *W* magazine, she began her career working with Annie Leibovitz in 1985, first as a contributing editor for *Vanity Fair* and later on various advertising campaigns, including American Express and the Gap. Her collaborations with designers and brands include Versace, Vera Wang, Maiyet, and Carolina Herrera. She also designs LOGO, an exclusive clothing line for QVC. She lives in her favorite place in the world, New York City. www.lorigoldstein.com